T0337435

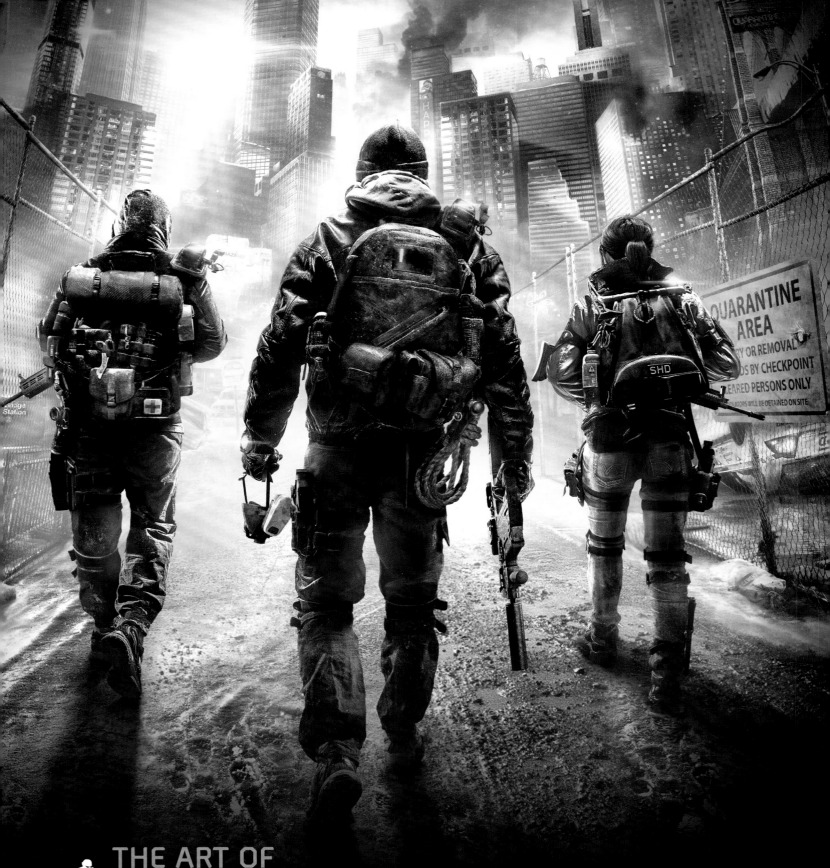

QUARANTINE
AREA
RY OR REMOVAL
DS BY CHECKPOINT
EARED PERSONS ONLY
ATORS WILL BE DETAINED ON SITE

THE ART OF
# TOM CLANCY'S
# THE DIVISION

THE ART OF TOM CLANCY'S THE DIVISION
ISBN: 9781783298341
ISBN Limited Edition: 9781785650611

Published by Titan Books
A division of Titan Publishing Group Ltd.
144 Southwark St.
London
SE1 0UP

First edition: March 2016

10 9 8 7 6 5 4 3 2 1

All Rights Reserved.

© 2016 Ubisoft Entertainment. All Rights Reserved. Tom Clancy's, The Division logo, the Soldier icon, Ubisoft and the Ubisoft logo are trademarks of Ubisoft Entertainment in the U.S. and/or other countries.

To receive advance information, news, competitions, and exclusive offers online, please sign up for the Titan newsletter on our website: www.titanbooks.com

Did you enjoy this book? We love to hear from our readers. Please e-mail us at: readerfeedback@titanemail.com or write to Reader Feedback at the above address.

No part of this publication may be reproduced, stored in a retrieval system, or transmitted, in any form or by any means without the prior written permission of the publisher, nor be otherwise circulated in any form of binding or cover other than that in which it is published and without a similar condition being imposed on the subsequent purchaser.

A CIP catalogue record for this title is available from the British Library.

Printed and bound in China.

# THE ART OF
# TOM CLANCY'S
# THE DIVISION

Andy McVittie
Foreword by David Polfeldt

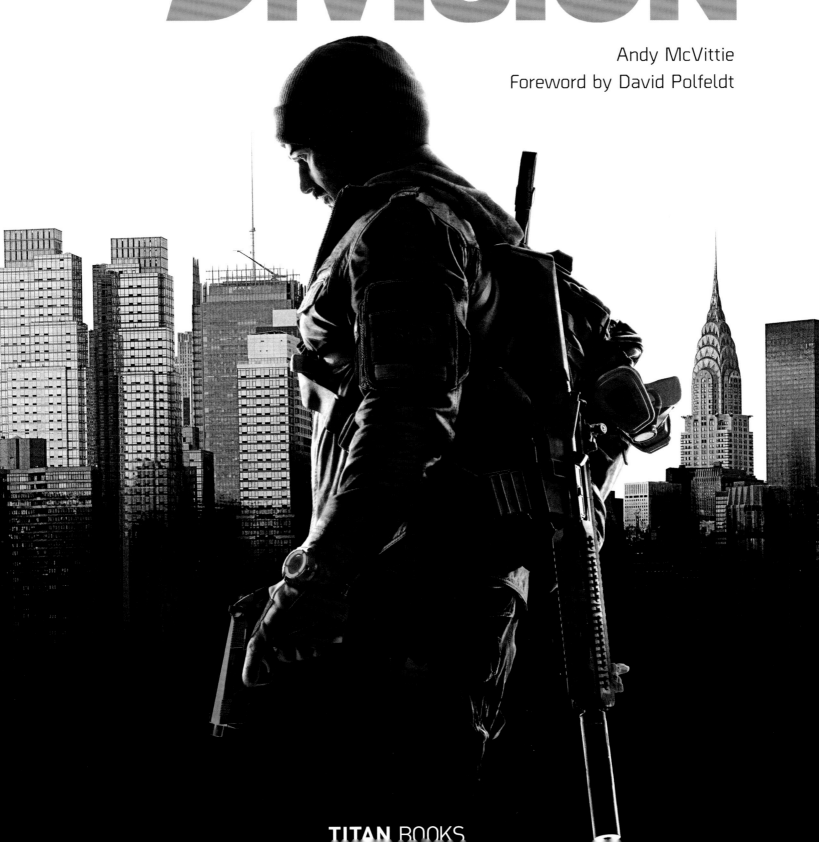

TITAN BOOKS

# CONTENTS

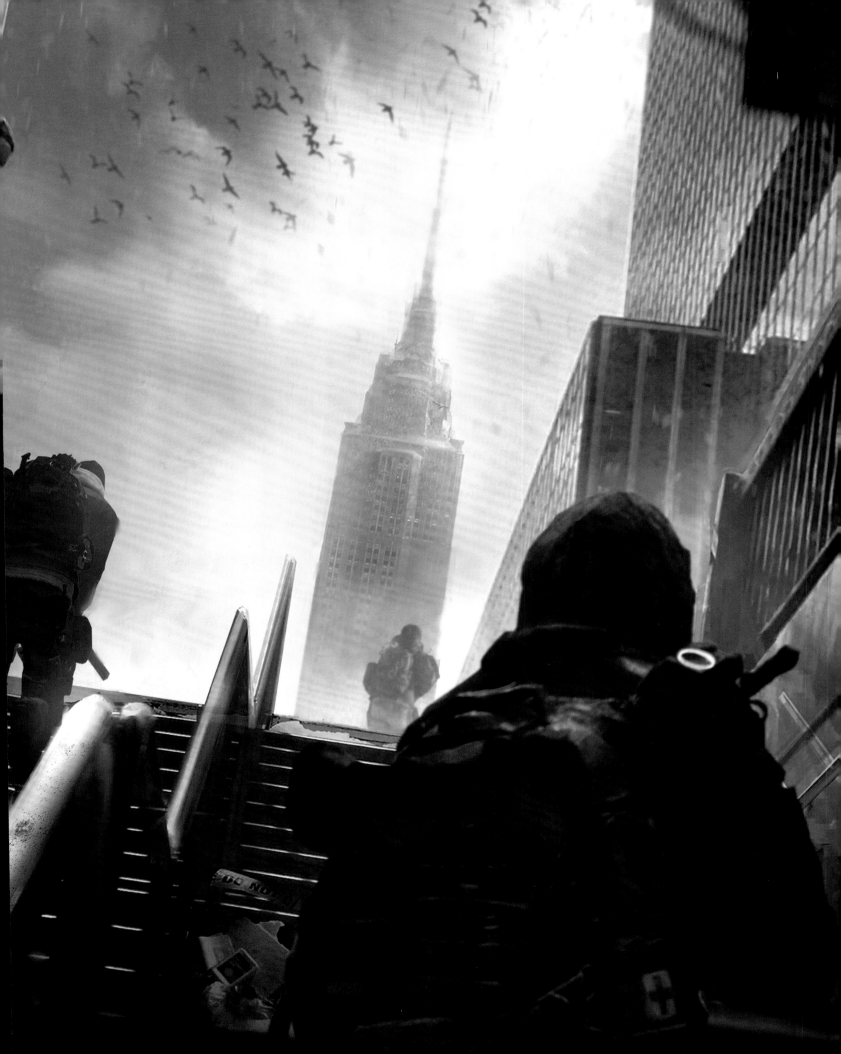

We work in the most amazing of mediums.

We create virtual worlds that the gamers can enter and live through an emotional, immersive journey where they are the real Hero. It's such an unbelievable joy to see a gamer exploring one of the digital dreams we have lovingly crafted, often over the course of many, many years, in a studio filled with concentrated artists and engineers, collaborating late into the night in the pale, blue light of an army of computer screens.

But before there is a game, we must dream about the dream itself.

We talk and we brainstorm. We use references and discuss what we like and what we don't. Looking at the real world, we research life, nature, and history. We read and we think on our own, and come back the next day with a rich bouquet of ideas that we share with each other, to inspire, to challenge, to discover, but most of all: To shape the virtual world in our minds before it exists anywhere else. Because later, as far as we are concerned, the dream will become reality when gamers can enter into it and act as they will.

Before we write the millions of lines of code that is the hidden skeleton of a game, we often start with images - we make pictures. Because when you think of it, ideas are like images, a wordless mix of color, composition, pace, mood and emotion. First there are some quick strokes, a few rough sketches that hopefully capture some vital ingredients. Then, after discussing the sketches intensely, we add more details, and embark on a patient visual exploration that reveals so many things about the game we are about to make. Often we don't know for sure what we meant to say until we see the right image. And we discover that those pictures contain hidden gems and pleasant surprises even for ourselves.

This is what concept art is about.

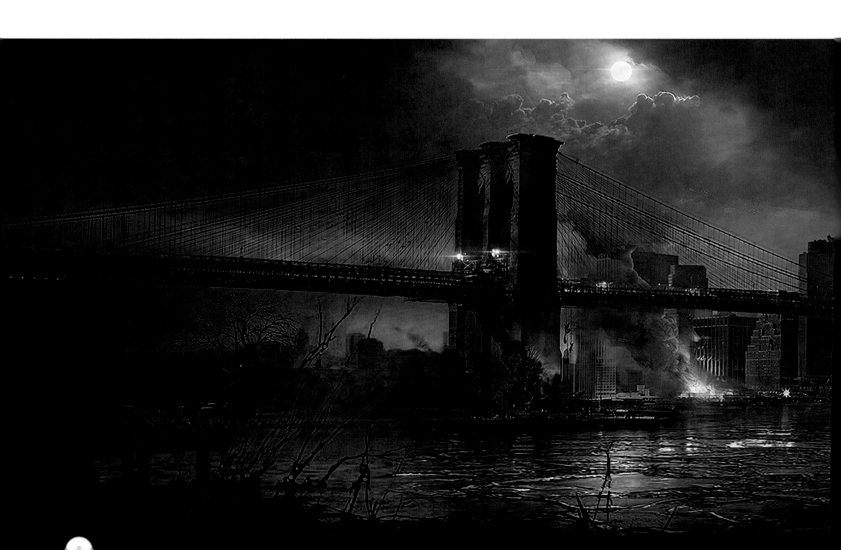

It is the challenge of expressing the shapeless dream, it is the craft of defining that which is currently without a comprehensive semantic. Thank god then, that we have been blessed with such an abundance of talented artists on Tom Clancy's The Division! From studios based in Sweden, England, France and the US, there have been passionate concept artists working day in and day out to carve out one answer after another. A street, an agent, a frightened civilian, a society collapsing, abandoned cars, dogs and wildlife, enemies preparing an ambush, majestic buildings... And then: Weather, color palettes, smoke, light, effects, particles, player skills, logotypes, and storyboards. And so it goes on! We plaster the walls of the studio with art and images. We walk among them as if in a matrix of some magic yet to appear. As we live our days among those pictures, the game is tenderly guided and protected by the simple fact that an image says more than a thousand words - and they make sure we subconsciously share the same dream.

What you are holding in your hand is a collection of some of the most important and most beautiful artwork we created during this project. We hope you will enjoy this book as much as we do on the team of Tom Clancy's The Division!

Thank you to all the amazingly talented artists I have had the privilege to work with on this project. I have an immense admiration for your craftsmanship!

David Polfeldt, *Managing Director*
Massive Entertainment | a Ubisoft Studio

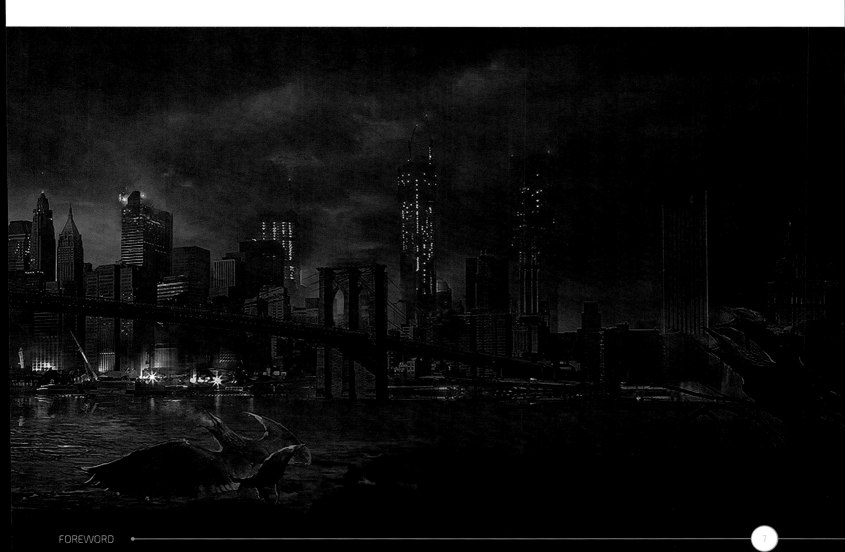

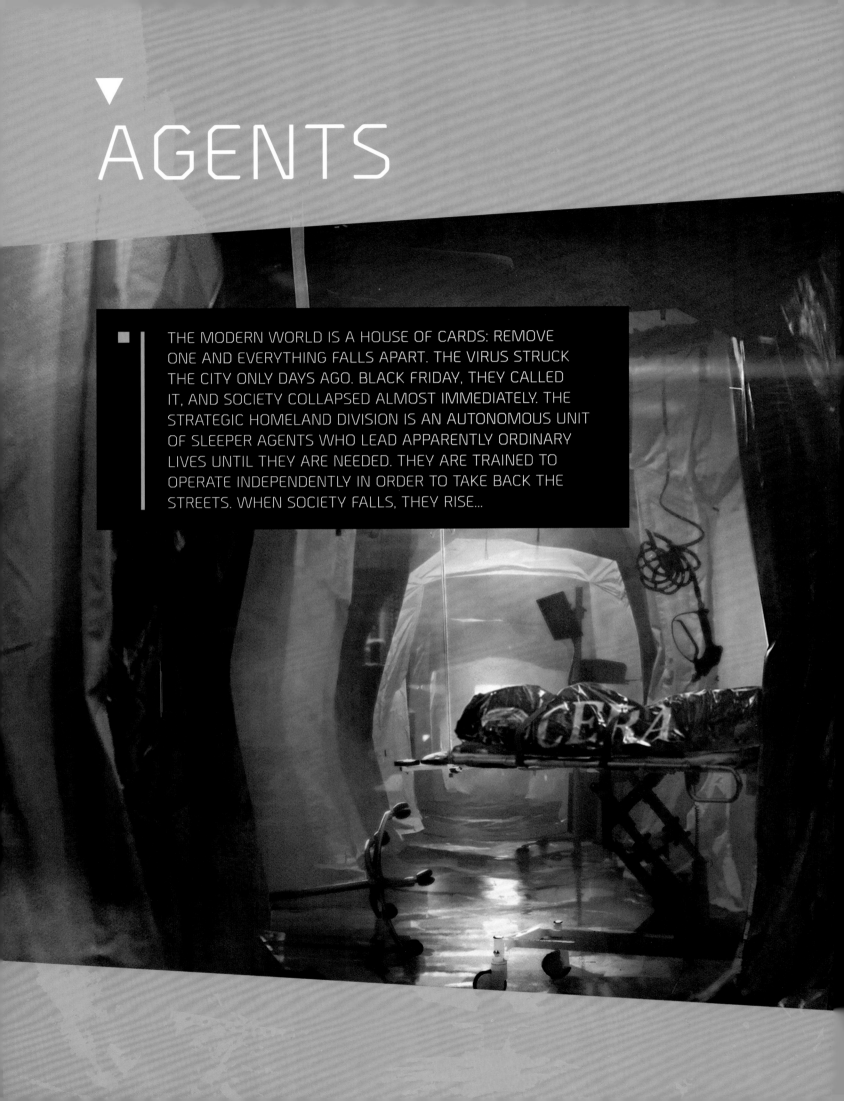

# AGENTS

THE MODERN WORLD IS A HOUSE OF CARDS: REMOVE ONE AND EVERYTHING FALLS APART. THE VIRUS STRUCK THE CITY ONLY DAYS AGO. BLACK FRIDAY, THEY CALLED IT, AND SOCIETY COLLAPSED ALMOST IMMEDIATELY. THE STRATEGIC HOMELAND DIVISION IS AN AUTONOMOUS UNIT OF SLEEPER AGENTS WHO LEAD APPARENTLY ORDINARY LIVES UNTIL THEY ARE NEEDED. THEY ARE TRAINED TO OPERATE INDEPENDENTLY IN ORDER TO TAKE BACK THE STREETS. WHEN SOCIETY FALLS, THEY RISE...

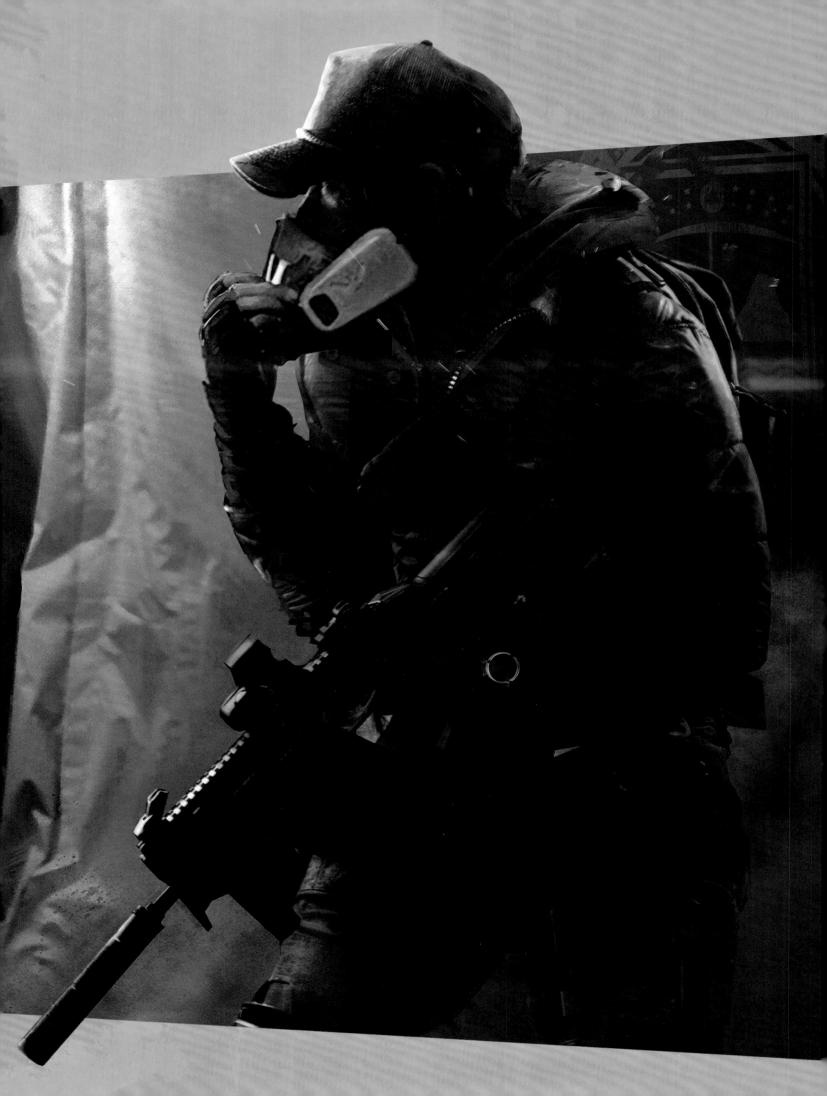

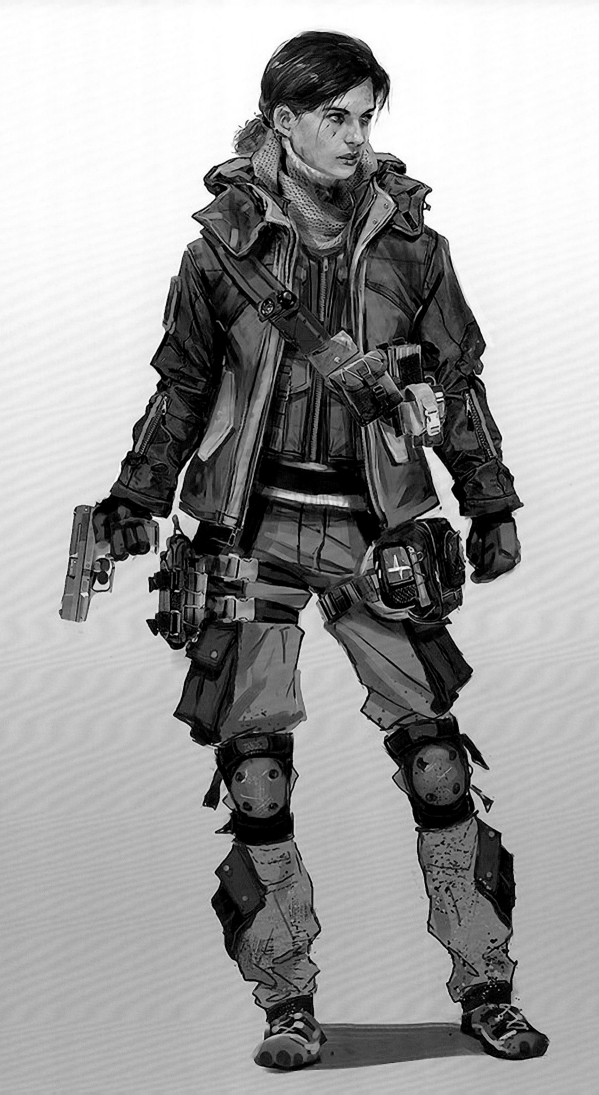

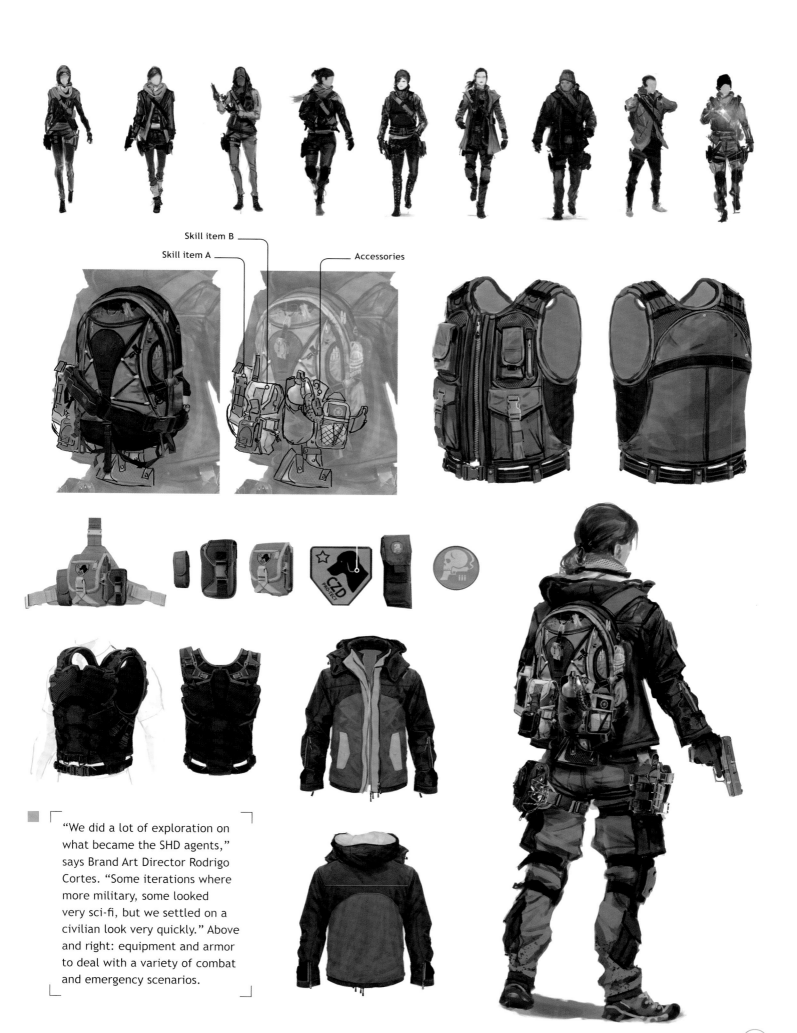

Skill item B

Skill item A

Accessories

"We did a lot of exploration on what became the SHD agents," says Brand Art Director Rodrigo Cortes. "Some iterations where more military, some looked very sci-fi, but we settled on a civilian look very quickly." Above and right: equipment and armor to deal with a variety of combat and emergency scenarios.

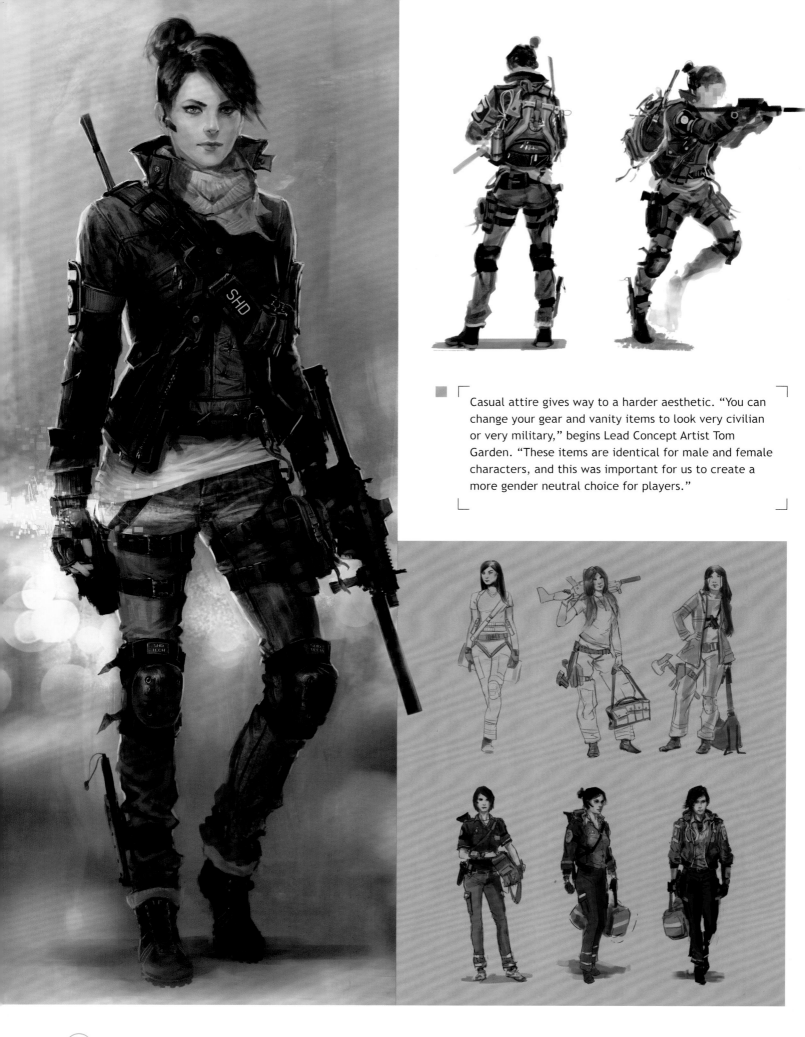

Casual attire gives way to a harder aesthetic. "You can change your gear and vanity items to look very civilian or very military," begins Lead Concept Artist Tom Garden. "These items are identical for male and female characters, and this was important for us to create a more gender neutral choice for players."

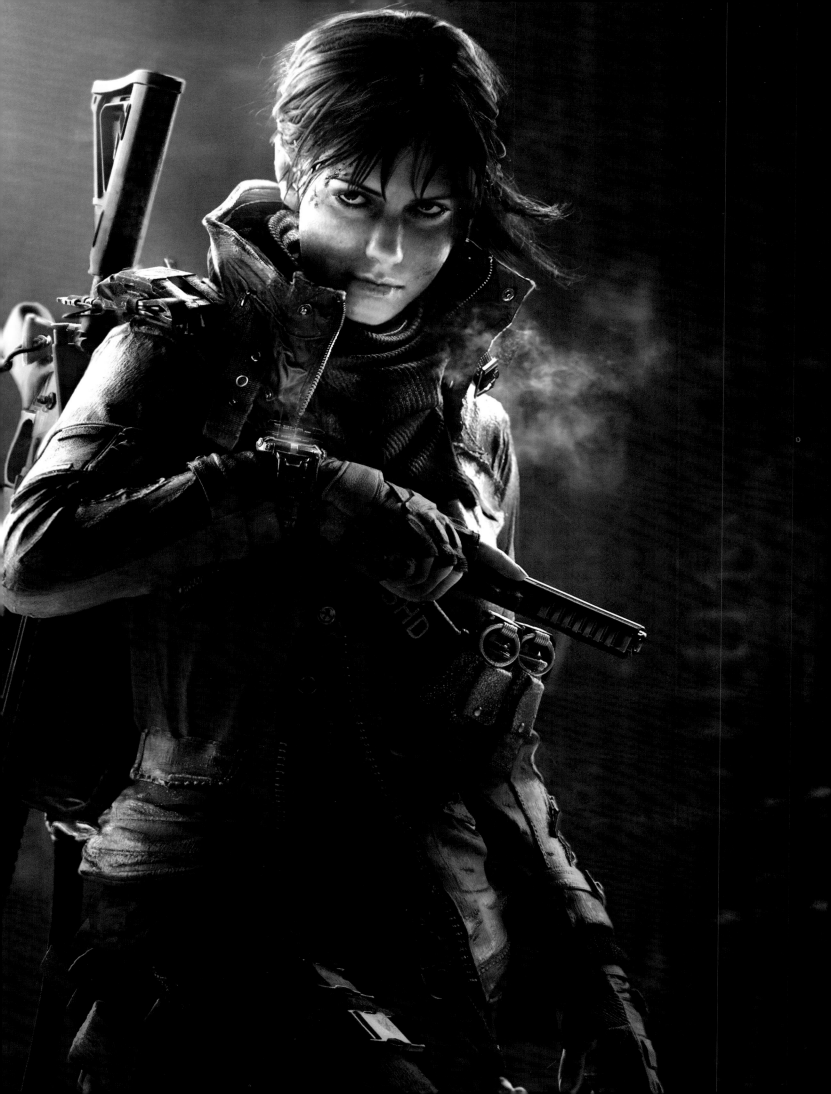

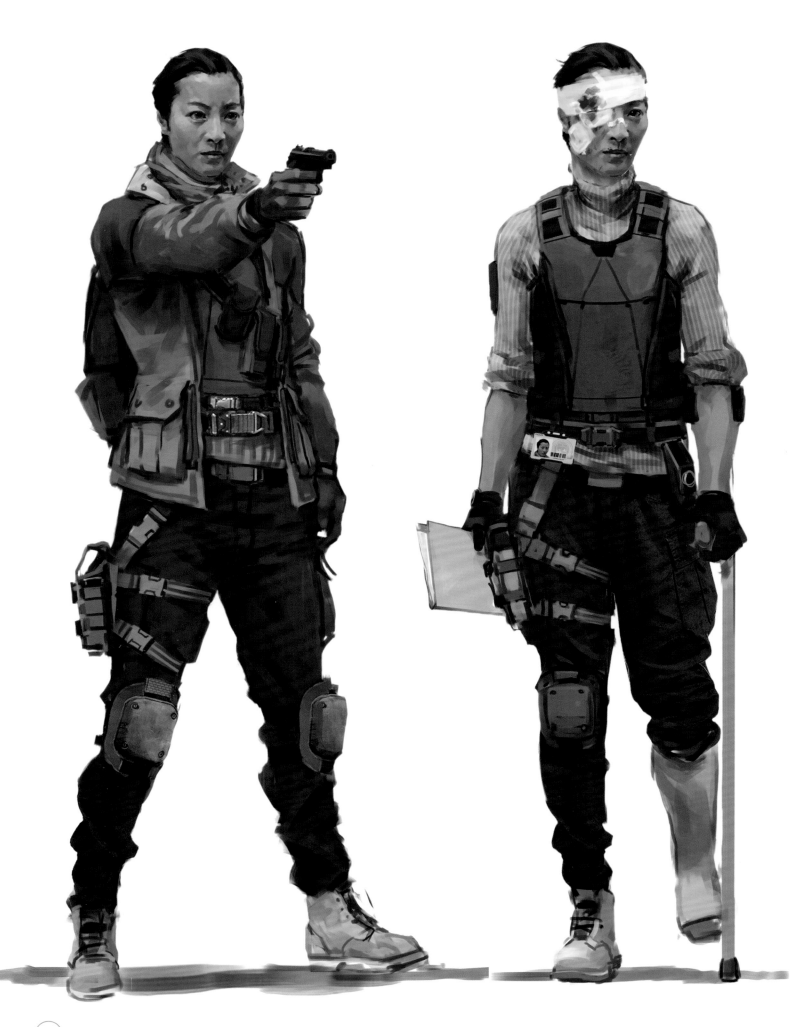

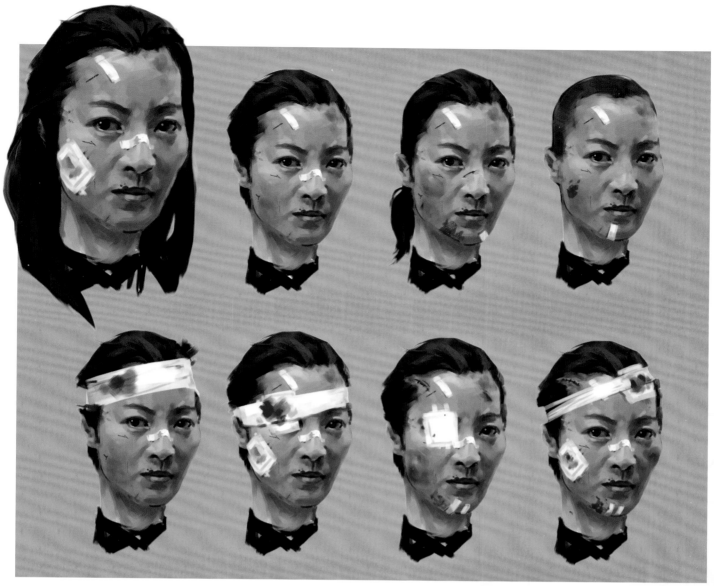

Battered, broken and yet unbowed. As these concept images show, surviving the chaos takes its toll in real time and with varying degrees of damage. This agent is still lucky enough to be classified as walking wounded. "Faye is a Division agent like the player character, however an incident incapacitates her and leaves her to run things

from behind a desk, much to her chagrin," says Tom Garden. "We wanted to make sure that, post-injury, she still looked ready to hop back into action. She keeps her vest and sidearm equipped, and has hooked her shade computer to her belt. She'll support you over the comms, but cannot wait to get a slice of the action herself."

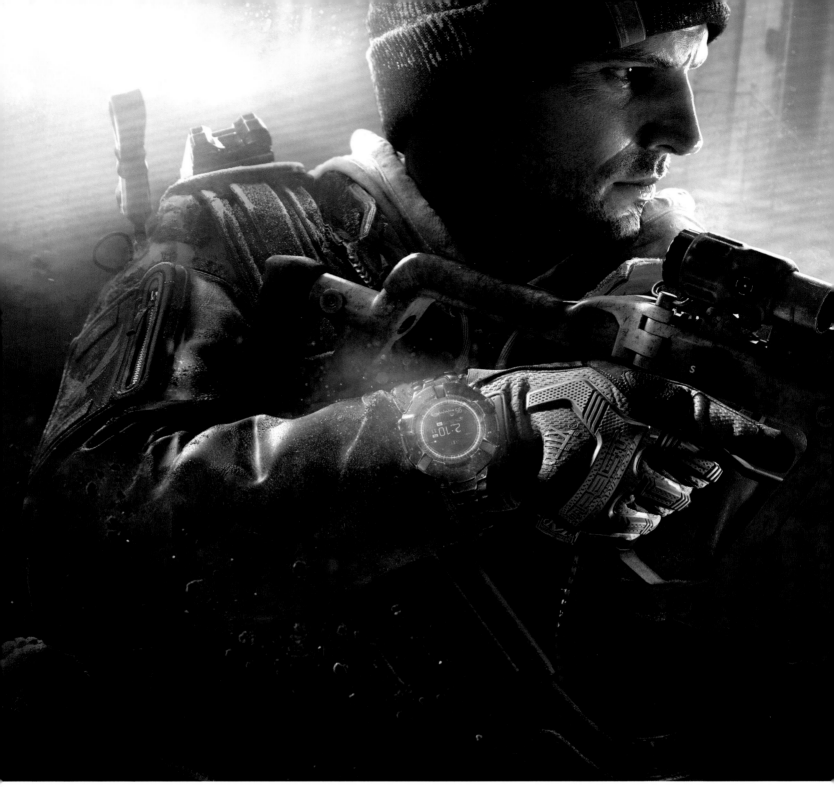

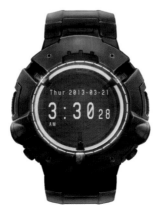
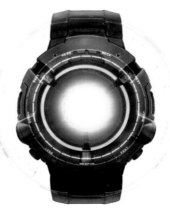
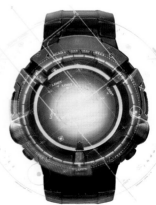

Coordination and effective communication are the keystones of successful operations. The SHD agent's wristwatch and other personal accoutrements, however, are well up to the task of keeping the team together. "The watch is a natural evolution of the smart phone," says Rodrigo Cortes. "The great thing for our agent is that it can be worn both in civilian life and on the job without drawing much attention. Even the contact lenses, which display the information for the agents, are based on existing prototype technology. Coupled with augmented reality it becomes a true force-multiplier with countless applications and areas of use."

Robust form follows rugged function. These images show the design team's dedication to making even the smallest details of gameplay tangible, practical and grounded in real-world technologies. The orange ring is a sign of unity on both the watch and backpack computer.

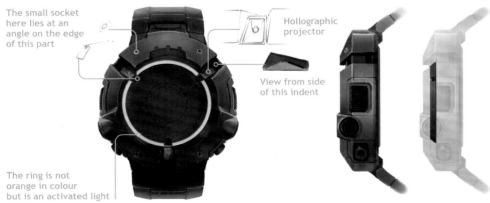

The small socket here lies at an angle on the edge of this part

The ring is not orange in colour but is an activated light

Hollographic projector

View from side of this indent

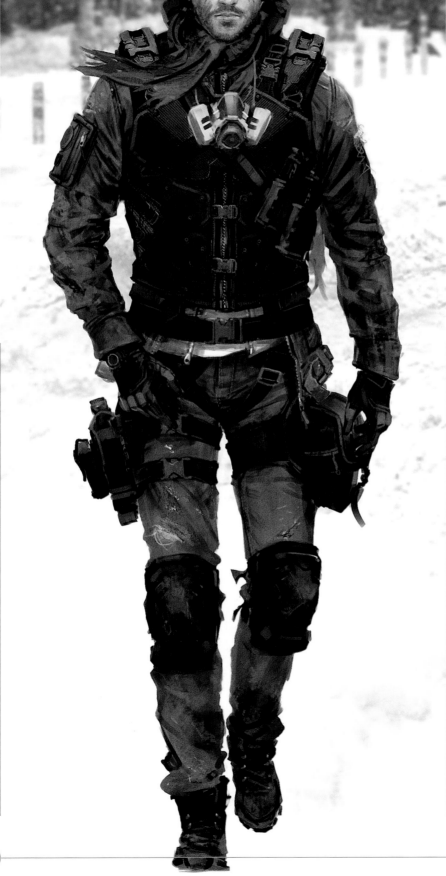

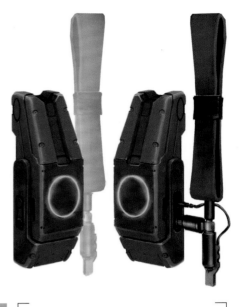

As an ostensibly covert cell, Division agents have no formal base of operations and must carry a lot of their equipment with them, this includes a lot of specialized gear. One of the more iconic pieces is the shade computer which is hooked onto their backpacks.

The team designed a Rappelling tool for the agents to use, it allows them to quickly ascend and descend climbable ropes in the game. This is essential for speed and maneuverability in city of skyscrapers.

Beneath an agent's normal daywear they have a special thermal body suit [*right*].

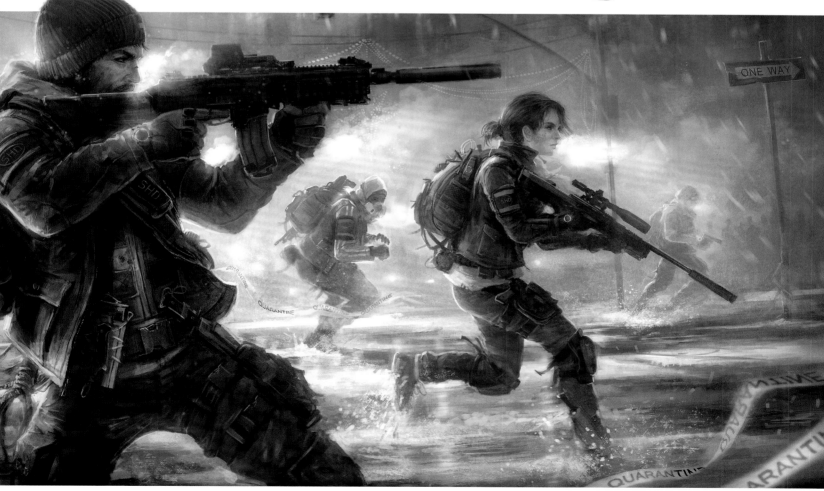

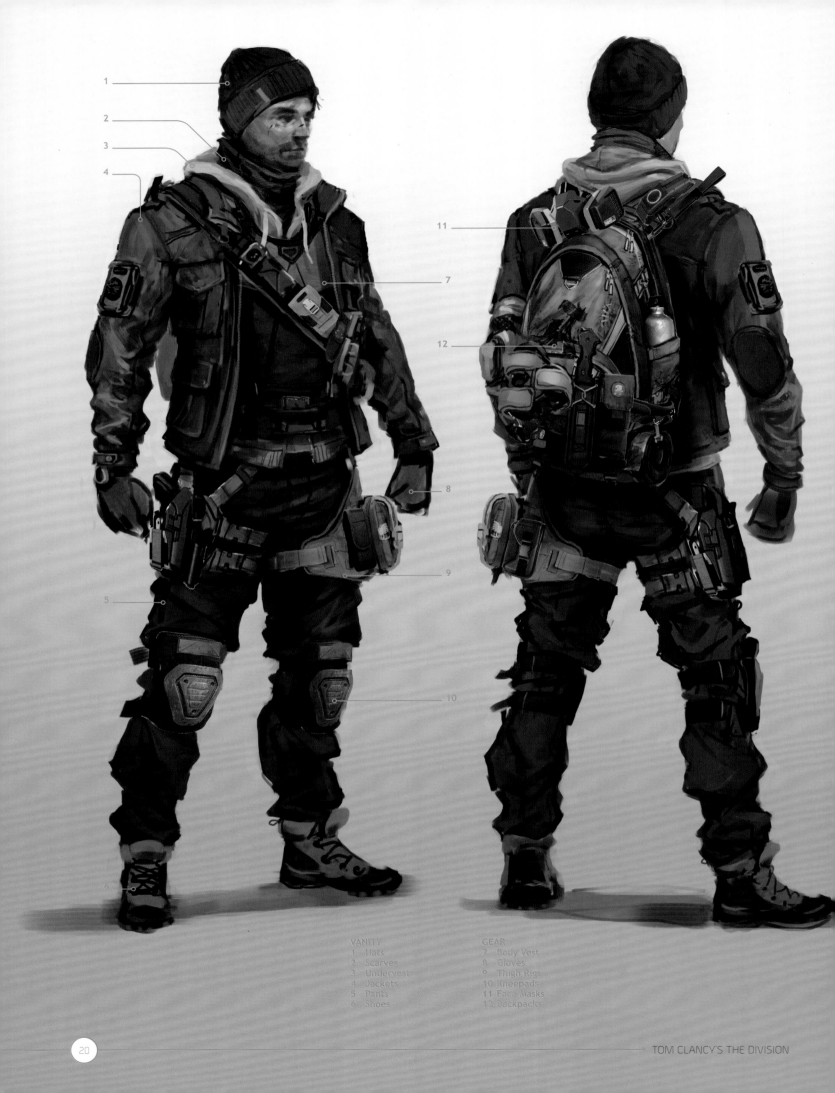

VANITY
1  Hats
2  Scarves
3  Undervest
4  Jackets
5  Pants
6  Shoes

GEAR
7  Body Vest
8  Gloves
9  Thigh Rigs
10  Kneepads
11  Face Masks
12  Backpacks

A fully-laden Division agent is a self-contained and battle-ready combat unit. Annotations to the left indicate the basic components of a typical load-out, with clothing and equipment options to deal with most situations that he or she is likely to encounter. Lead Concept Artist Tom Garden dives into the detail: "We have six gear carrying slots and six vanity slots on the character. This allows for a lot of personalization and customization, not only in terms of gameplay but also how you will look. You also have the option to take off hats, scarves or jackets if you wish. For your gear, as you level up the aesthetics will look much cooler and you will gain a more tactical silhouette with more thigh rigging, bags and protective armor."

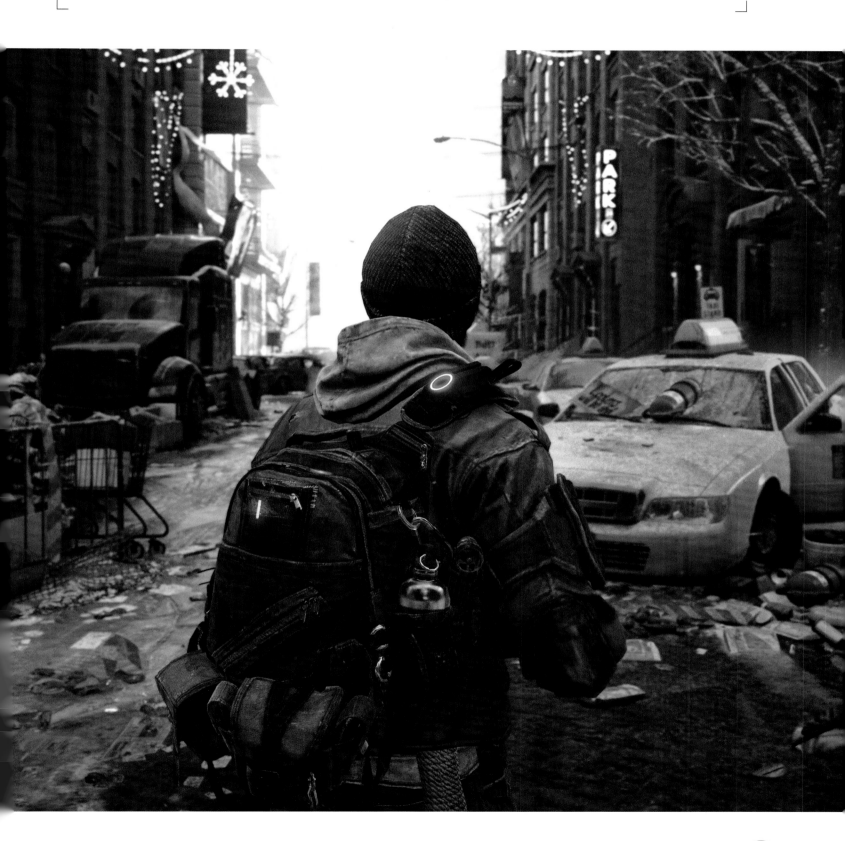

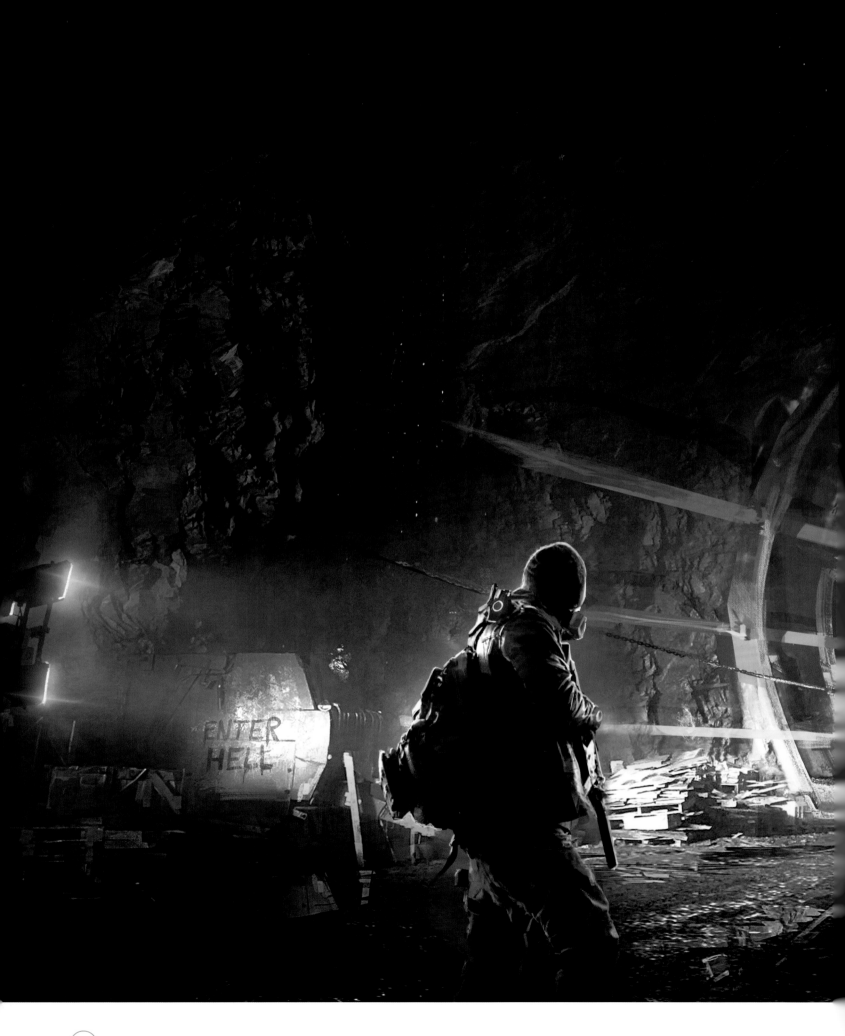

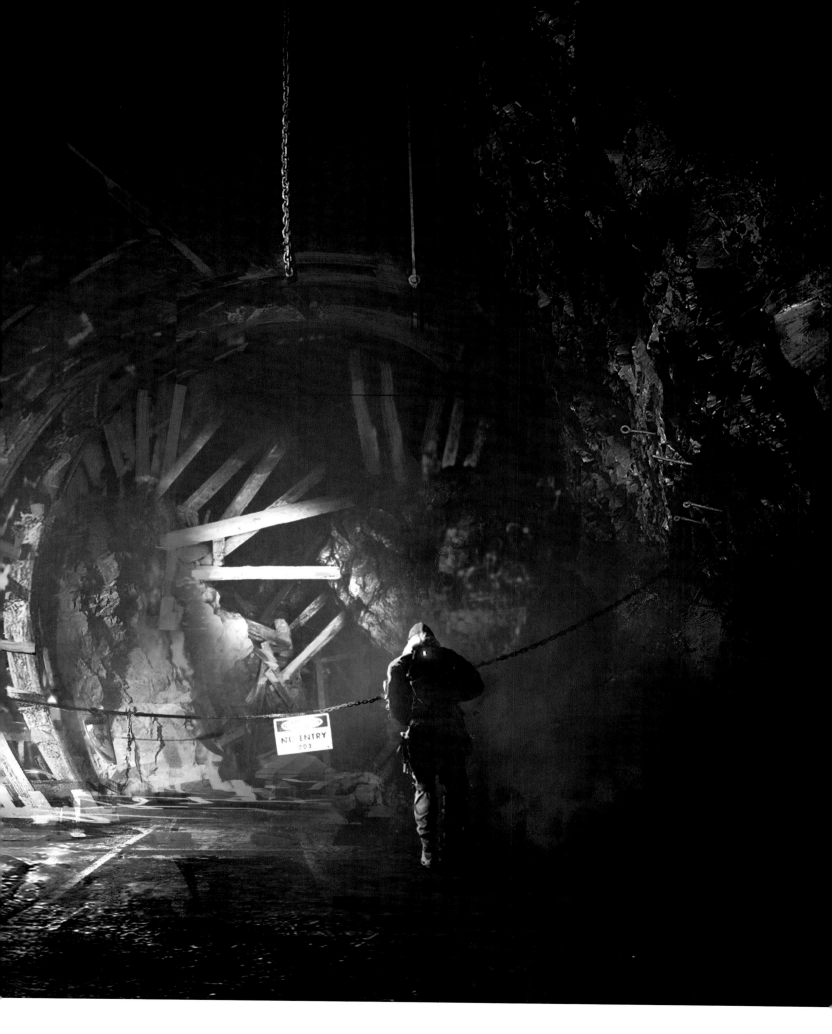

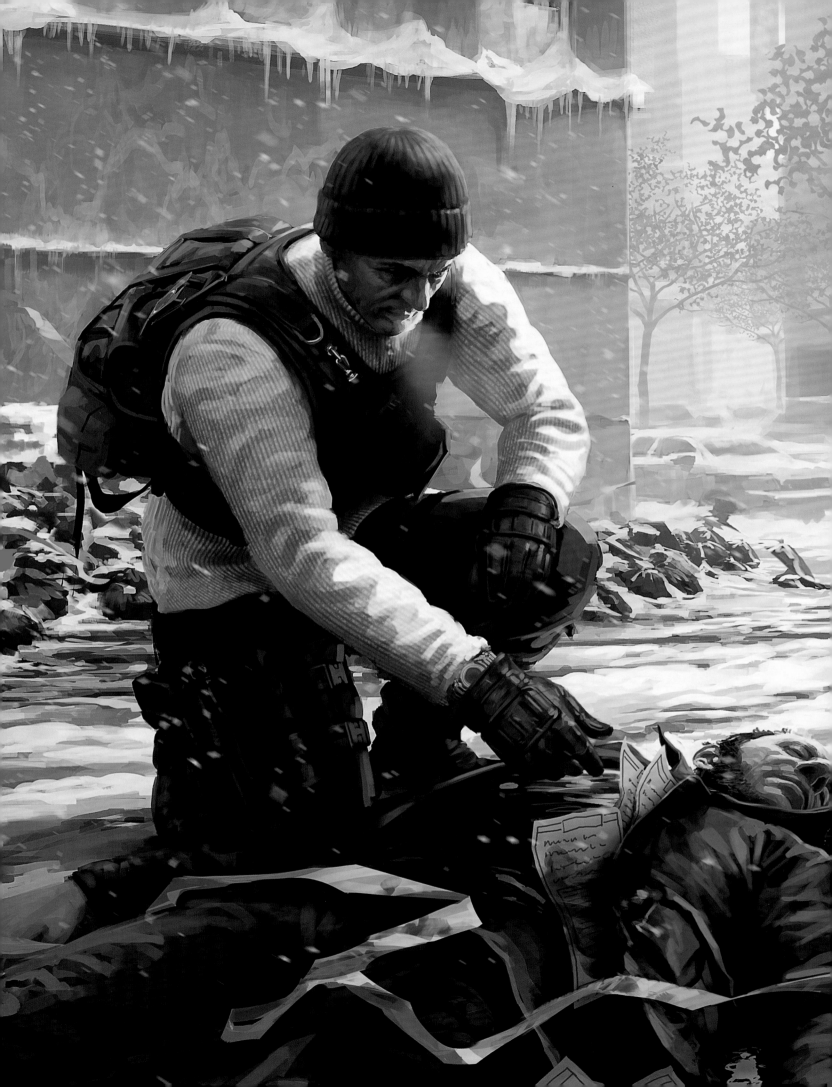

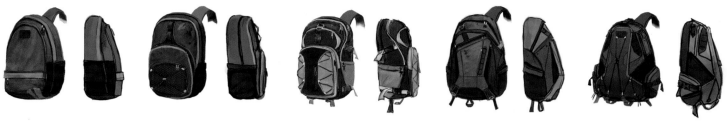

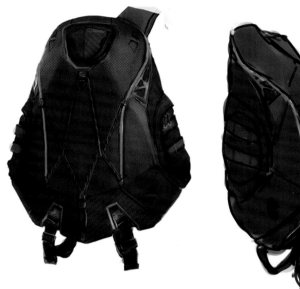

Division agents are neither reactionary vigilantes nor fearful survivalists, but must still be ready to react to any number of situations at a moment's notice. The backpack is an iconic part of our agents. The art team took inspiration from military contractors, 'preppers' and go-bags for the visual aesthetics. As the players level the bags will evolve and gain new accessories. The artists also included a visual representation of each skill item active on the bag, as well as on the face mask.

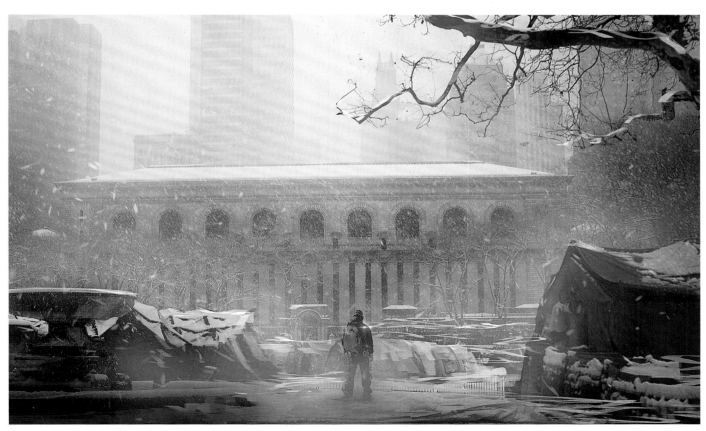

Strobes and mines are designed to make life difficult for adversaries of any variety. The Firefly delivers blinding flashes that incapacitate an opponent long enough for an agent to gain a more lethal advantage. Hotspot and Distraction mines may create a more lasting impression. "The player has many skills at their disposal as they level up," says Tom garden. "We went through many ideas before settling on the final group of skills. It was a balancing act to make them feel grounded in reality, but fun and rewarding in terms of gameplay and visuals."

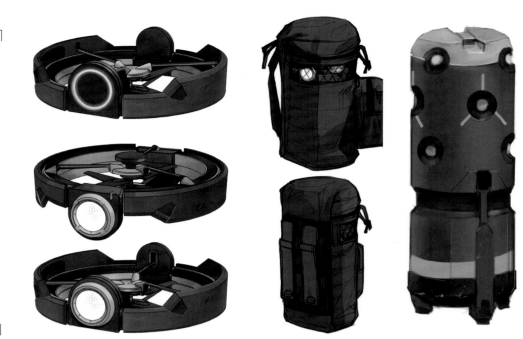

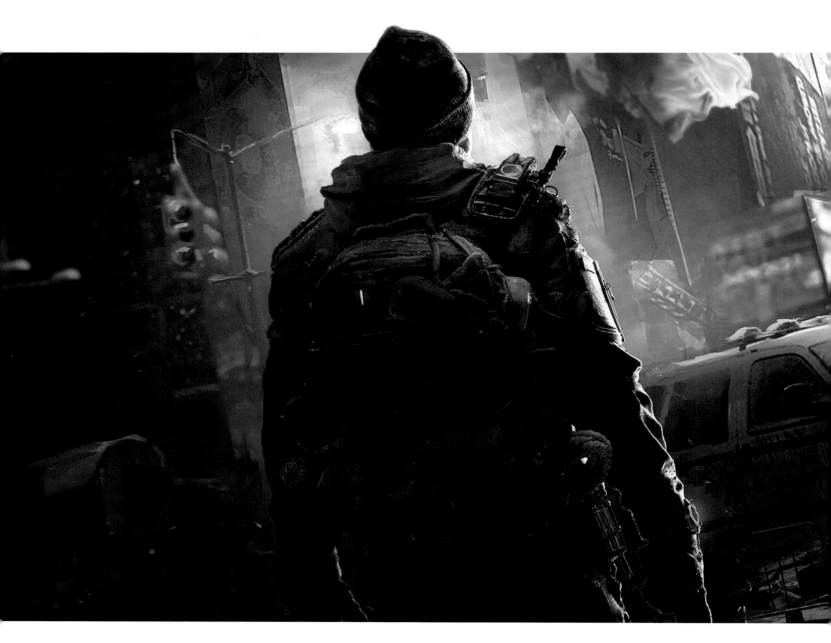

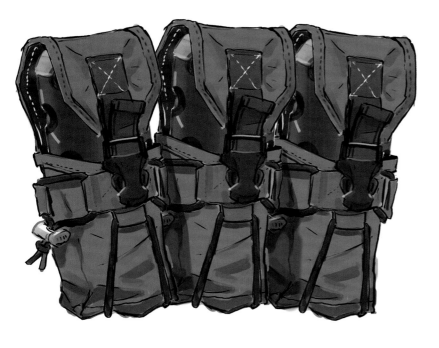
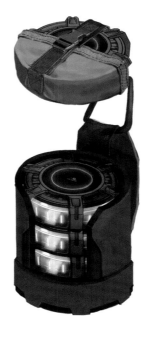
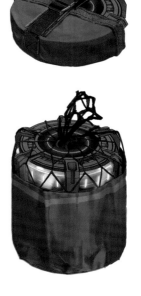
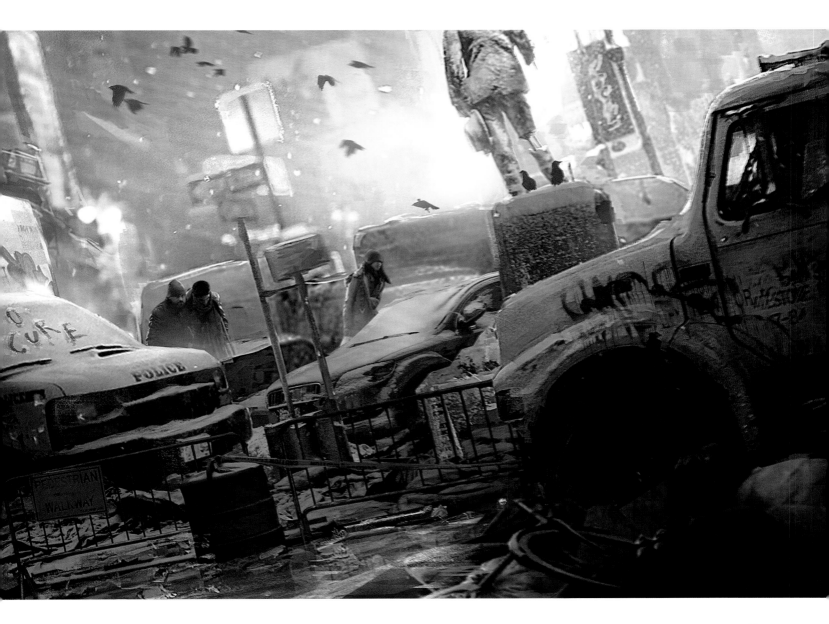

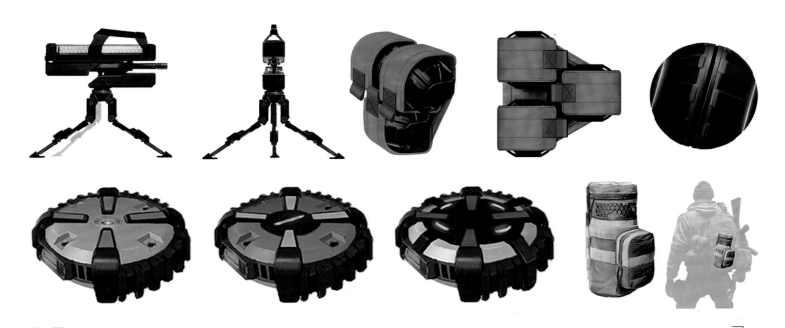

Turret and Seeker Mines are as good as an armed and accurate companion if correctly deployed. The Turret and Seeker Mines were the first skills the art team designed. Alongside these are numerous mines, grenades, shields, and non-combat equipment for player use throughout the game. These integrate with the player's appearance but some will only be displayed on the backpack such as the iconic Pulse skill.

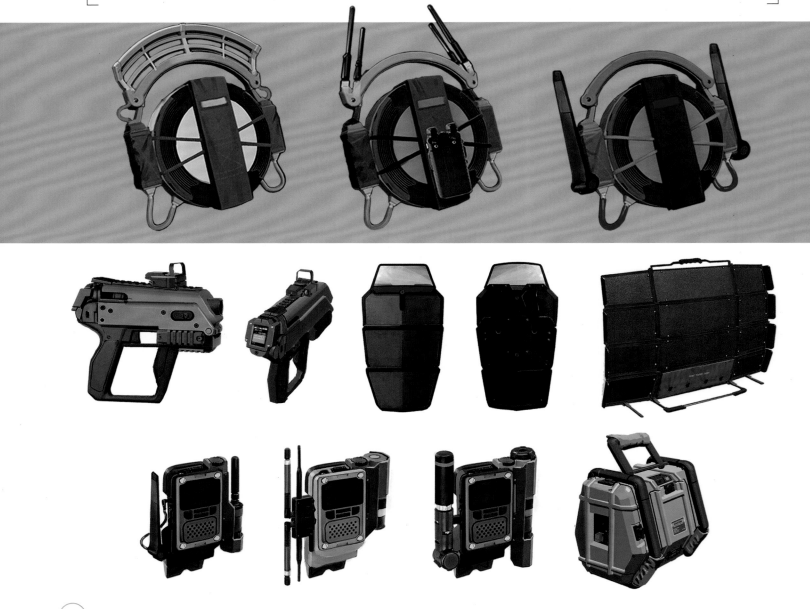

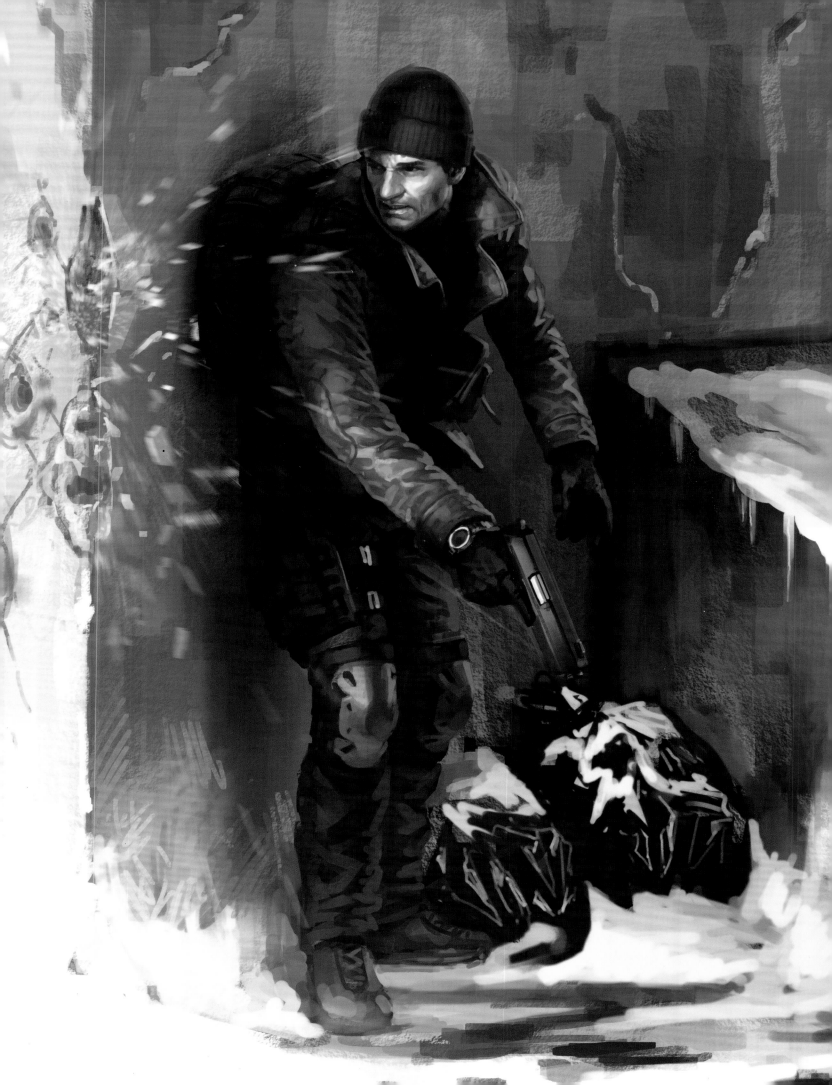

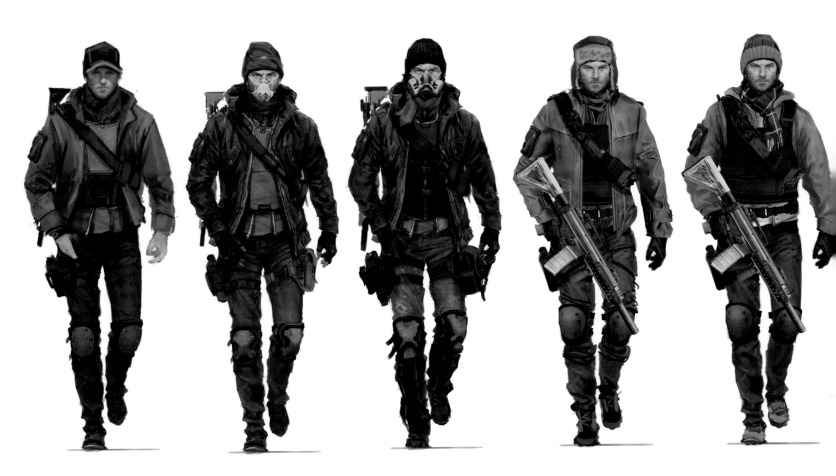

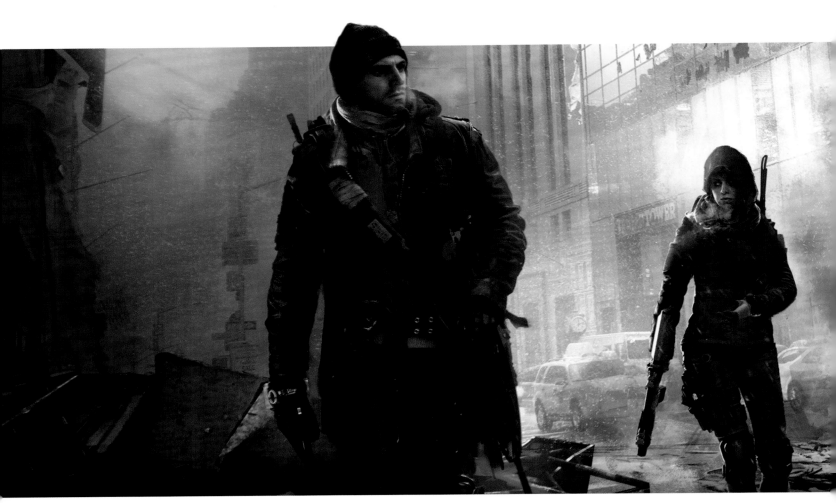

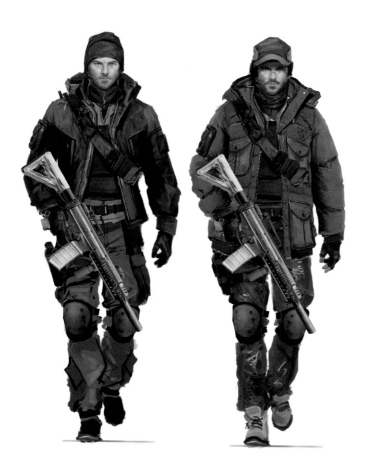

SHD agents should dress properly for the task at hand and the prevailing weather conditions. The art team developed a variety of looks for the agents which are possible by simply playing around with different combinations of items. One key items that can change is the look of the player's jacket. Players can choose to wear the jacket or remove it to reveal a Body Vest. Below are some of the very first agent sketches created by the concept artists.

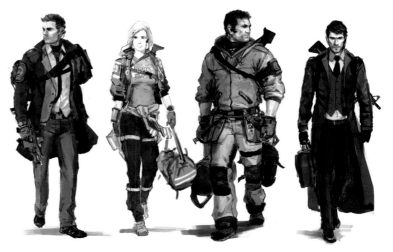

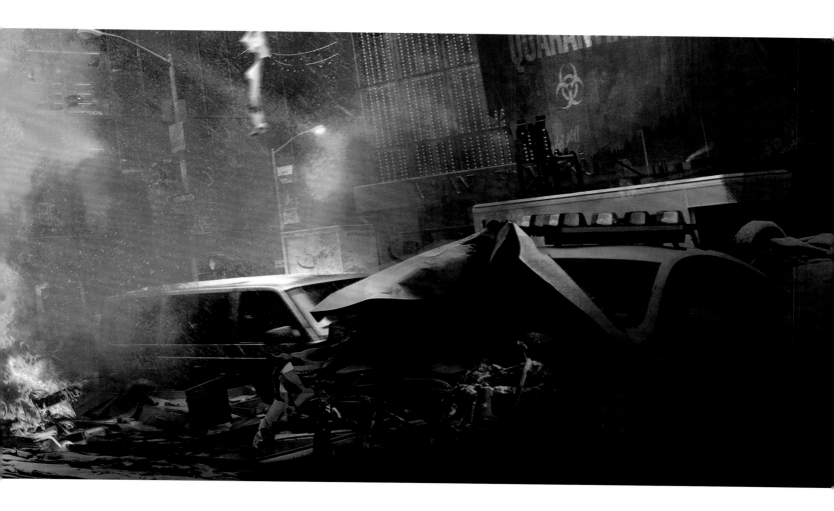

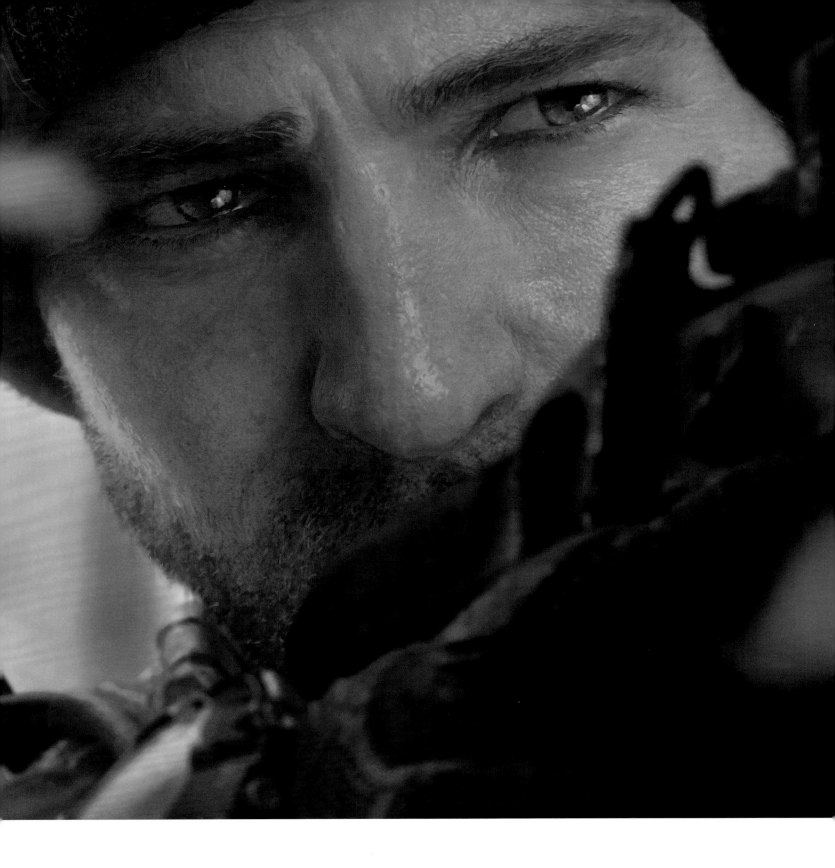

The steely gaze of this agent as he focuses on his target indicates both his grim determination and the tremendous skill of the artists in conveying the scene in such convincing and utterly lifelike detail. The vivid reflection in his eyes, the shine on his nose and pores of his skin shows that the artists have ventured far beyond the uncanny valley here. Realism in the game is an important factor to the team when creating the look of the agents. Having high resolution marketing art and renders helped to reach that goal within the playable game.

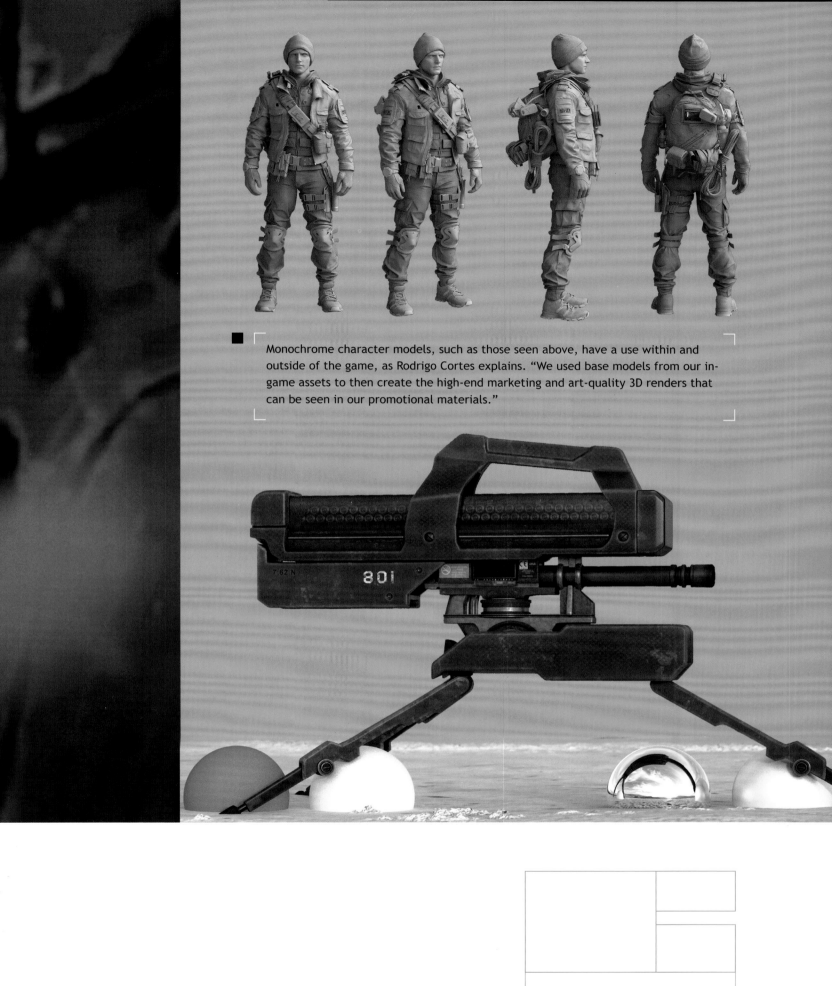

Monochrome character models, such as those seen above, have a use within and outside of the game, as Rodrigo Cortes explains. "We used base models from our in-game assets to then create the high-end marketing and art-quality 3D renders that can be seen in our promotional materials."

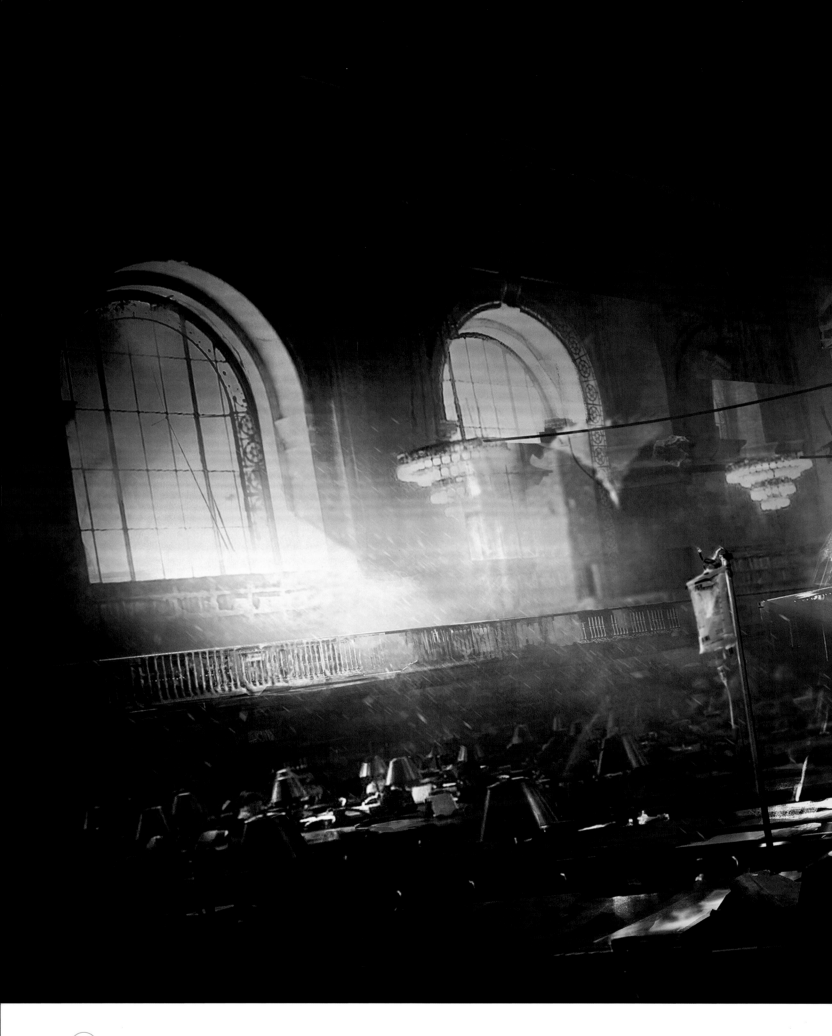

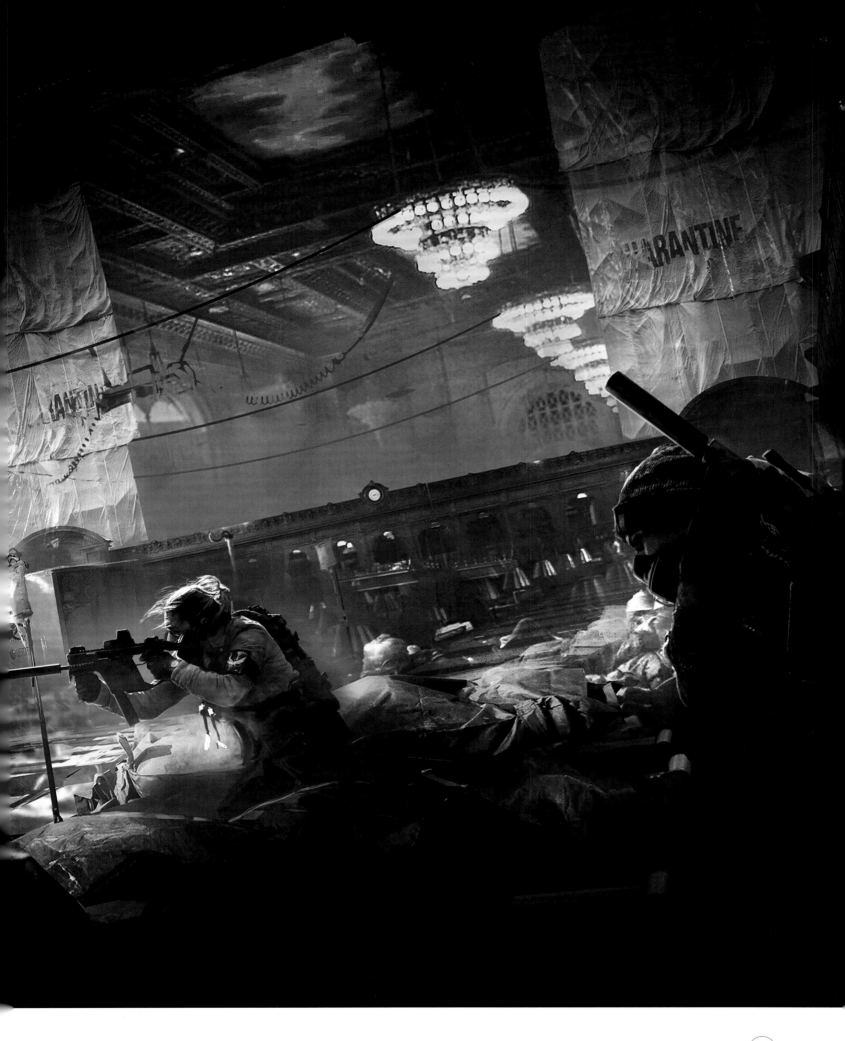

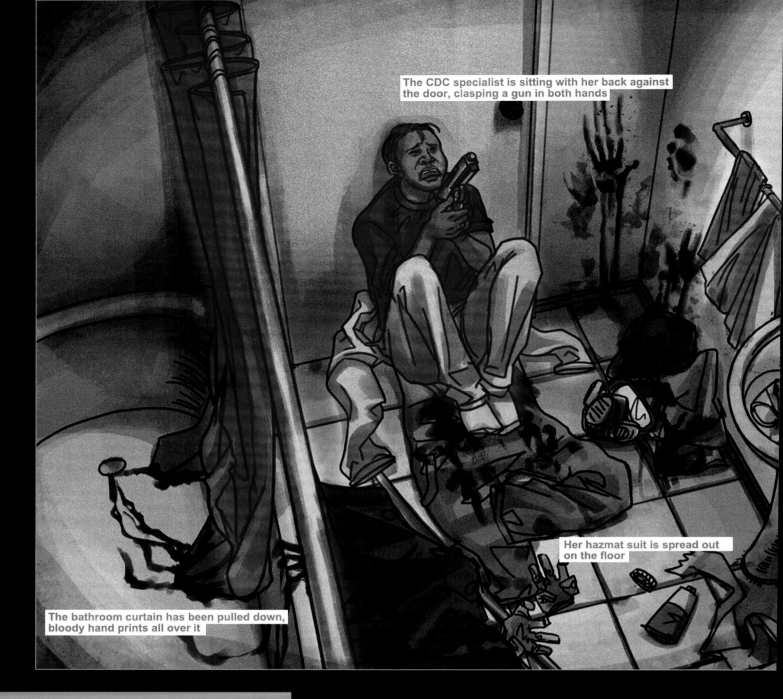

The CDC specialist is sitting with her back against the door, clasping a gun in both hands

Her hazmat suit is spread out on the floor

The bathroom curtain has been pulled down, bloody hand prints all over it

## ECHOS

Certain events of the outbreak can be replayed in short segments and a spectral orange hue. ECHO is a tool that allows agents to analyze their environments by assembling data from a range of sources. It is a useful resource for any agent to trace hostile movements, missing persons or hidden caches of supplies and equipment.

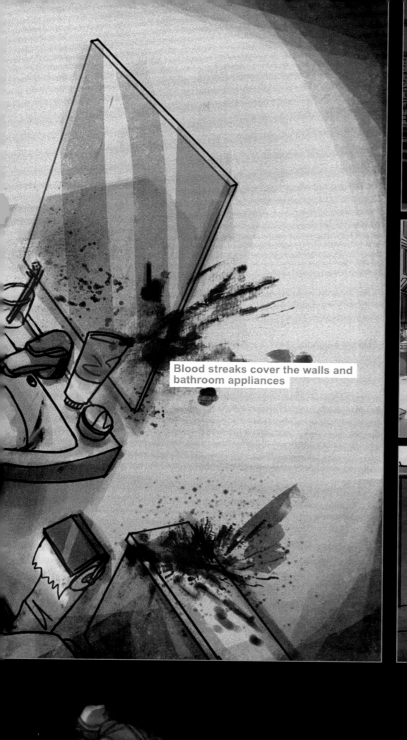

Blood streaks cover the walls and bathroom appliances

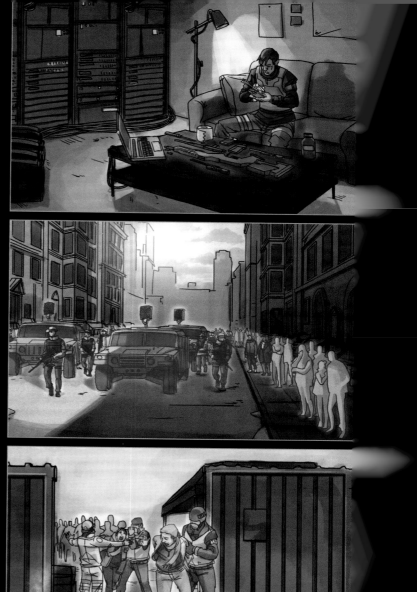

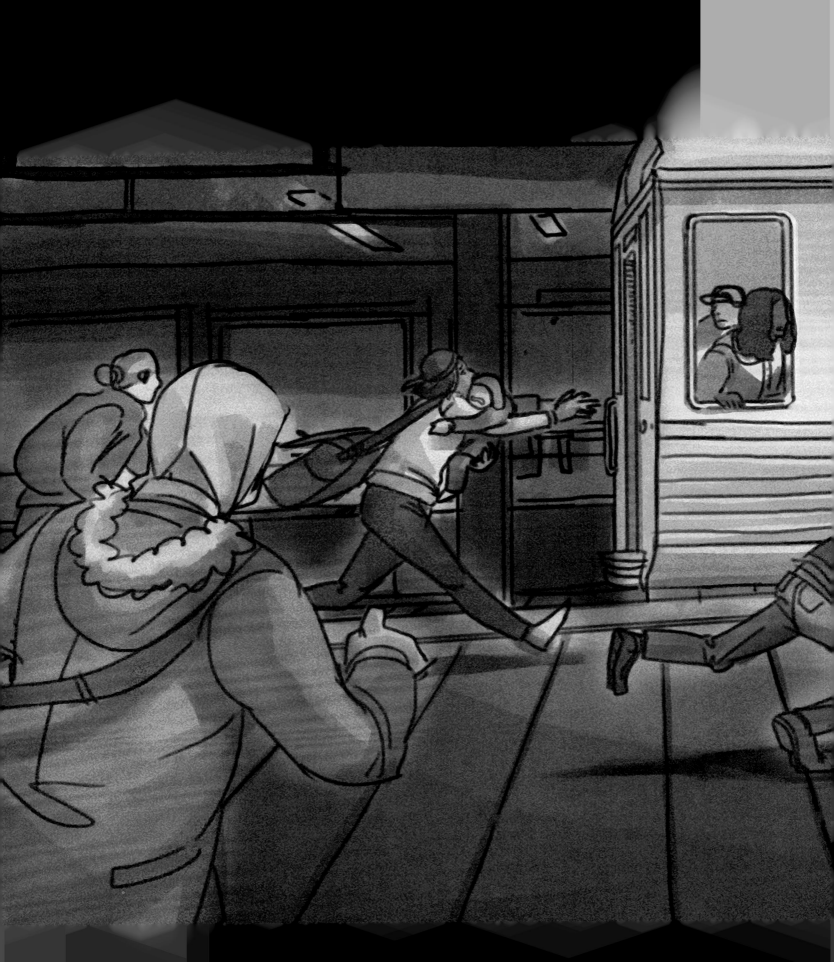

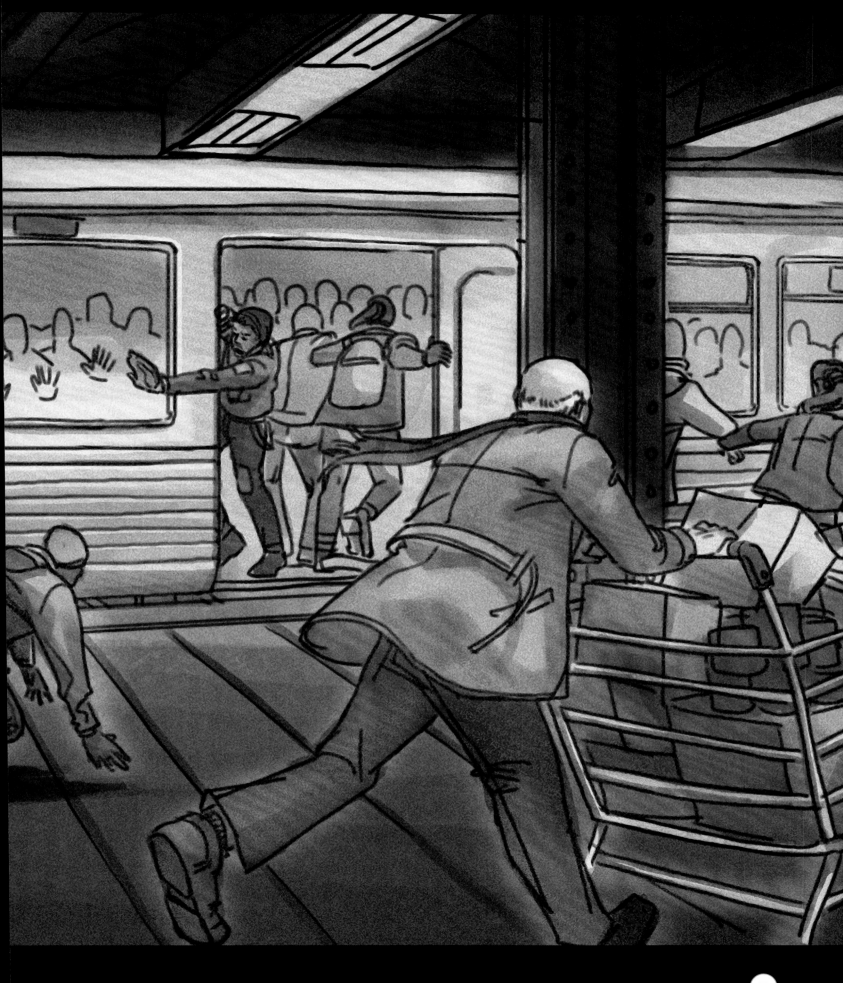

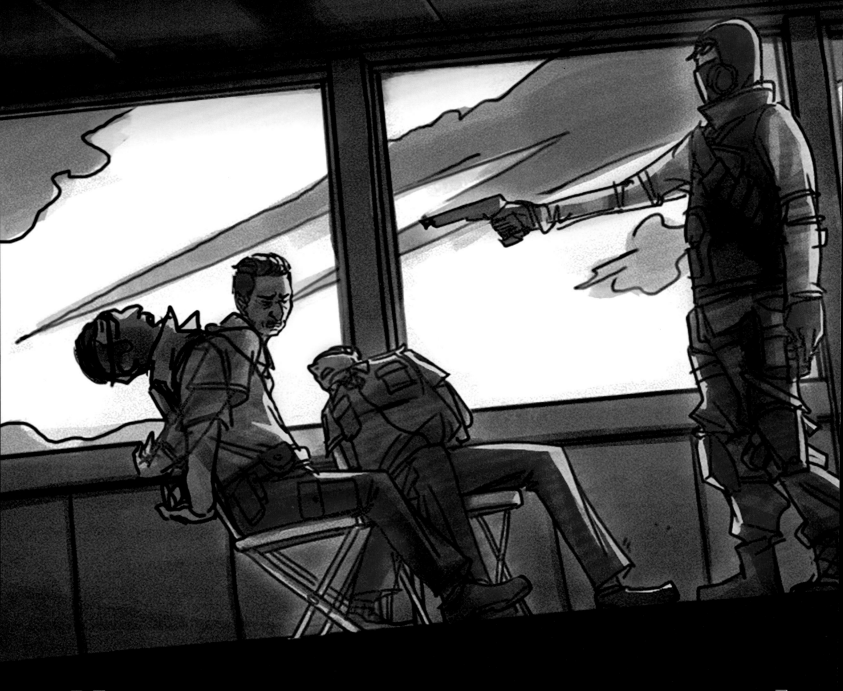

A traumatic scene is reviewed through the prism of the ECHO system. There are many like it, and most are difficult to witness. However, important gameplay details may reveal themselves on close examination. Lead Concept Artist Tom Garden explains further: "An important aspect in the creation of ECHOs was to communicate the differences between real-world elements and ECHO elements. A withered real world plant might reveal its sprightly self once the ECHO is activated, to give a sense of passing time. Special attention was paid to the small details in the environment. Seemingly trivial things, such as an overturned picture frame or an ECHO flashlight differing slightly from its real-world position, may prove to be important clues in your investigations. Make sure to keep a look out for these irregularities!"

When game development is at its most fun, it is an organic and collaborative process between multiple disciplines. Someone has a need or a problem and others chip in to solve it. The ECHO is an example of such a thing," adds Rodrigo Cortes. "Essentially driven by a narrative need, it is a collaborative effort between code, design, UI and writers. The basic need was to find a way to relay information from the past without disrupting the cooperative experience for the player. Not wanting to lock people into cut-scenes or risk members of the player group missing what happened, the ECHO was suggested as a possible solution. It was however a new challenge, so it required insight and help from multiple experts. Like many other features created through iterative design, it has blossomed over time into its current form."

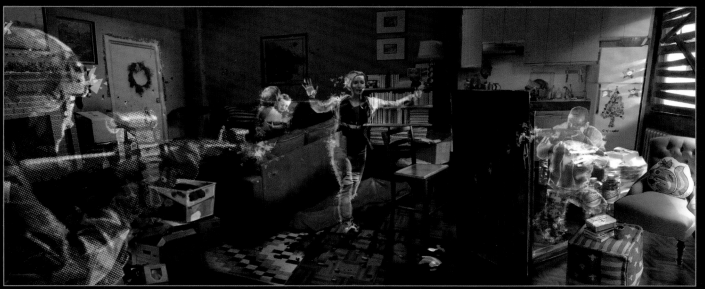

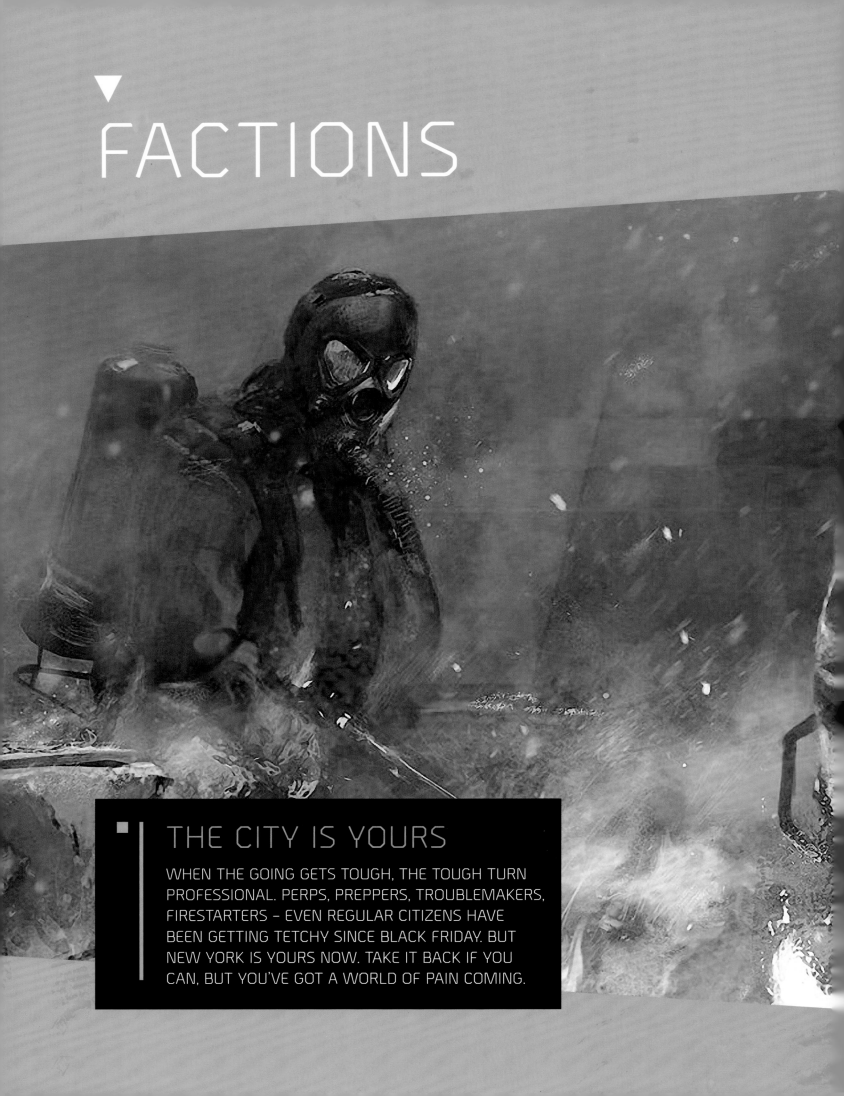

# FACTIONS

## THE CITY IS YOURS

WHEN THE GOING GETS TOUGH, THE TOUGH TURN PROFESSIONAL. PERPS, PREPPERS, TROUBLEMAKERS, FIRESTARTERS – EVEN REGULAR CITIZENS HAVE BEEN GETTING TETCHY SINCE BLACK FRIDAY. BUT NEW YORK IS YOURS NOW. TAKE IT BACK IF YOU CAN, BUT YOU'VE GOT A WORLD OF PAIN COMING.

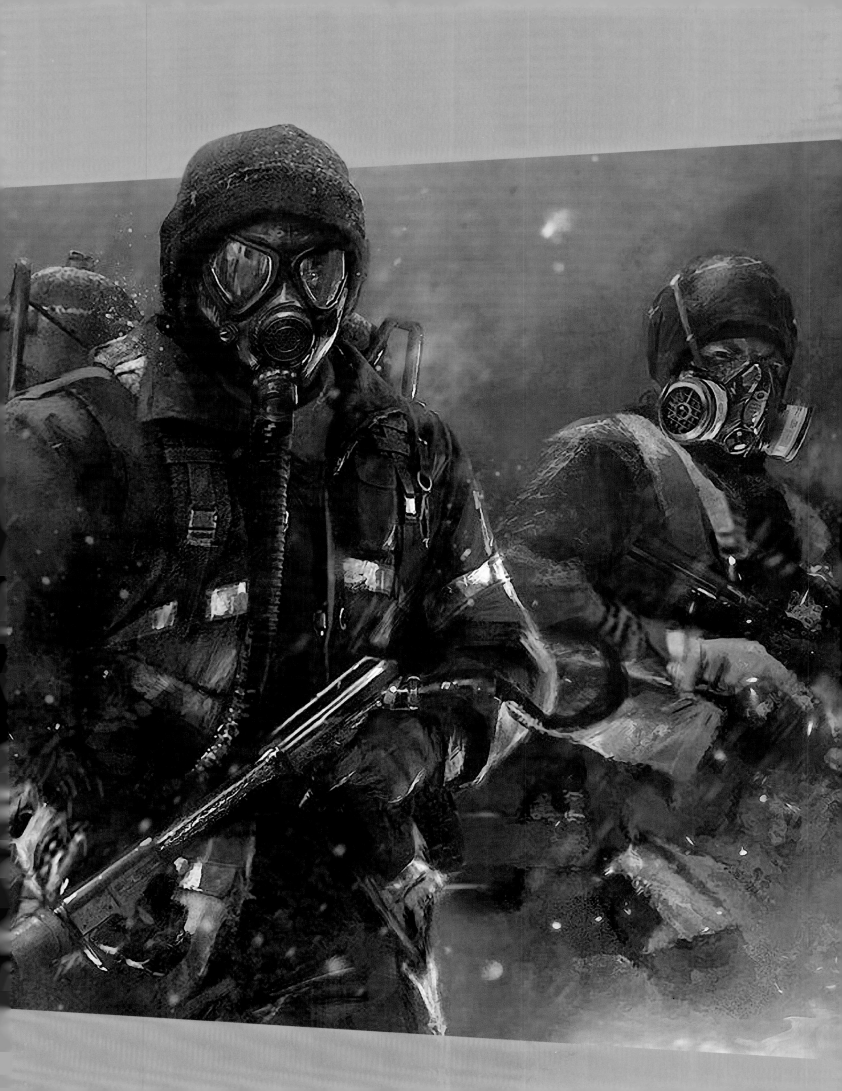

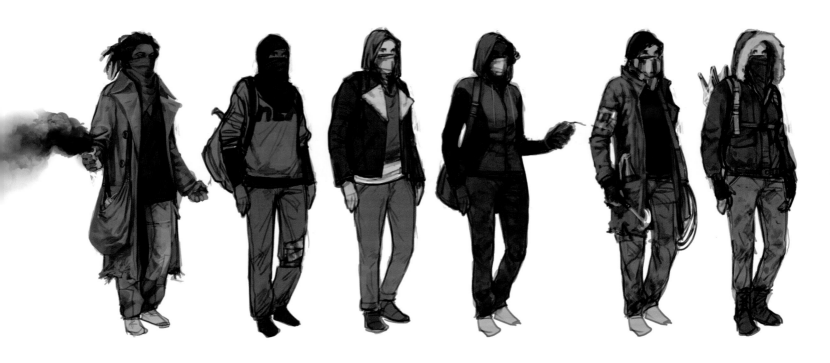

## RIOTERS

Ordinary citizens pushed past their limits by the outbreak, these New Yorkers will do anything to survive. They have no leader and recognize no authority except survival of the strongest.

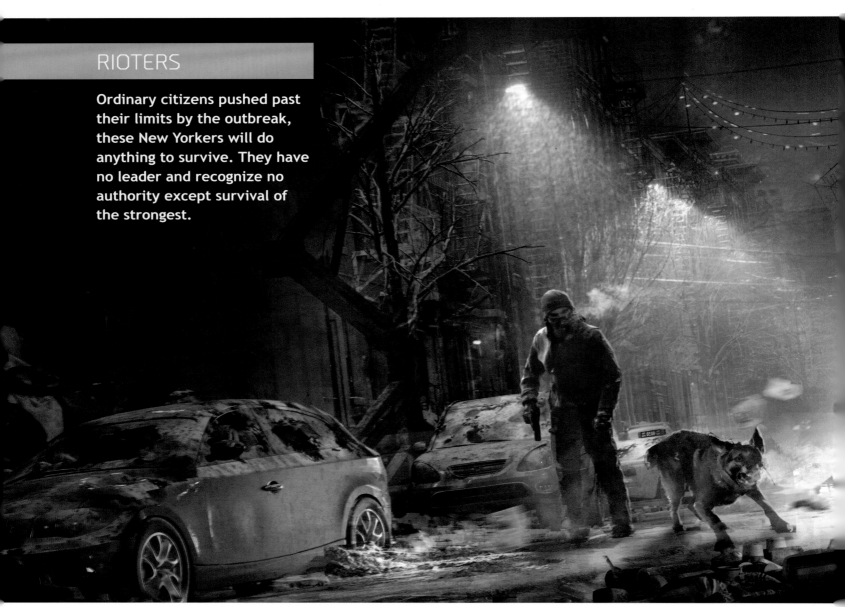

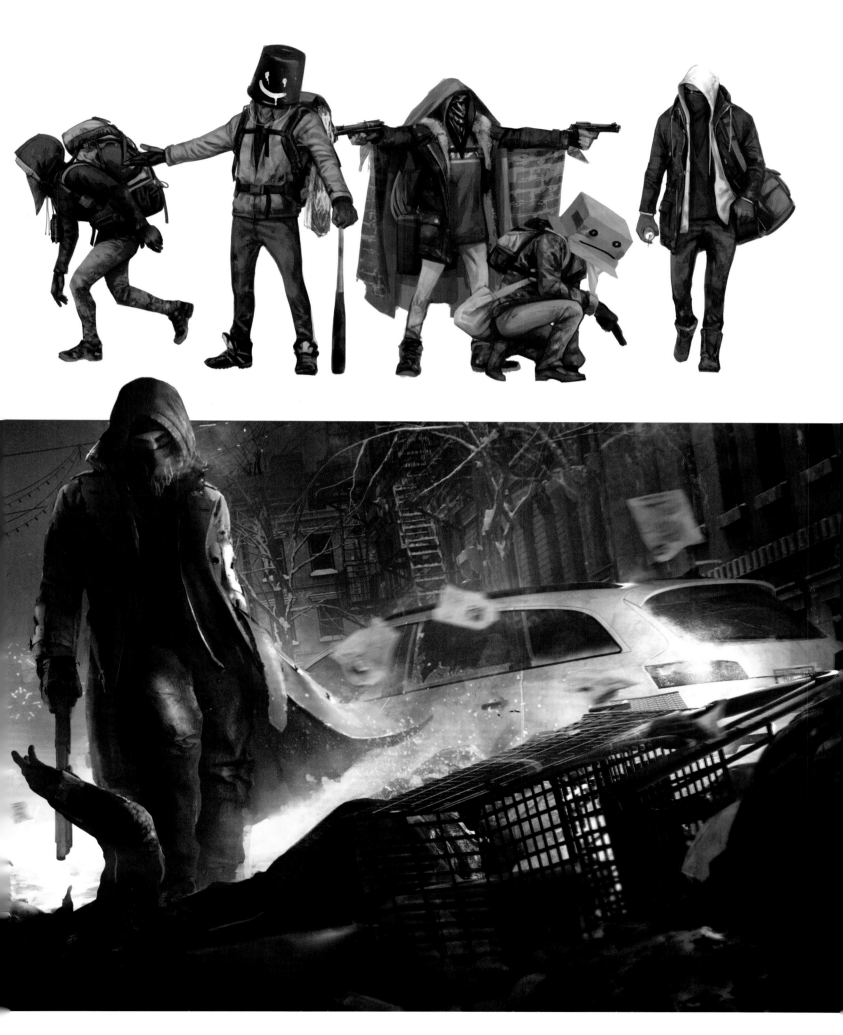

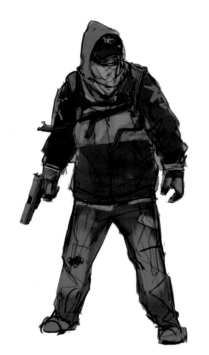
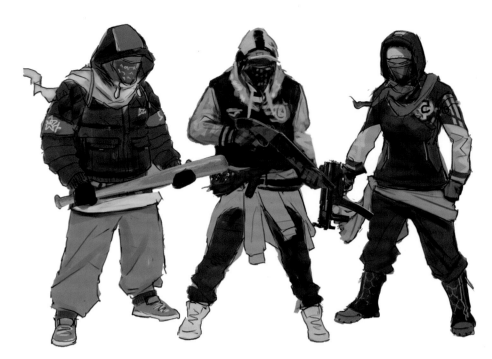
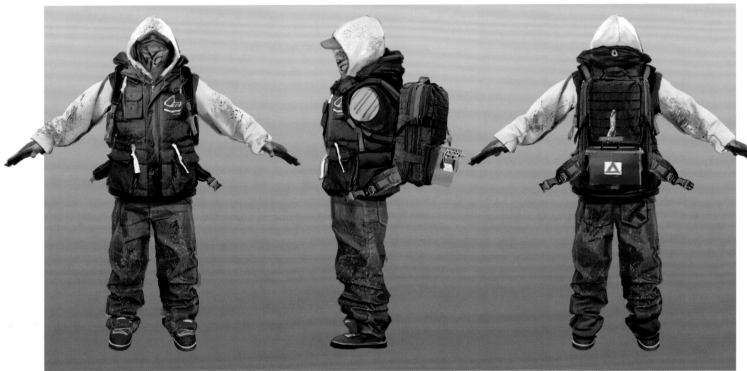
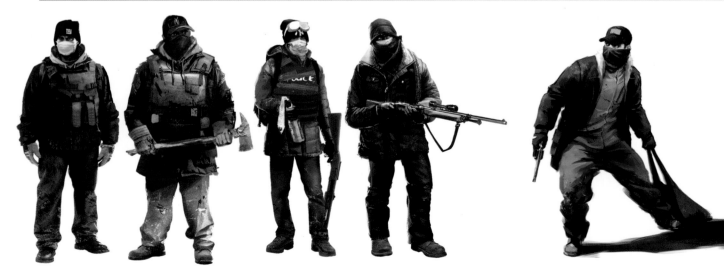

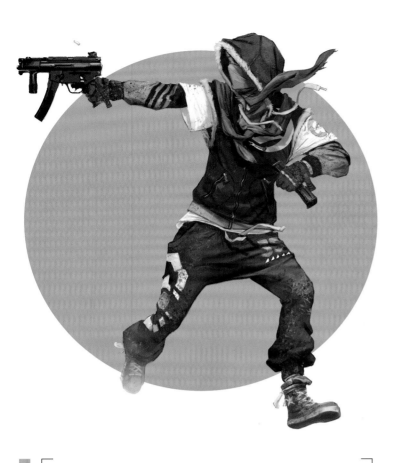

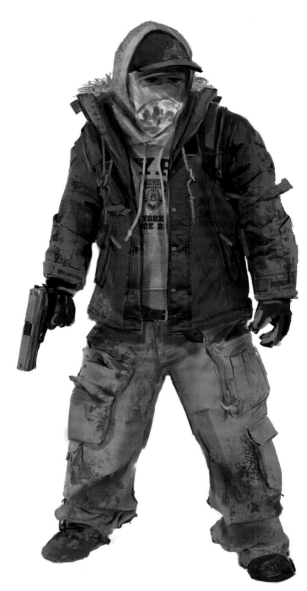

The Rioters are the first faction you will face. They are not technically a faction, as they have no true leader, but that doesn't make them any less dangerous. They are the feral side of society that stands for chaos and opportunism in a situation such as this.

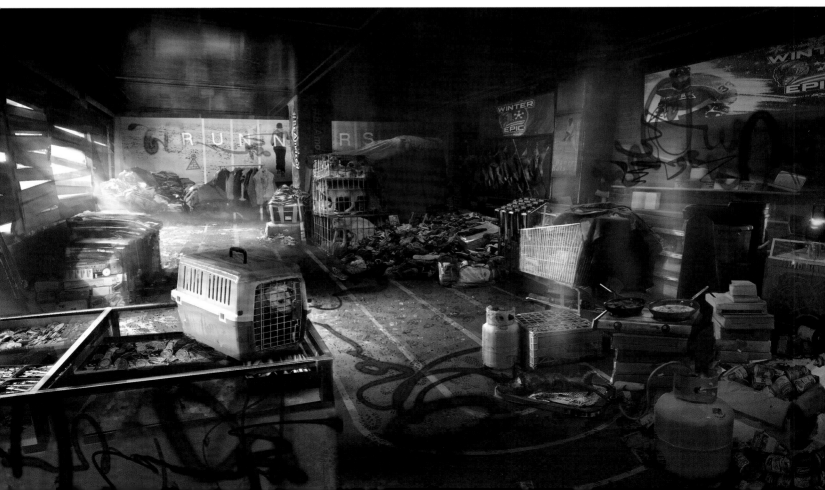

Determined to burn the Green Poison out of Manhattan, these blue-collar workers turned arsonists think they're the only ones willing to make the hard choices. Led by a man named Joe Ferro, they'll burn anything and anyone - living or dead - if they think it might be infected. And they won't stop until Manhattan is "clean". This roaming faction is drawn to areas of high contamination, and they are likely to turn up in any city neighborhood. The zealous pursuit of their goal makes them a dangerous force to be reckoned with.

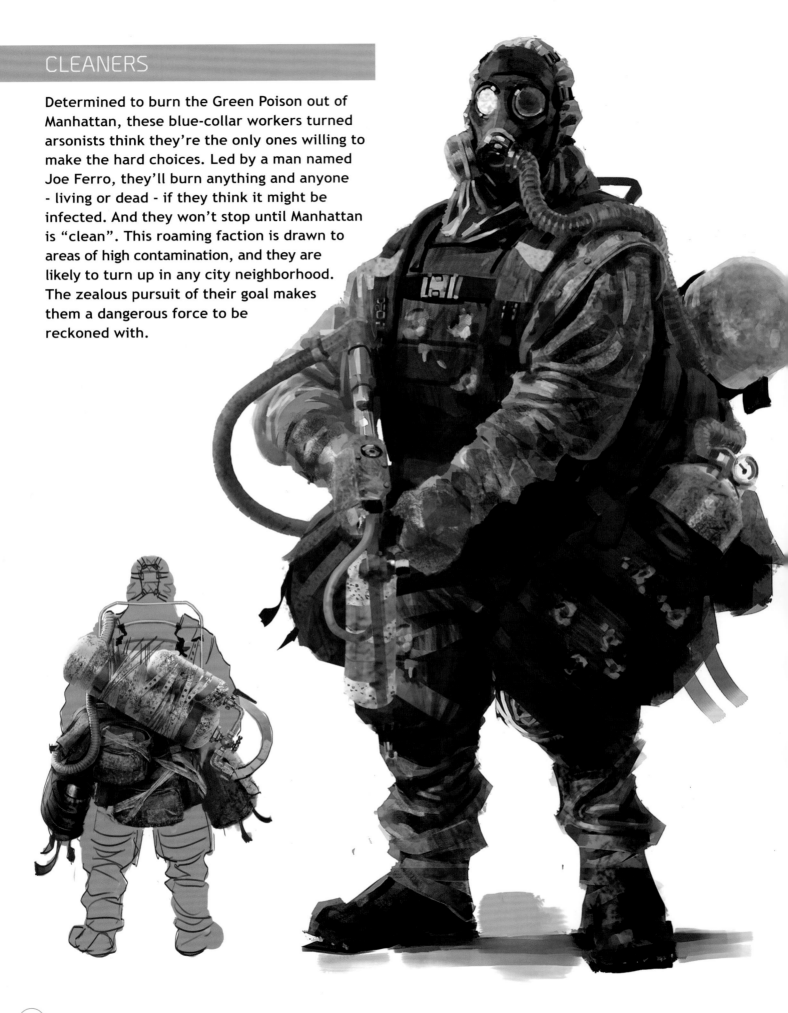

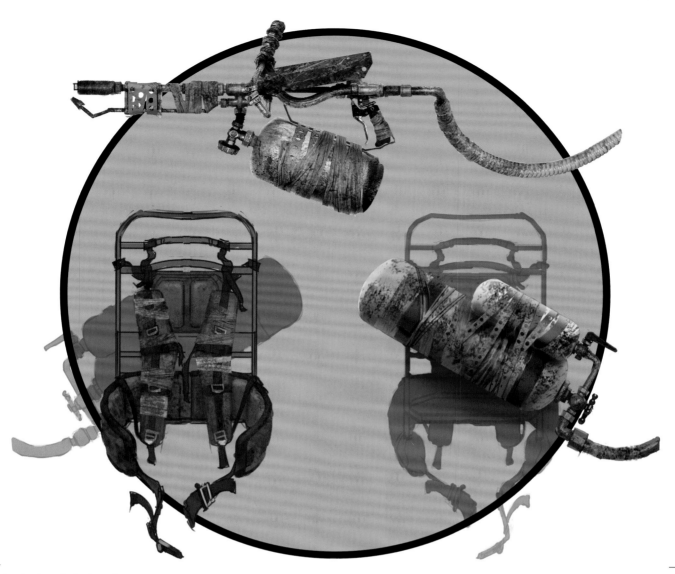

As single-minded as they are, the Cleaners' appearance and apparatus is rather more ad-hoc. But needs must in the wake of the viral apocalypse. The art team explains that it was important to get the right blend of a design for the Cleaners, mixing the look of a workforce with some serious weaponry, both scavenged and homemade. They are trying desperately to purge the sickness from anything or anyone they deem infected, even if it is one of their own.

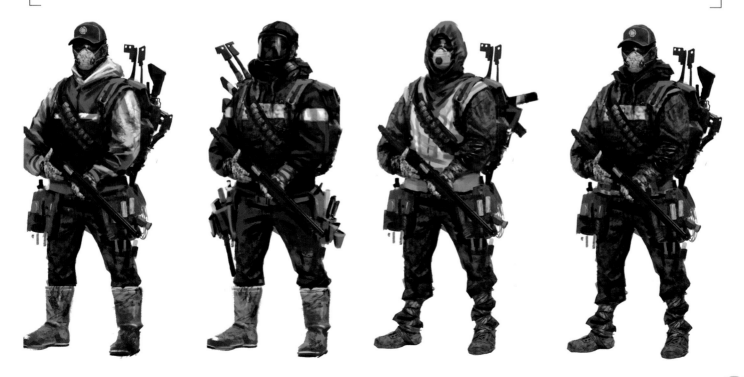

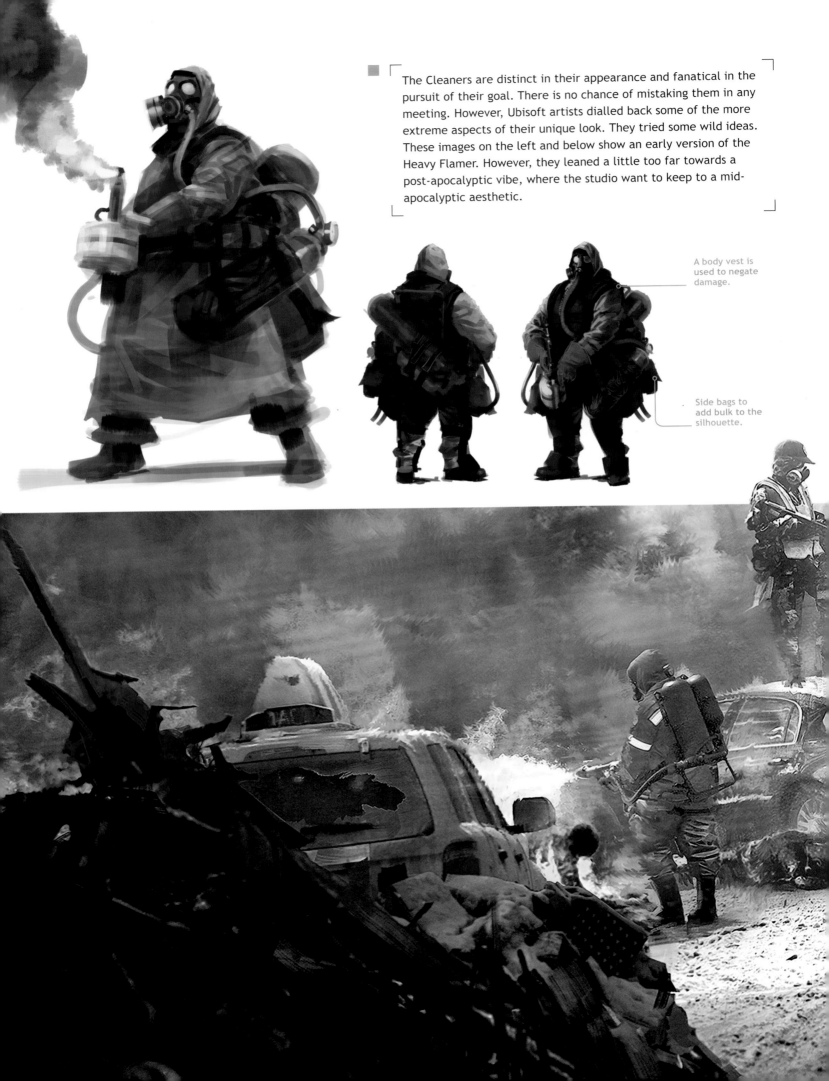

The Cleaners are distinct in their appearance and fanatical in the pursuit of their goal. There is no chance of mistaking them in any meeting. However, Ubisoft artists dialled back some of the more extreme aspects of their unique look. They tried some wild ideas. These images on the left and below show an early version of the Heavy Flamer. However, they leaned a little too far towards a post-apocalyptic vibe, where the studio want to keep to a mid-apocalyptic aesthetic.

A body vest is used to negate damage.

Side bags to add bulk to the silhouette.

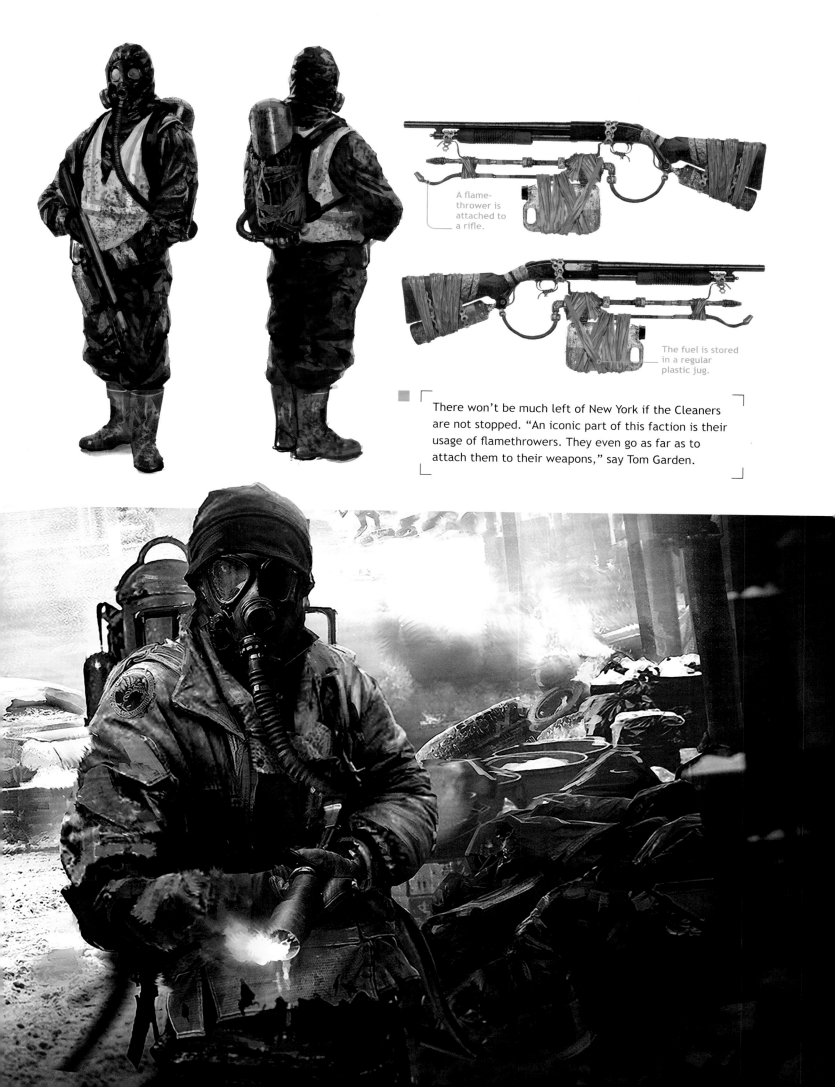

A flame-thrower is attached to a rifle.

The fuel is stored in a regular plastic jug.

There won't be much left of New York if the Cleaners are not stopped. "An iconic part of this faction is their usage of flamethrowers. They even go as far as to attach them to their weapons," say Tom Garden.

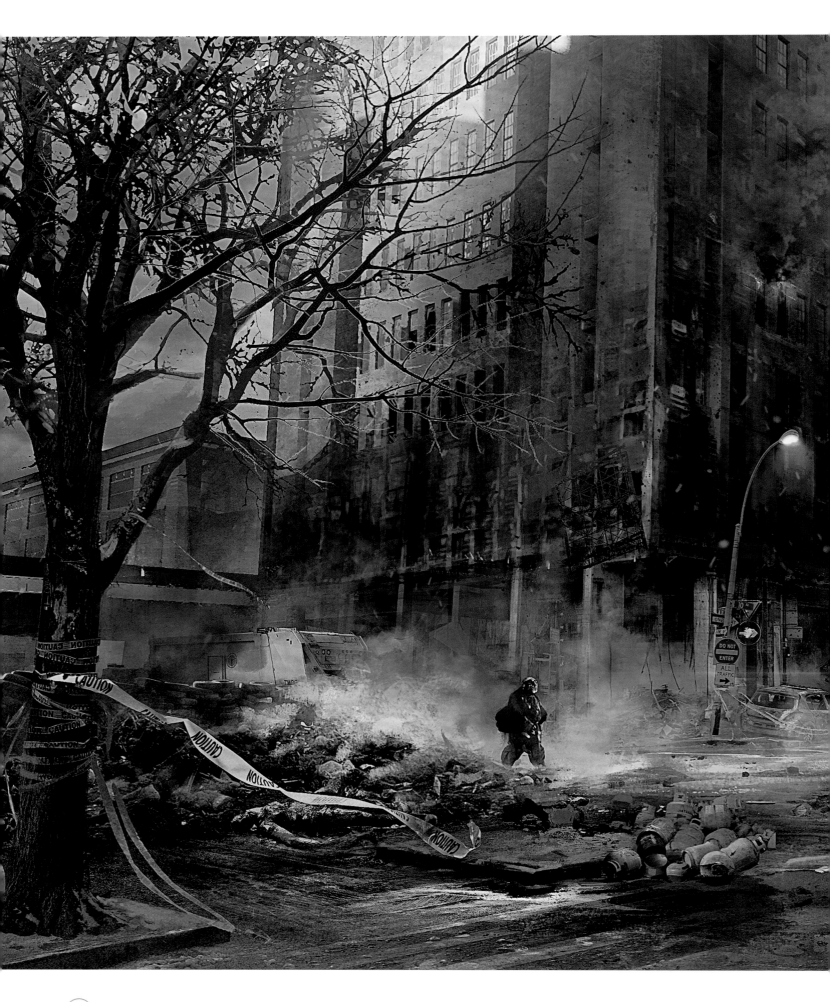

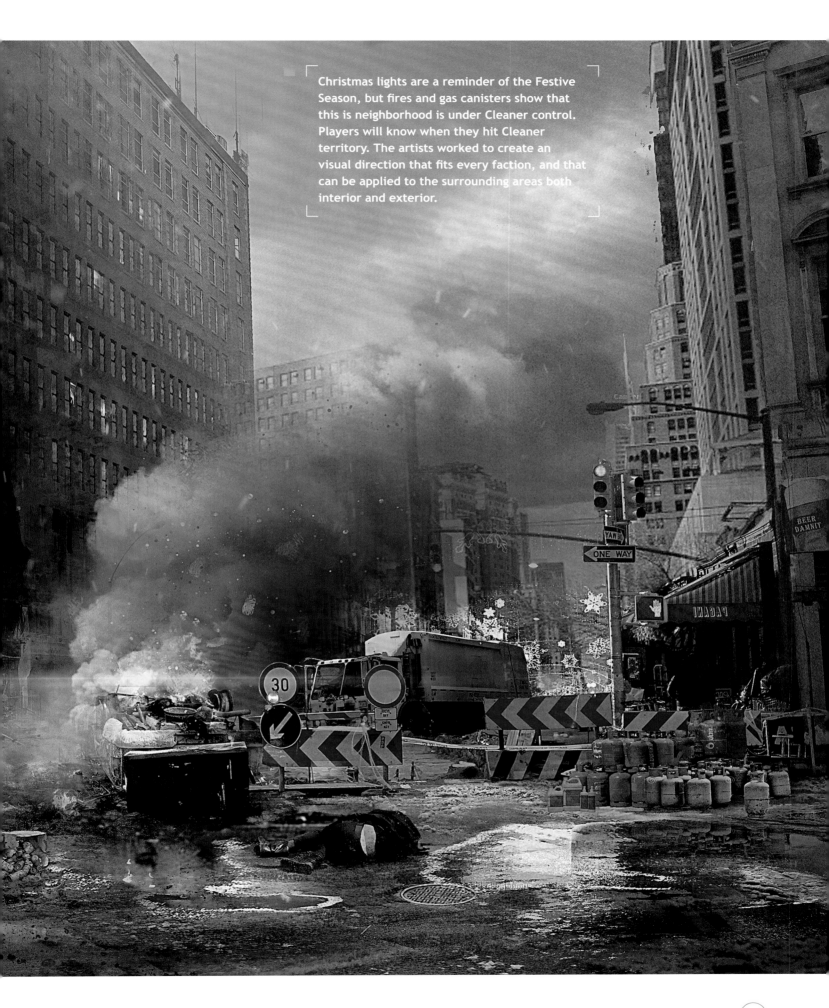

Christmas lights are a reminder of the Festive Season, but fires and gas canisters show that this is neighborhood is under Cleaner control. Players will know when they hit Cleaner territory. The artists worked to create an visual direction that fits every faction, and that can be applied to the surrounding areas both interior and exterior.

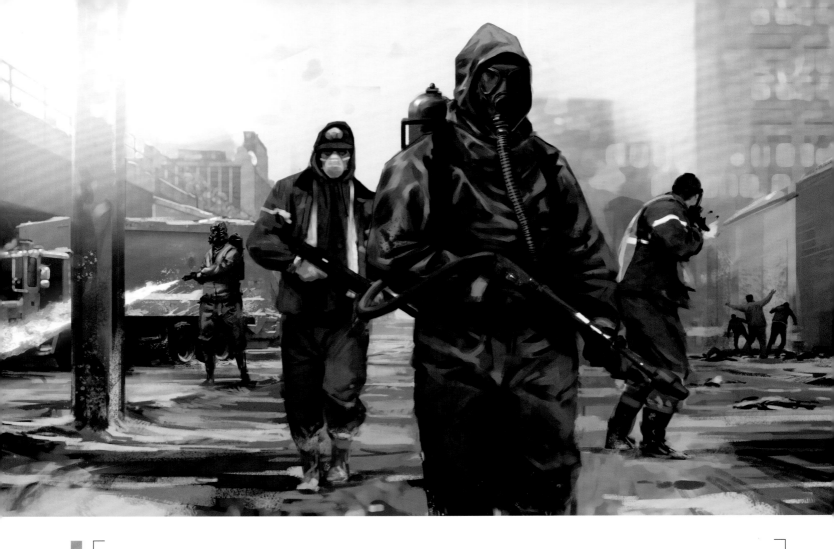

The gangs patrolling the streets of New York City bring color, character and distinct challenges to the game. As these images demonstrate, there is much scope for diversity of appearance, equipment and weaponry, even among members of the same faction. Creating a singular design to work for the Cleaners was quite straightforward, as the art team had a clear vision of what they should be. But, of course, turning this vision into an entire faction of varying archetypes, when they all need to be distinct and recognizable in their own way and also fit within the main style of that faction, was no easy feat. The artists had to rely on their gameplay functions as a core, and then expand on that using colors, different materials and silhouettes. Creating believable archetypes in this setting, without falling into fantasy, post-apocalypse or sci-fi was a great challenge for the team.

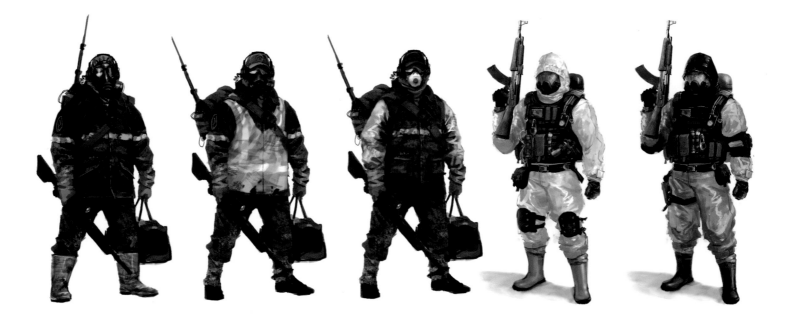

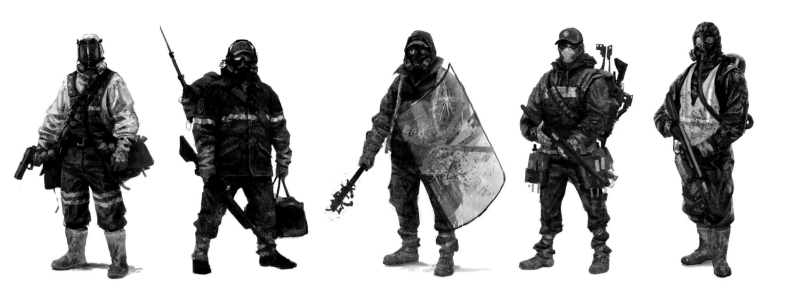

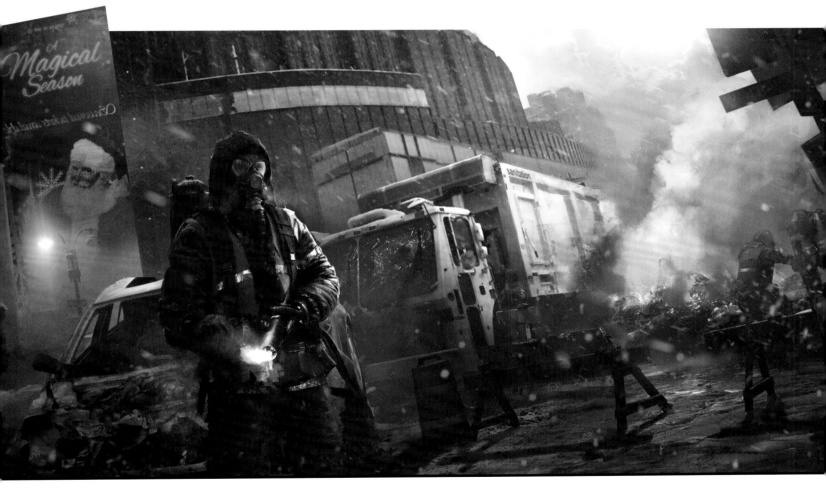

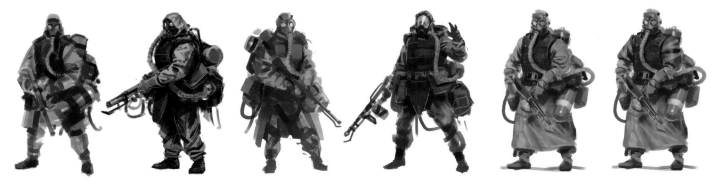

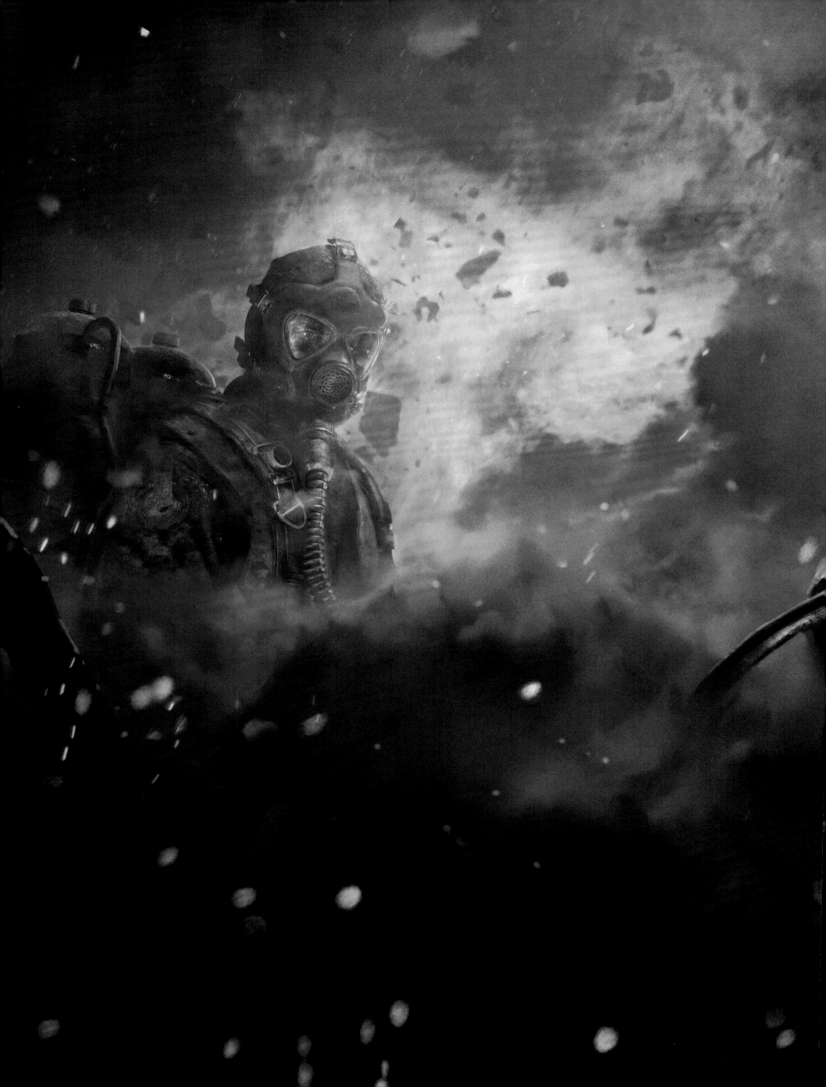

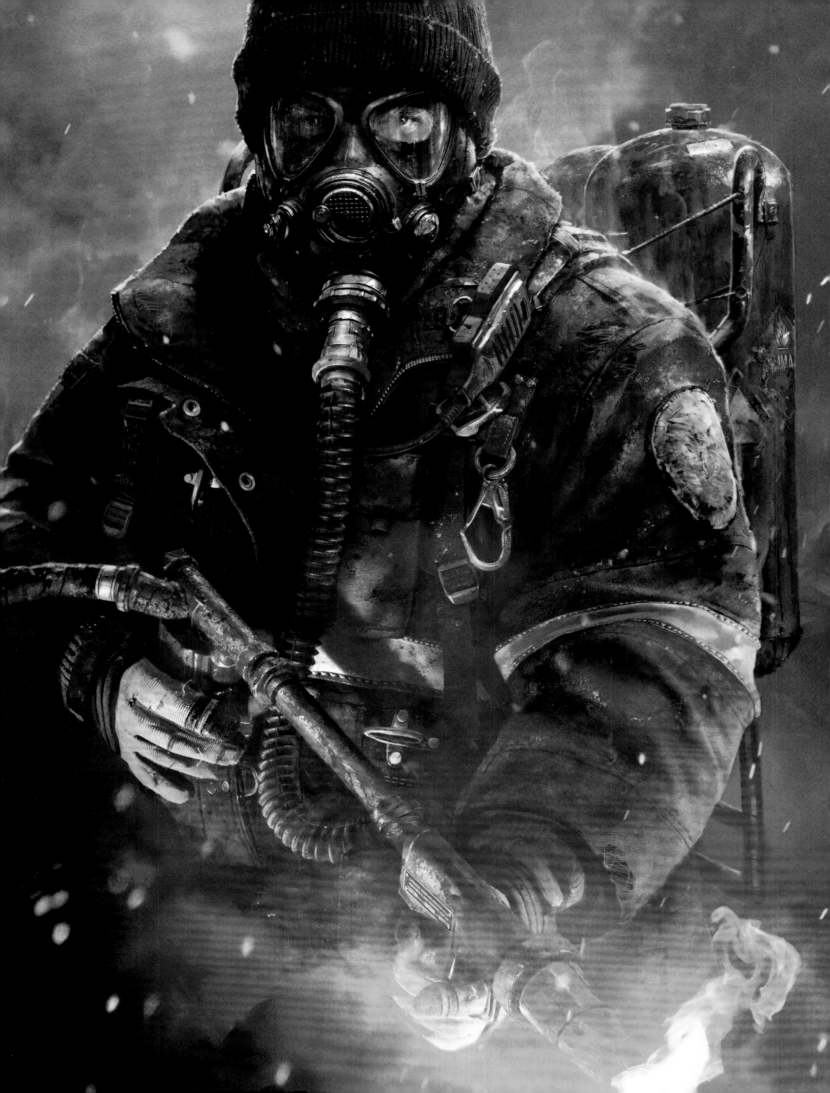

## RIKERS

Escaped prisoners from Riker's Island, these hardened criminals are led by the dangerous LaRae Barrett. They take what they want from the wreckage of Manhattan, determined to live like kings before the virus takes it toll. With no love for the JTF and no mercy for anyone they come across, they rule parts of Manhattan through blood and fear. Art Director Rodrigo Cortes explains the design choice, "They broke free in the wake of the virus and started wreaking havoc. This gave us a very unique look; the orange jumpsuits, stolen police uniforms and riot control gear etc."

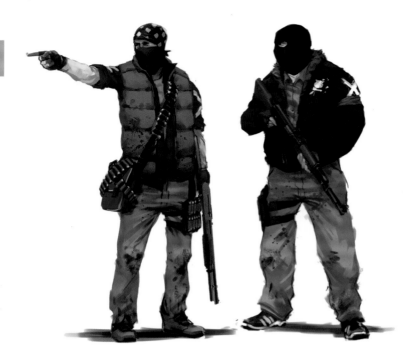

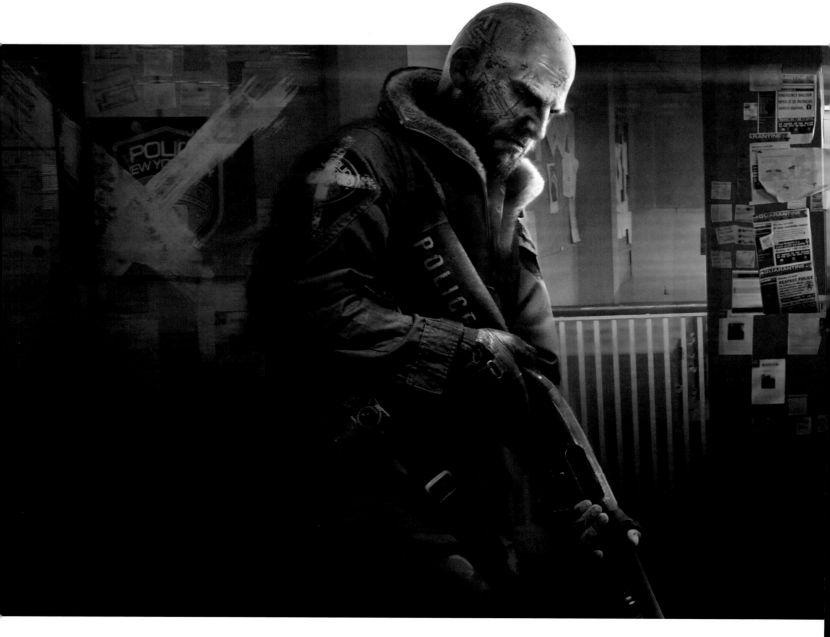

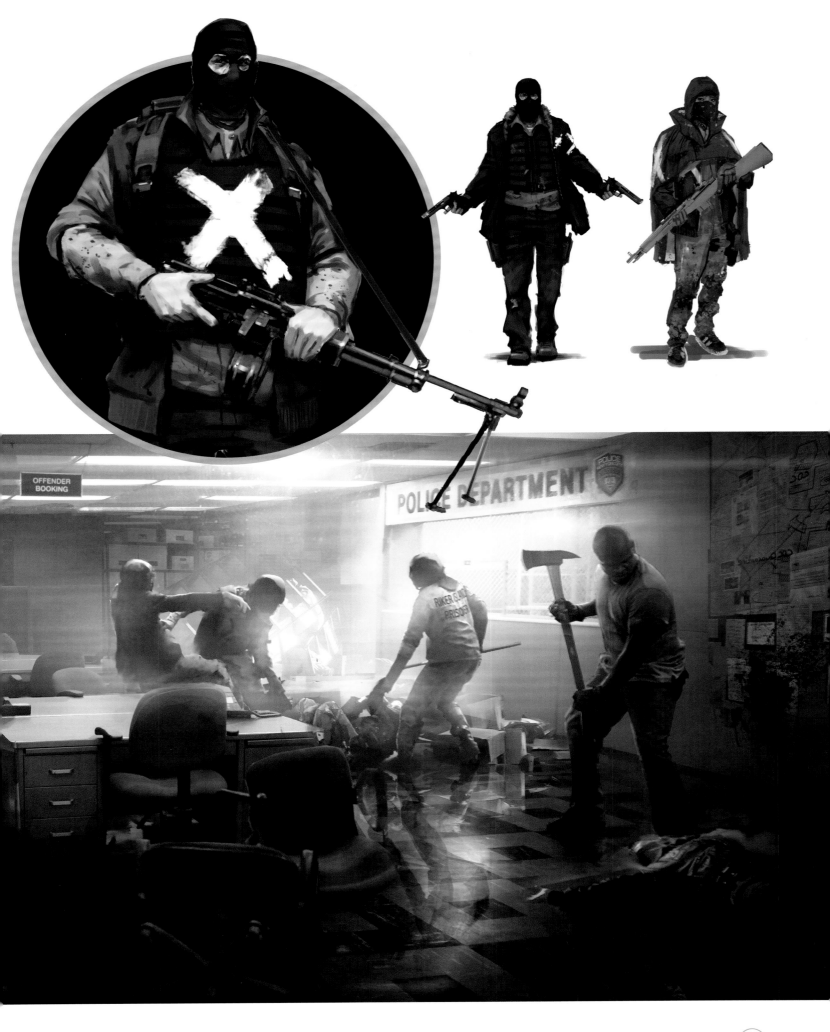

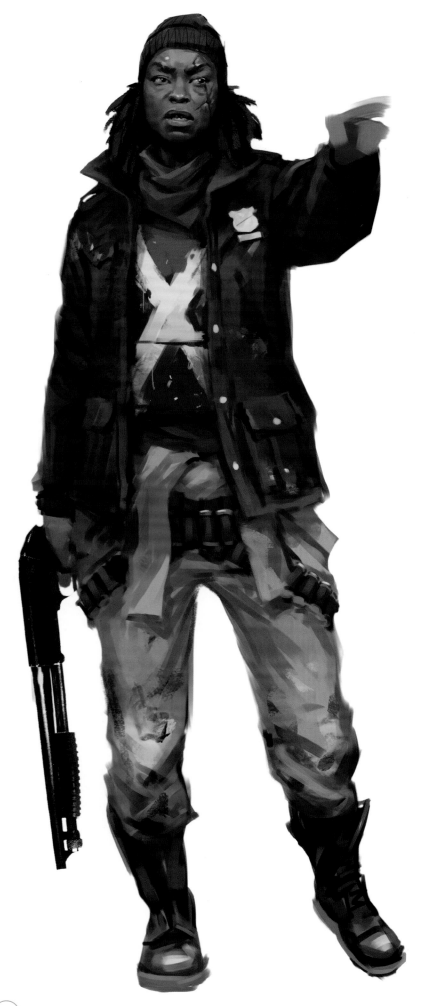

The Rikers are an extension of various prison gangs, but this faction is at least united in its mission to misrule. "They provide an intimidating challenge," says Tom Garden. "They rely more heavily on firepower than the Cleaners and are different to face in battle." The team tried variants on the orange jumpsuit, but such distinct visual became impossible to avoid. The idea was introduced the Rikers raided the police stash to steal their weapons and parts of their uniforms and gear.

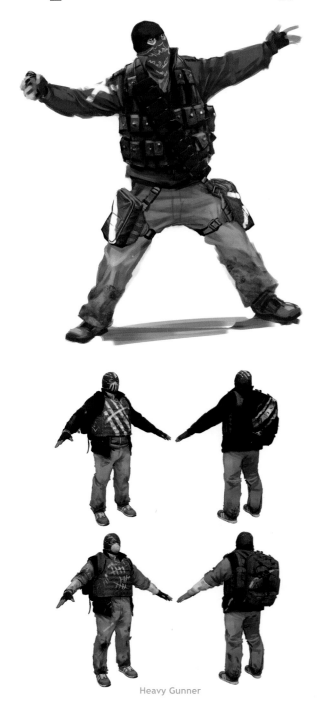

Heavy Gunner

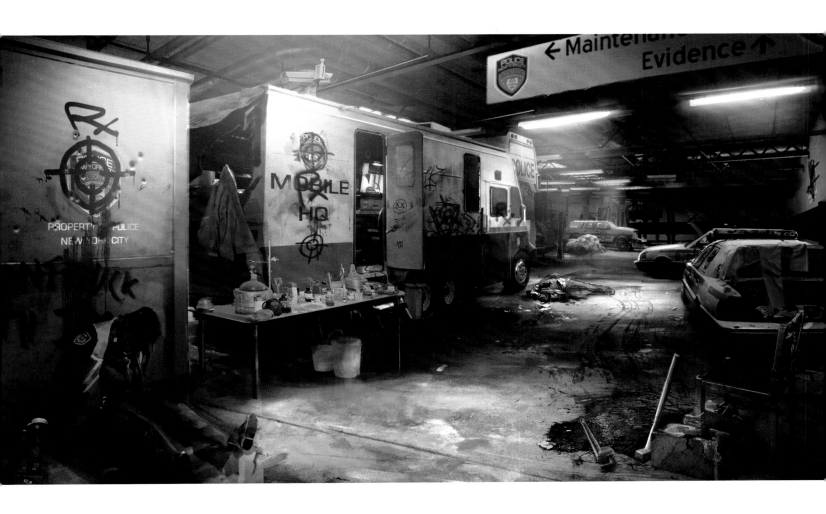

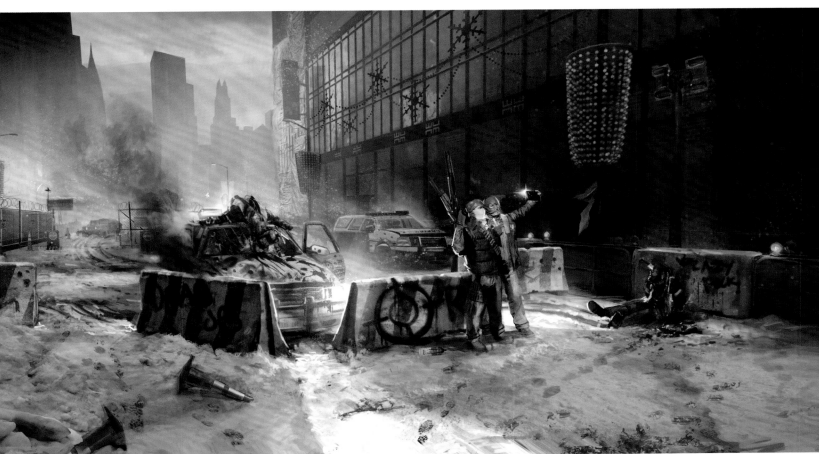

## LAST MAN BATTALION

A private military company originally dispatched to Manhattan to protect certain corporate assets, the LMB were abandoned by their clients once the quarantine hit. Under the leadership of Lt. Col. Charles Bliss, they have placed huge chunks of Manhattan under their version of martial law. If you're not with the LMB you're against them, and they have no compunctions about using cutting-edge weapons on anyone who stands in their way.

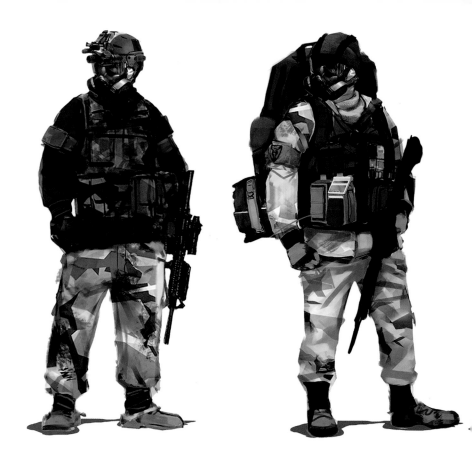

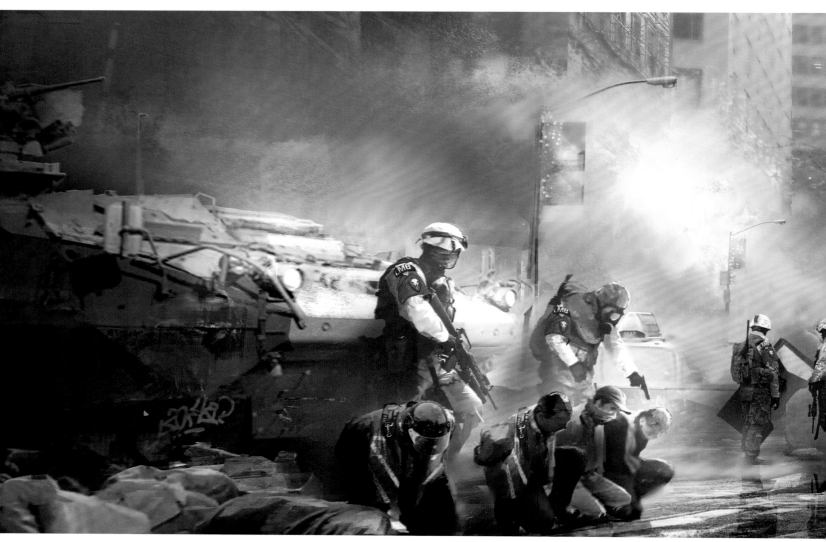

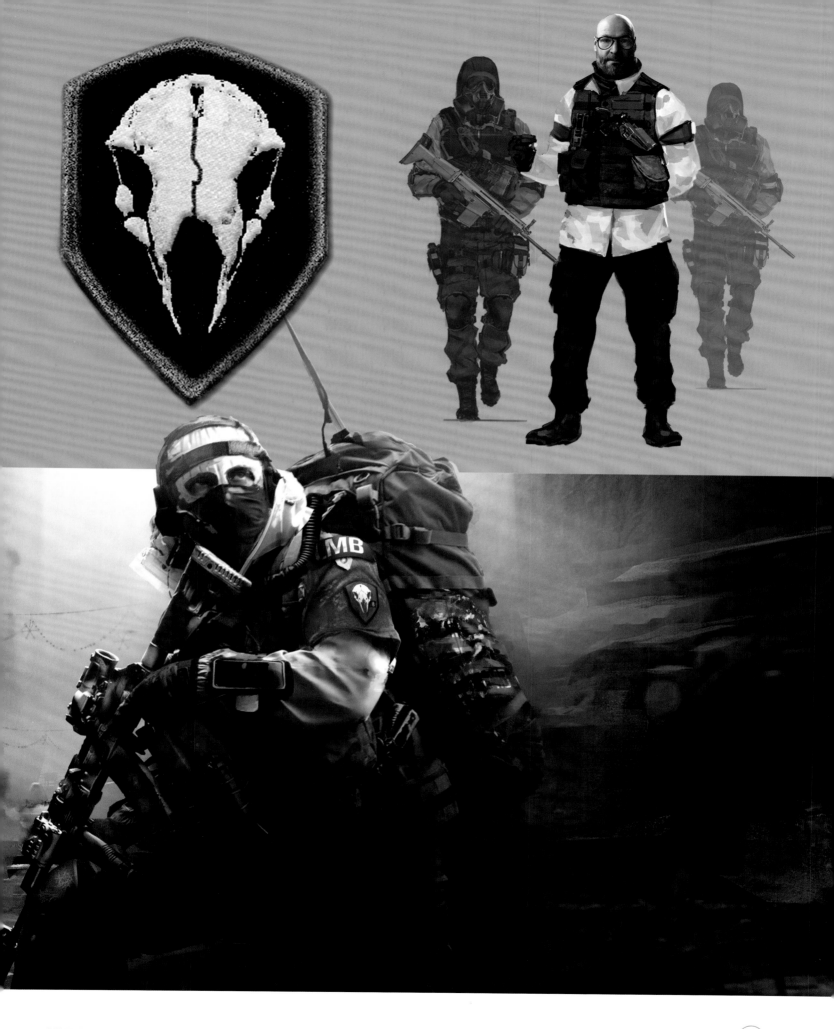

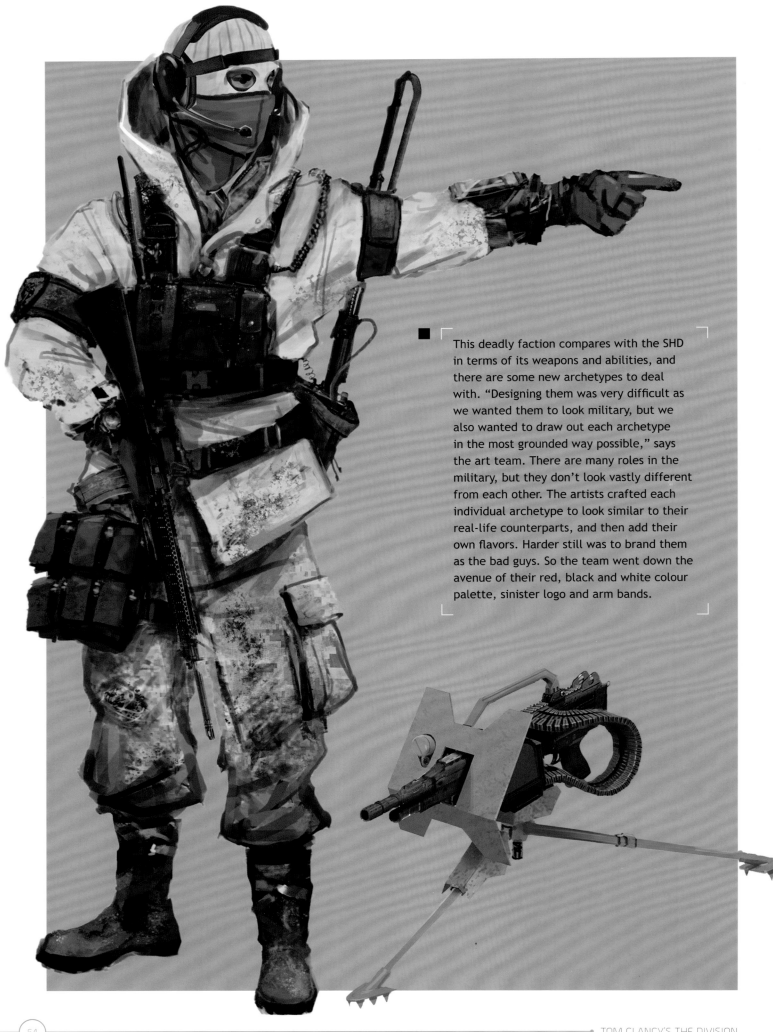

This deadly faction compares with the SHD in terms of its weapons and abilities, and there are some new archetypes to deal with. "Designing them was very difficult as we wanted them to look military, but we also wanted to draw out each archetype in the most grounded way possible," says the art team. There are many roles in the military, but they don't look vastly different from each other. The artists crafted each individual archetype to look similar to their real-life counterparts, and then add their own flavors. Harder still was to brand them as the bad guys. So the team went down the avenue of their red, black and white colour palette, sinister logo and arm bands.

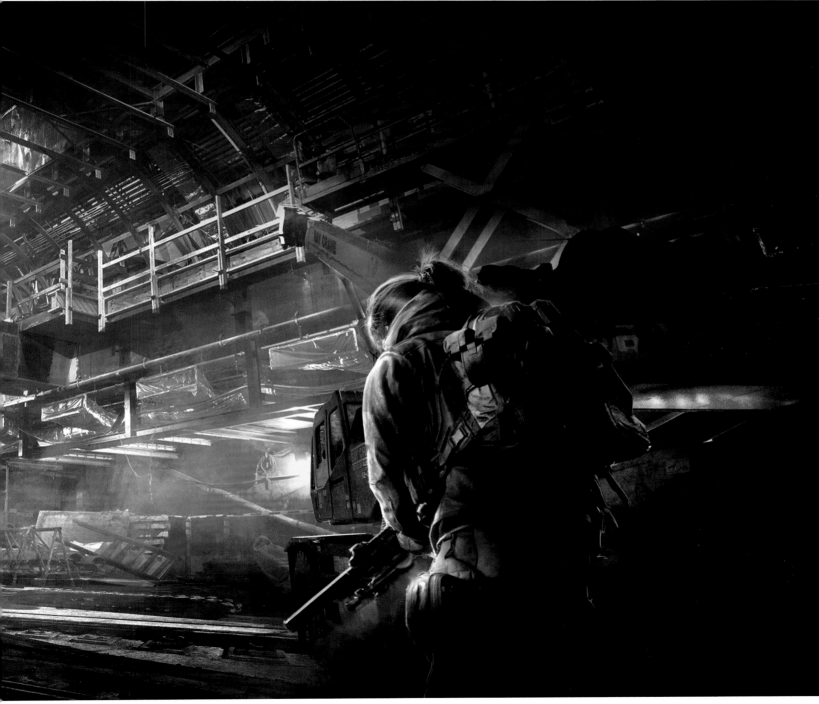

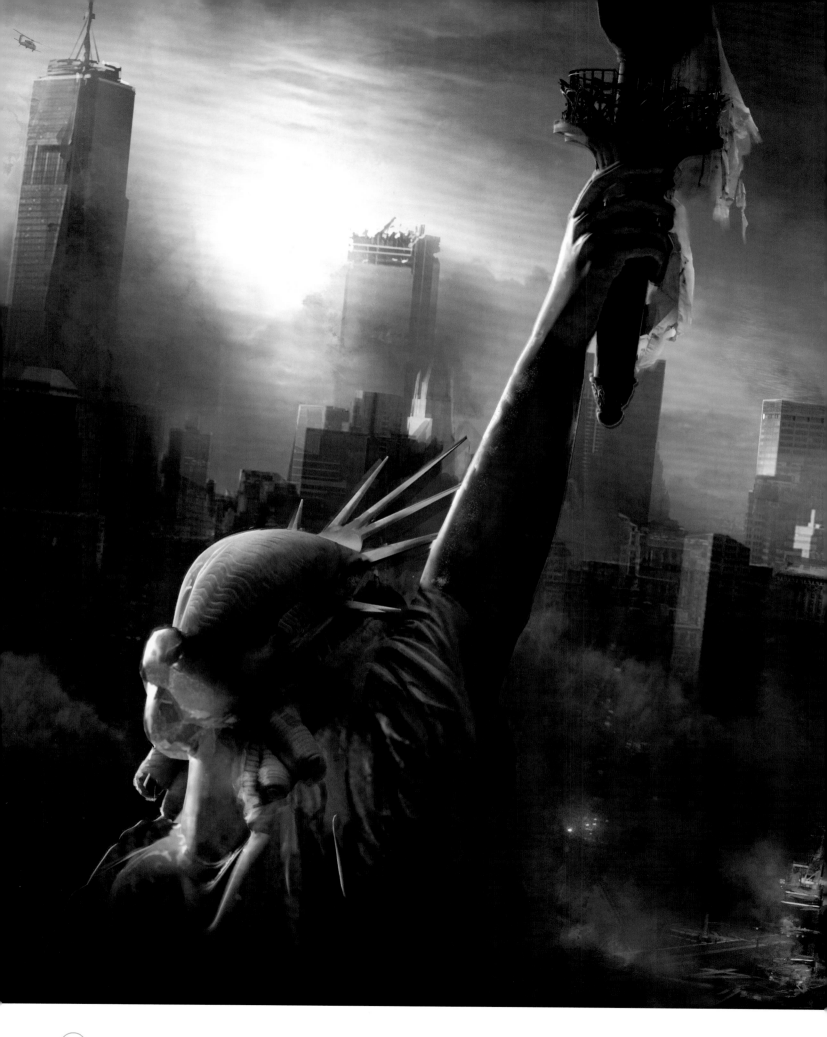

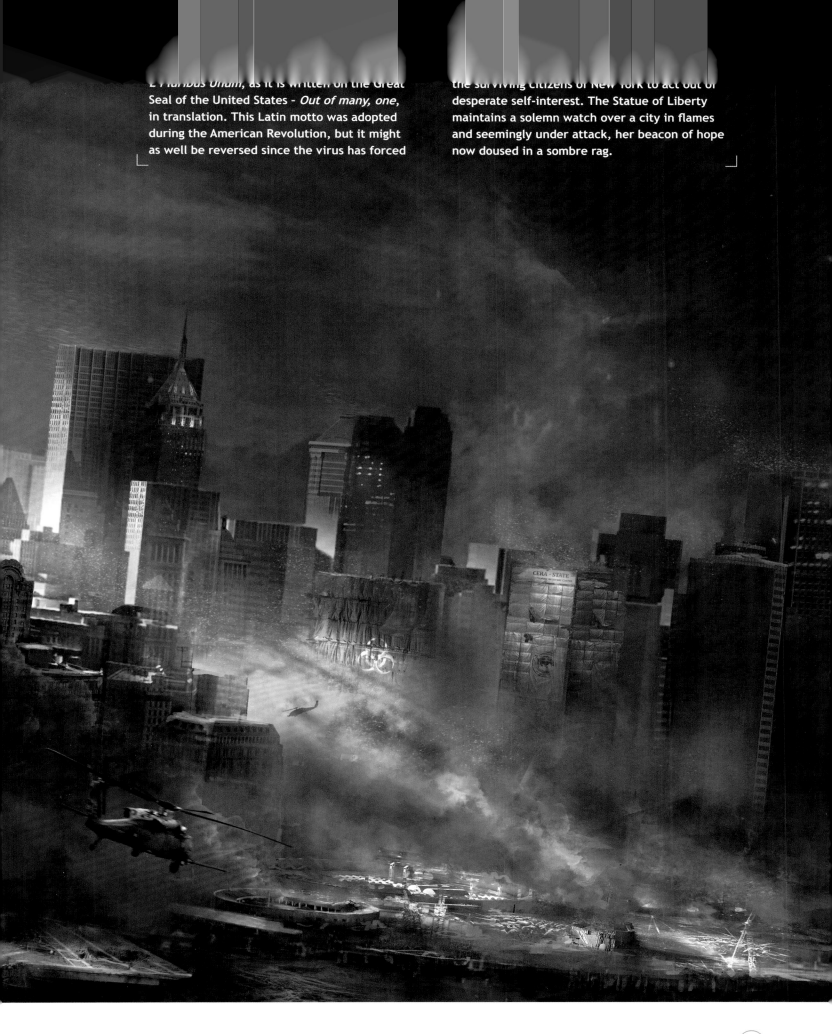

E *Pluribus Unum*, as it is written on the Great Seal of the United States – *Out of many, one*, in translation. This Latin motto was adopted during the American Revolution, but it might as well be reversed since the virus has forced the surviving citizens of New York to act out of desperate self-interest. The Statue of Liberty maintains a solemn watch over a city in flames and seemingly under attack, her beacon of hope now doused in a sombre rag.

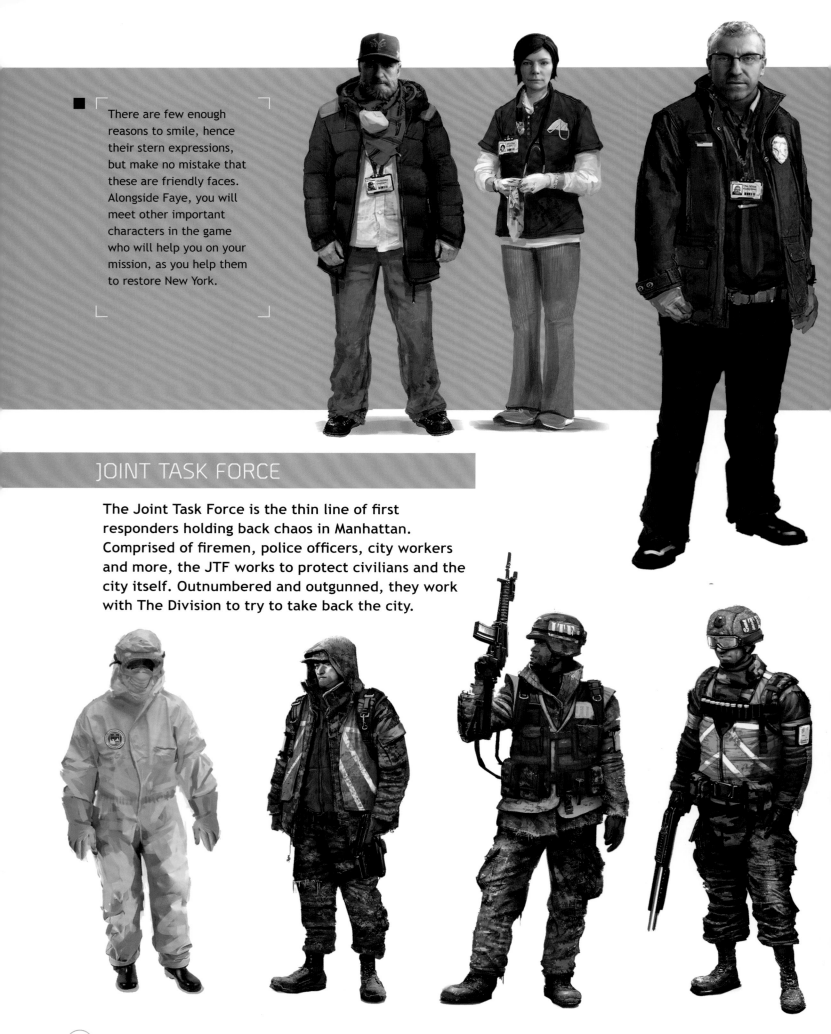

There are few enough reasons to smile, hence their stern expressions, but make no mistake that these are friendly faces. Alongside Faye, you will meet other important characters in the game who will help you on your mission, as you help them to restore New York.

## JOINT TASK FORCE

The Joint Task Force is the thin line of first responders holding back chaos in Manhattan. Comprised of firemen, police officers, city workers and more, the JTF works to protect civilians and the city itself. Outnumbered and outgunned, they work with The Division to try to take back the city.

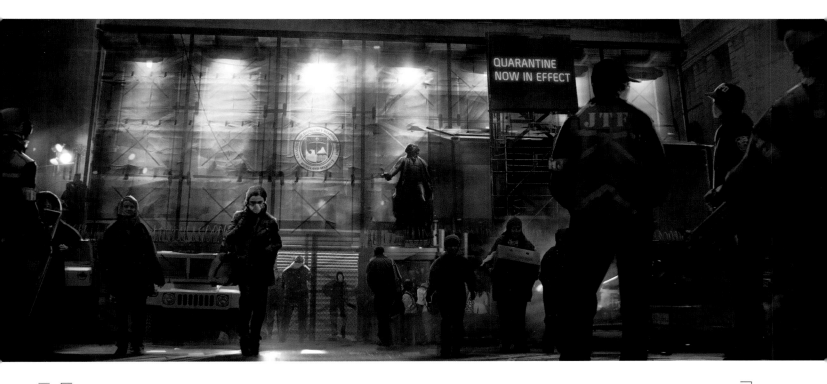

As New York City burns and disintegrates, there are a still a few who remain dedicated to restoring public order and re-establishing their important roles in society. These men and women will play vital roles if this fallen city is ever to rise again. But coordinating their efforts will be difficult when large parts of the necessary infrastructure have collapsed, many of the roads connecting the city are now impassable and their numbers have been so depleted following the Black Friday outbreak. A single building becomes a center of operations for the few who remain. "This Base of Operations is the most important stronghold left in New York, and it will be your job to restore it," explains Tom Garden. "You can also expect some help from the Joint Task Forces, who have already been handling the situation so far. They range from police and emergency forces, medics and national guards."

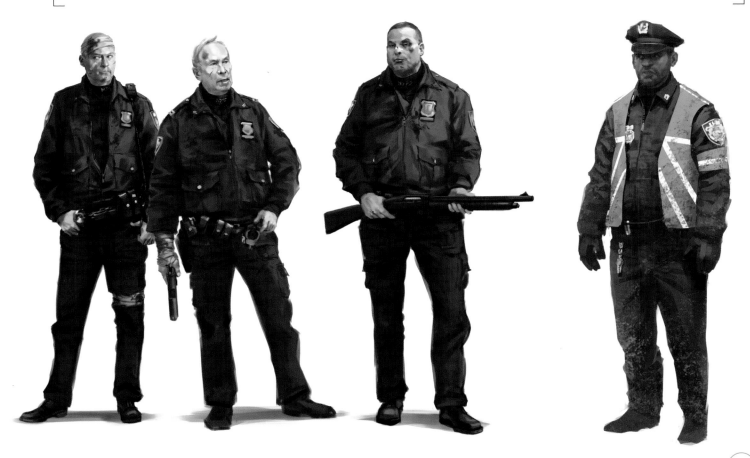

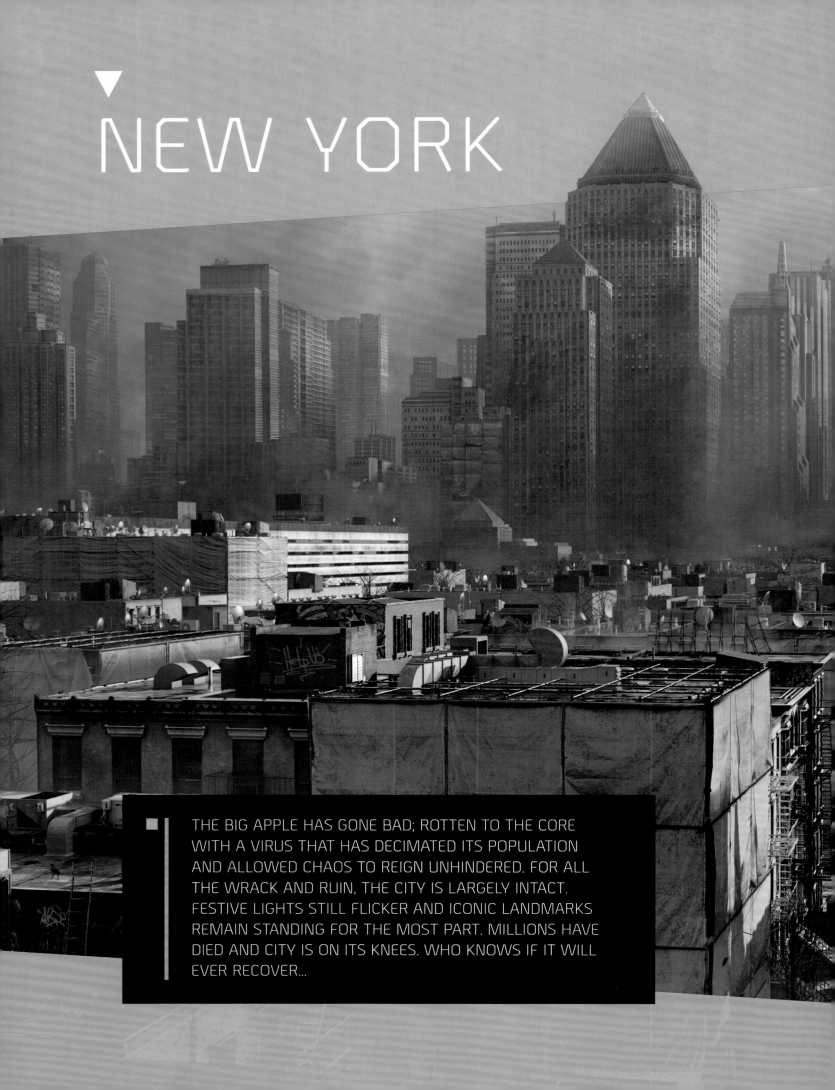

# NEW YORK

THE BIG APPLE HAS GONE BAD; ROTTEN TO THE CORE WITH A VIRUS THAT HAS DECIMATED ITS POPULATION AND ALLOWED CHAOS TO REIGN UNHINDERED. FOR ALL THE WRACK AND RUIN, THE CITY IS LARGELY INTACT. FESTIVE LIGHTS STILL FLICKER AND ICONIC LANDMARKS REMAIN STANDING FOR THE MOST PART. MILLIONS HAVE DIED AND CITY IS ON ITS KNEES. WHO KNOWS IF IT WILL EVER RECOVER...

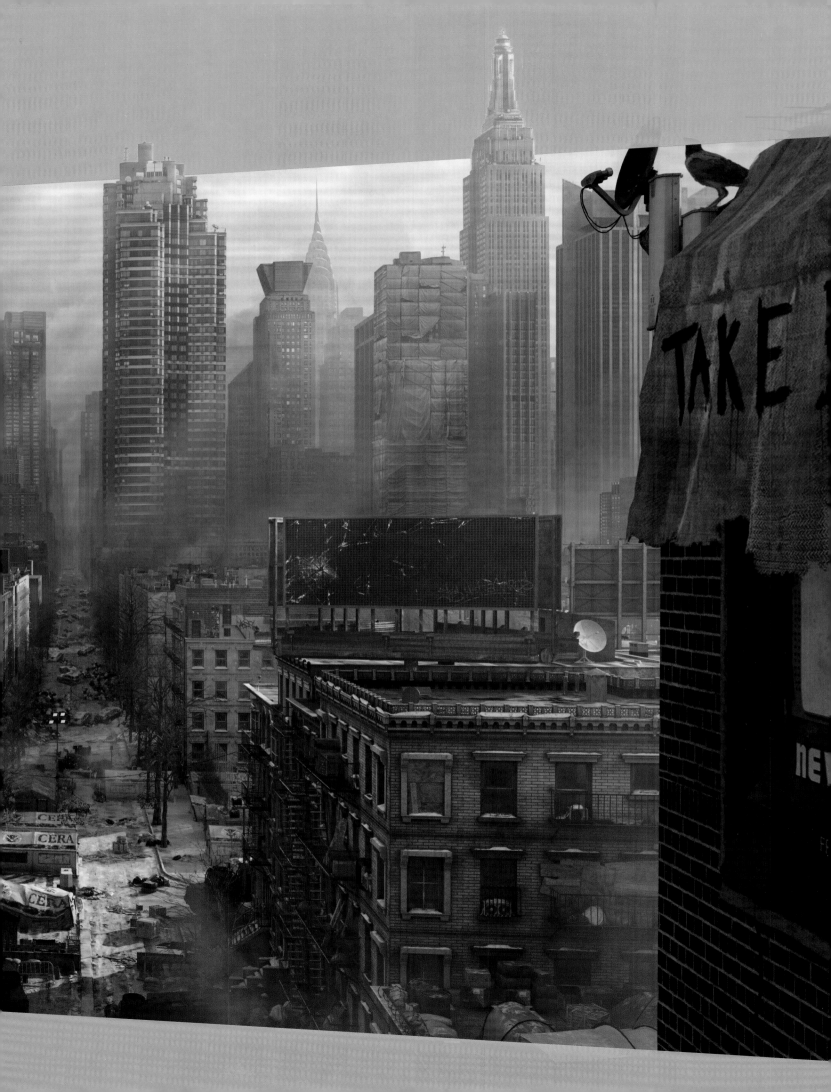

## BROOKLYN

Bright lights and Christmas decorations make for an almost comforting sight against the leaden winter skies, although open windows and empty freeways tell a different story. Players start the game in Brooklyn shortly after activation. From here, players are immersed in the world of The Division. By using specific visuals like the Christmas lights, the studio wanted to establish a feeling of familiarity as well as signs of hope mixed together with the chaos and disorder.

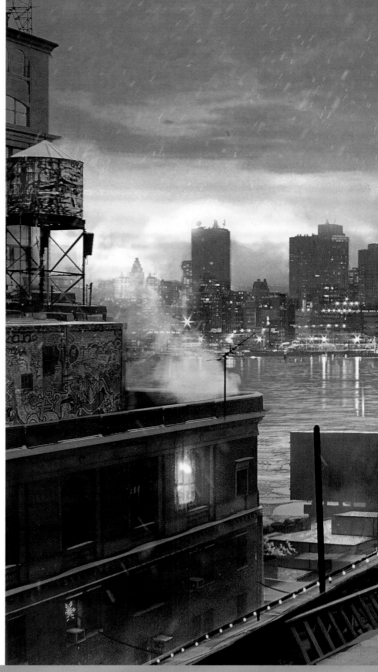

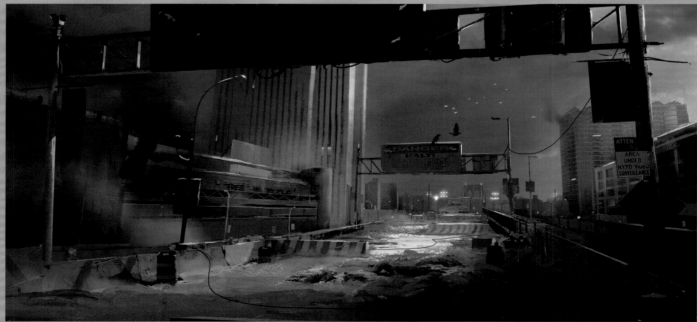

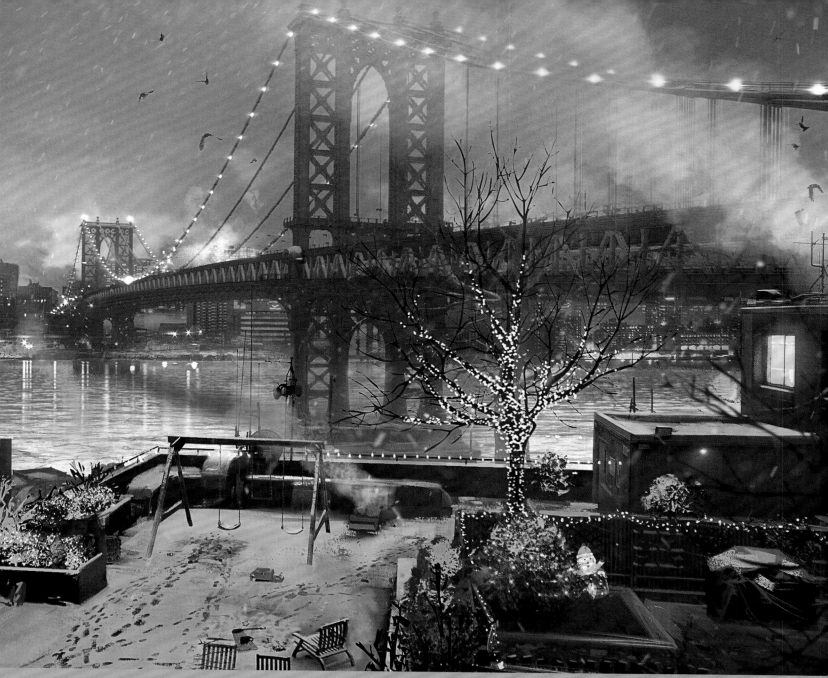

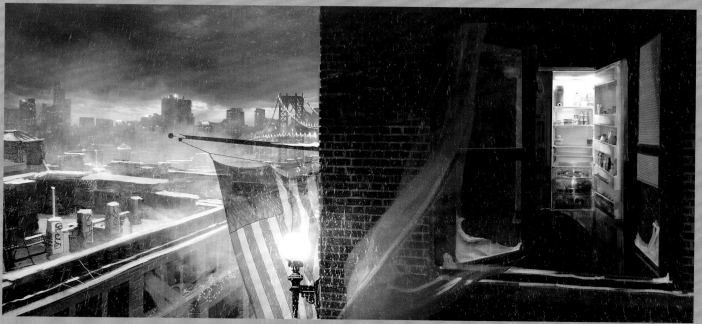

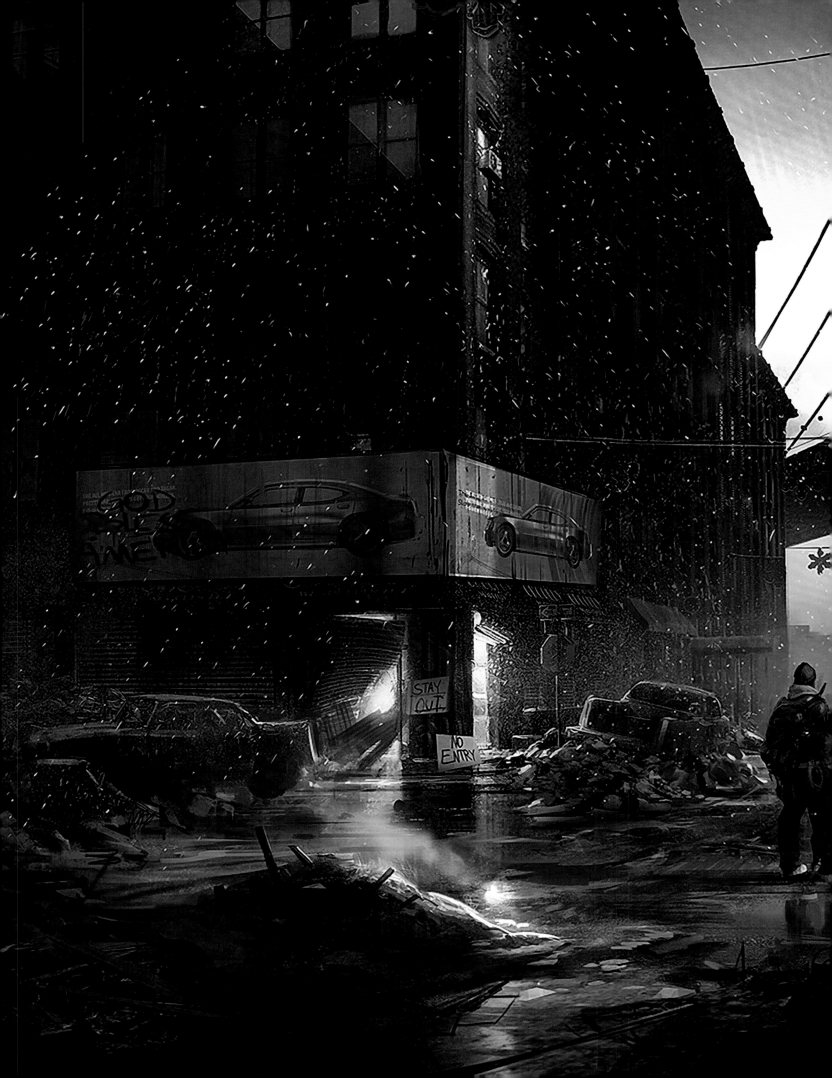

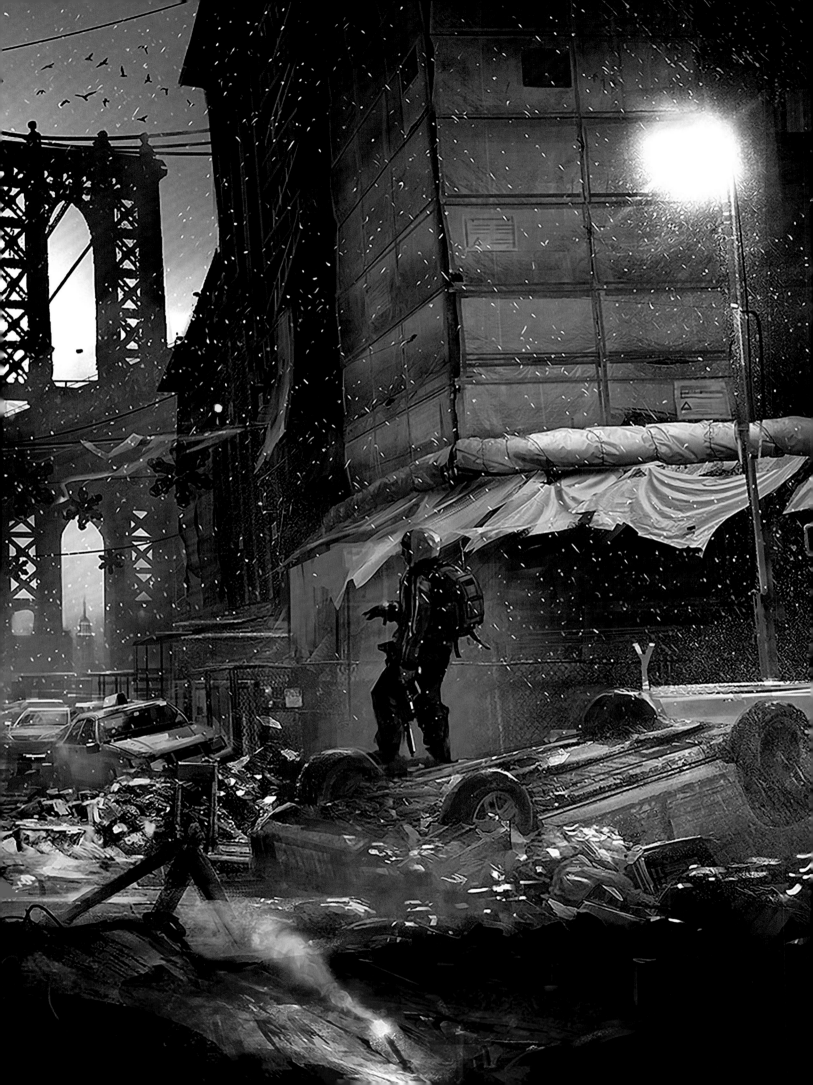

## POLICE PRECINCT

Although Ground Zero for the outbreak was Manhattan, the chaos reaches across the East River. The climax of the scene depicted here will see players fighting through a police precinct on their way to finding a ride across the water to discover the extent of the damage.

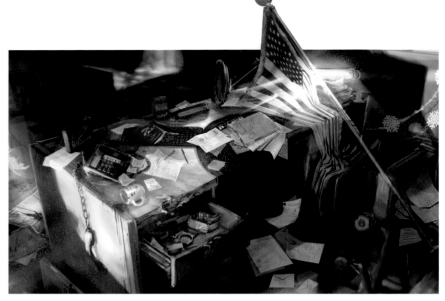

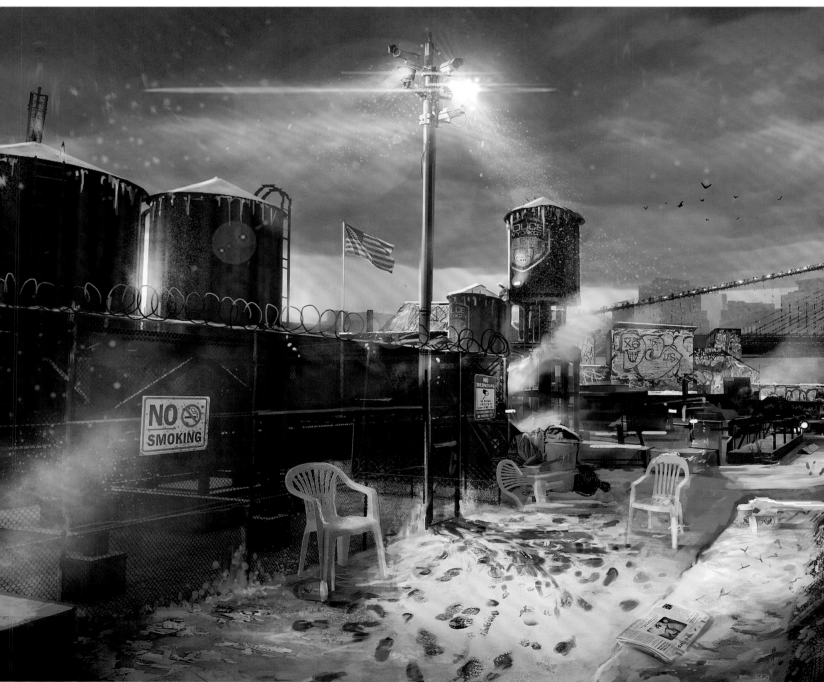

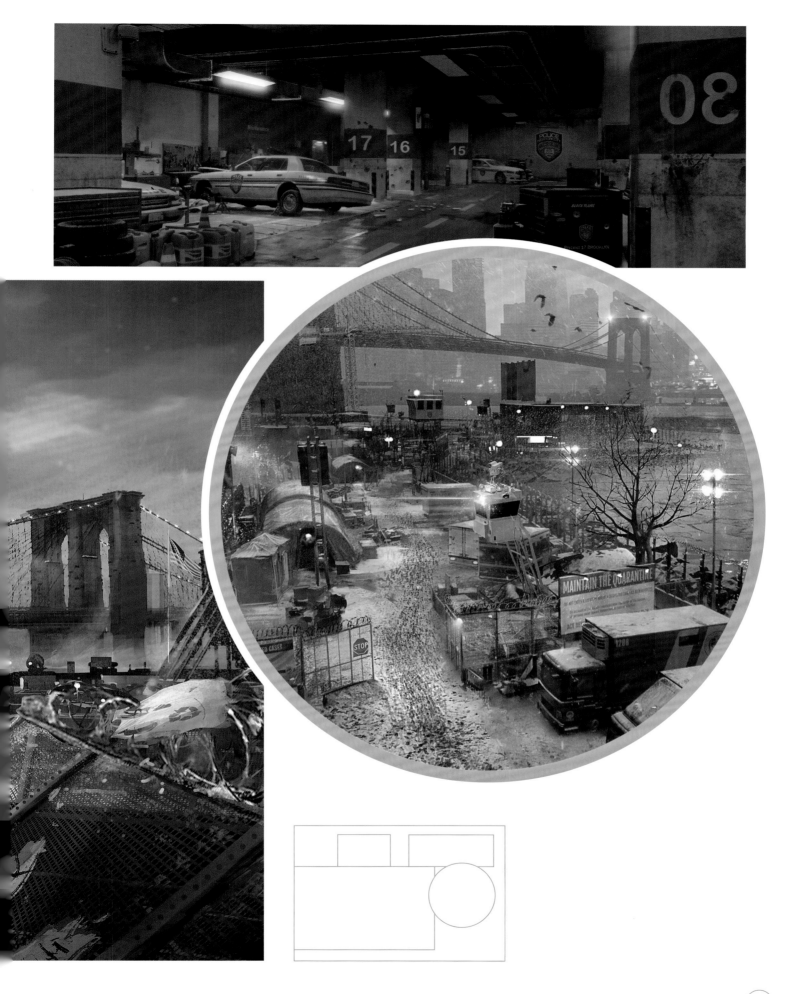

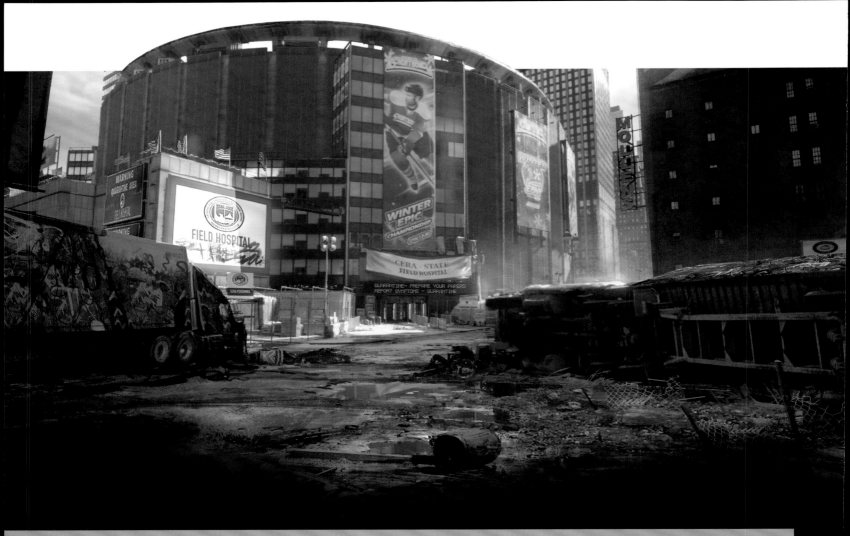

## MADISON FIELD HOSPITAL

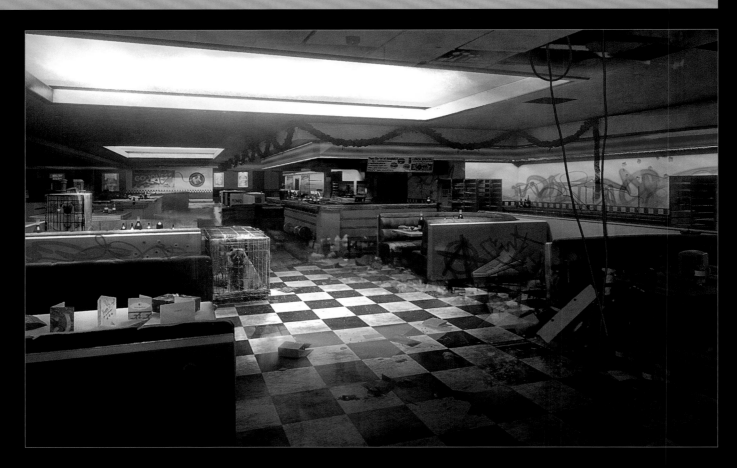

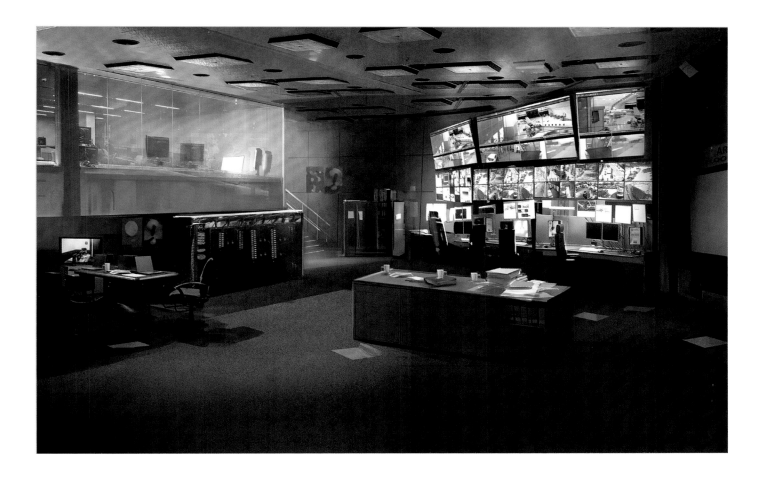

Scenes from a mission set in Madison Square Garden. Every picture has a tale to tell, although some are less easy to discern than others. With a lot of the environments in *The Division*, the artists tried to blend a few key ideas together. What did this place look like before the outbreak? What has happened since and what is happening now? These layers are vital to telling the story in the environment.

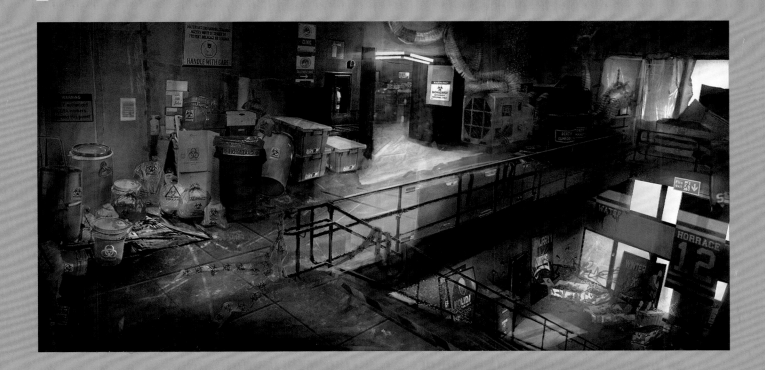

# NAPALM PRODUCTION SITE

Construction sites should be a sign of renewal and a city that is moving onwards and upwards. Not here, though, where hard hats, high visibility vests and working Joes are conspicuous in their absence. The open frameworks of these buildings offers little defence against the worst of the winter weather, but still provides open vantage points and shaded hiding places. Other factions may have the same ideas, of course.

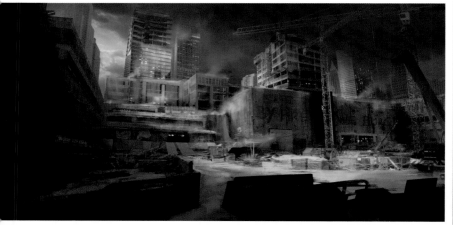

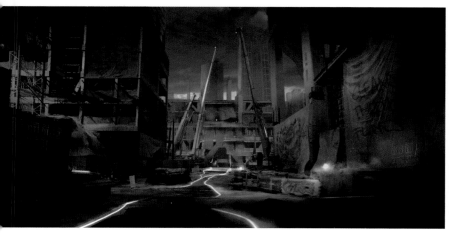

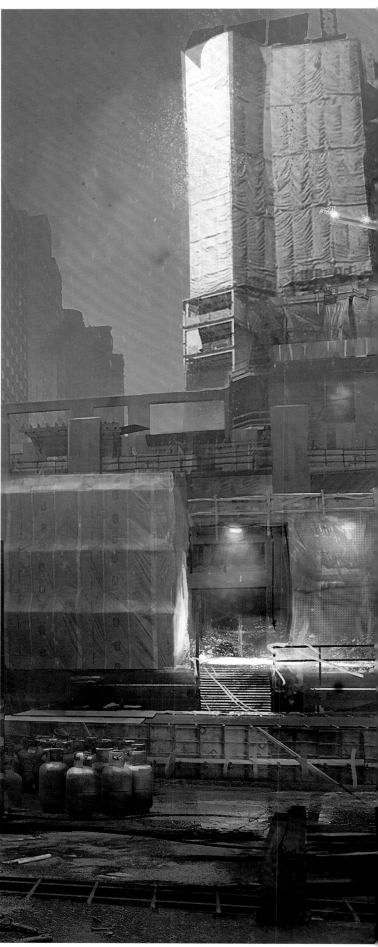

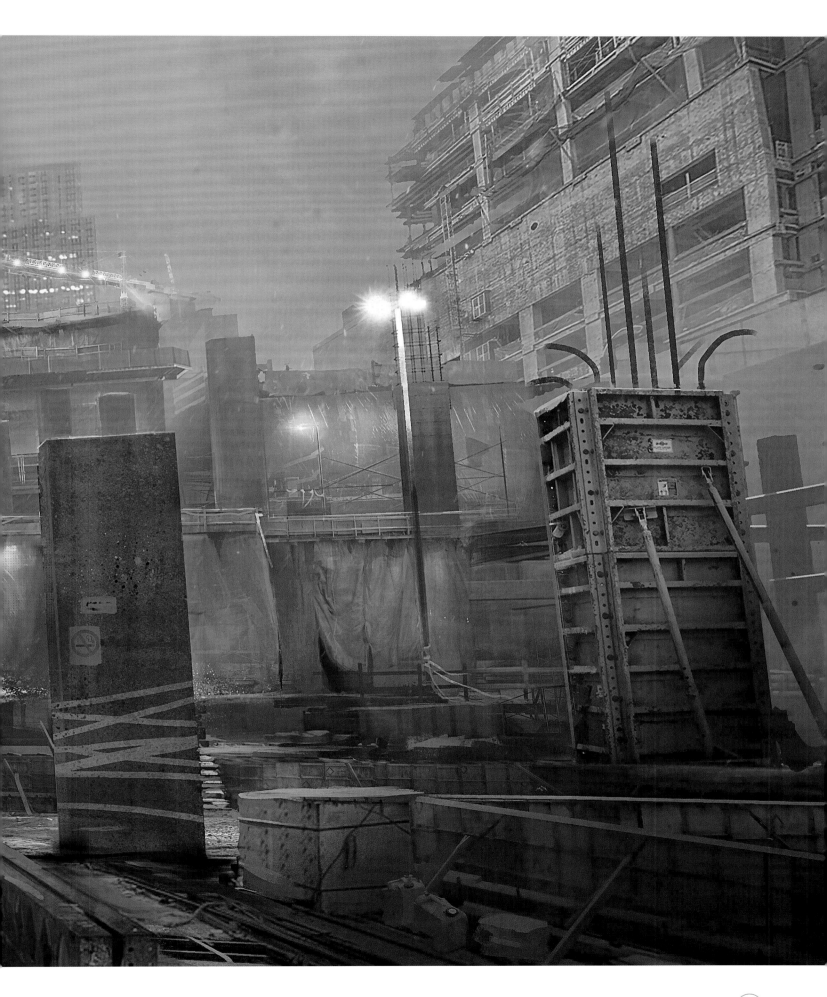

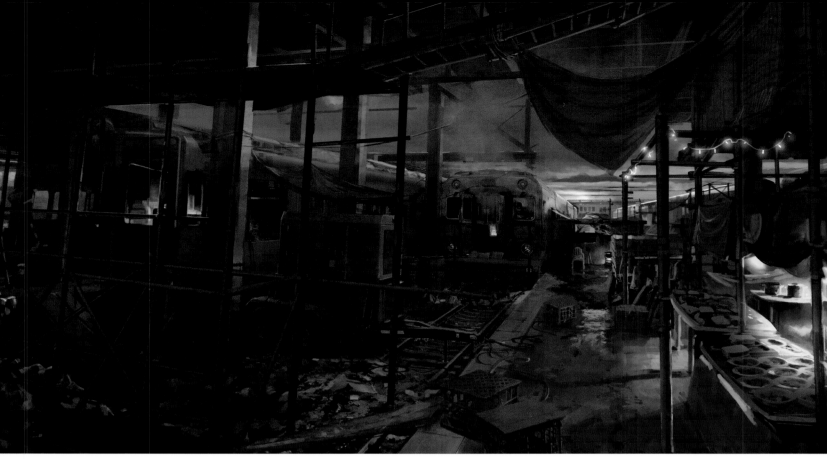

## HUDSON REFUGEE CAMP

This train yard, once an important piece of New York City's transport infrastructure, is now little more than a refugee camp. The sick, shunned by those not yet infected, group together to find some semblance of shelter and comfort. Part of the Division agent's mission is to protect these people, but the Cleaners, a dangerous, fanatical group bent on cleansing the world of the Green Poison, have the opposite mission. Where they would incinerate this camp, the Division must protect it, for the sick may hold the critical infection samples needed to finish work on the vaccine.

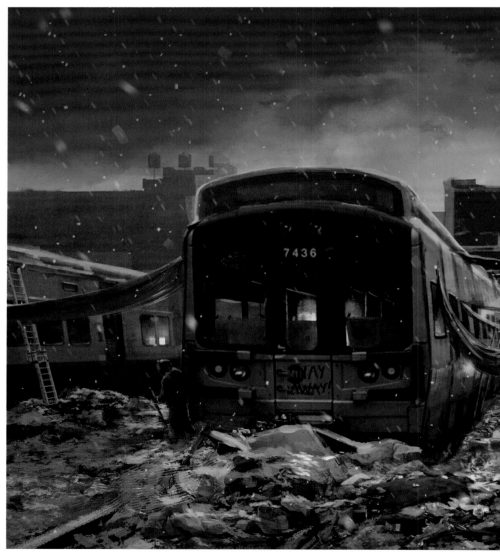

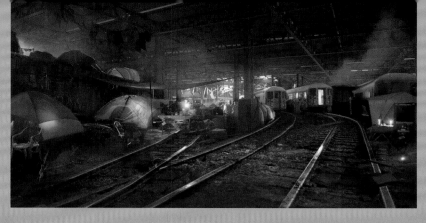

"The overpass of the train yard, with all the unused trains, created a great space to place out a sprawling camp," says Tom Garden.

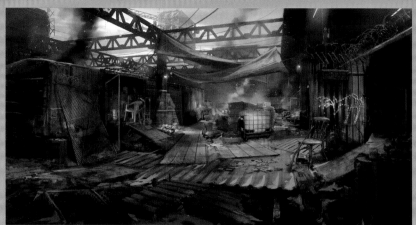

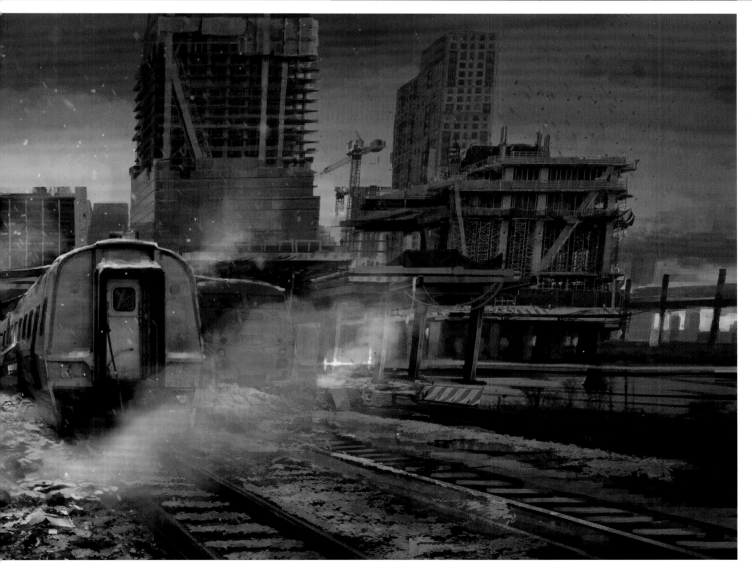

## BROADWAY EMPORIUM

Retail opportunities abound at this fictionalized department store, but nobody's buying when five-finger discount is the preferred currency. Meanwhile, a gang of overzealous Cleaners gives the Festive Season a boost by lighting the Christmas tree. Their chosen method leaves a lot to be desired, though. The artists show how a scene like this is created from the initial concept art (below) through the stages to a 3D model and into the final iteration you'll see on screen.

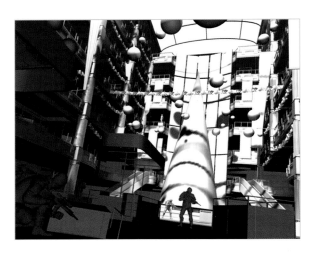

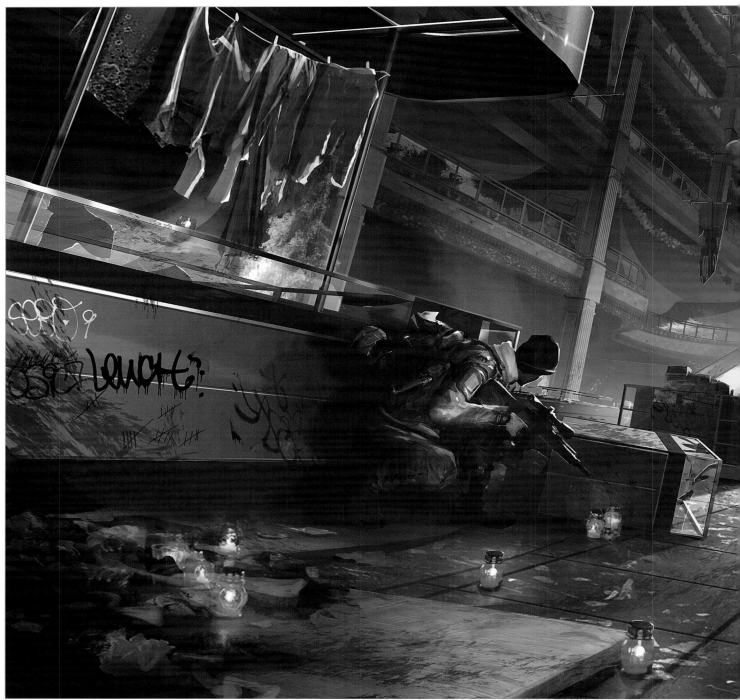

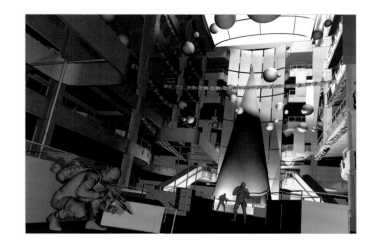
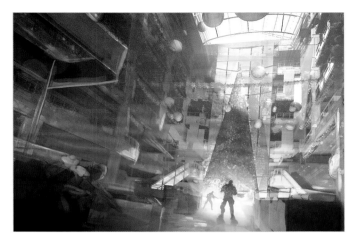
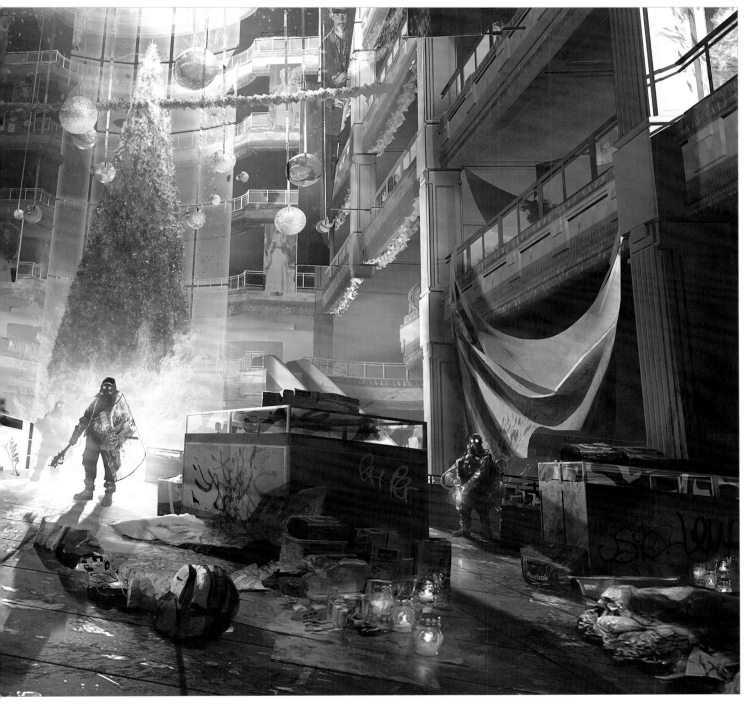

With its retail concessions, Broadway Emporium evokes famous New York department stores. As these images show, looters have paid a visit recently. Their bounty may yet become barter in a new economy.

A former jewelry display has become a makeshift camp.

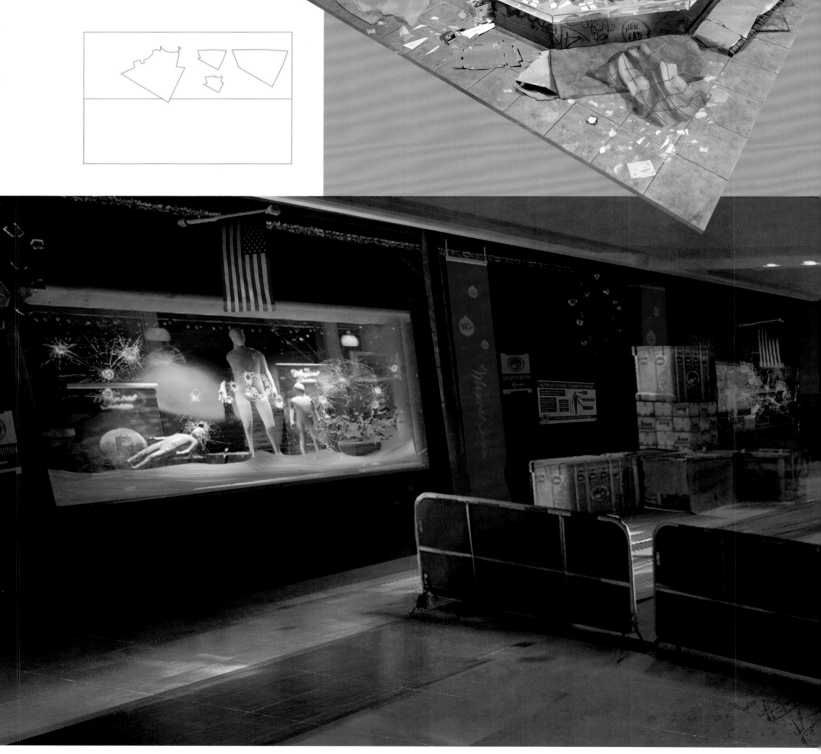

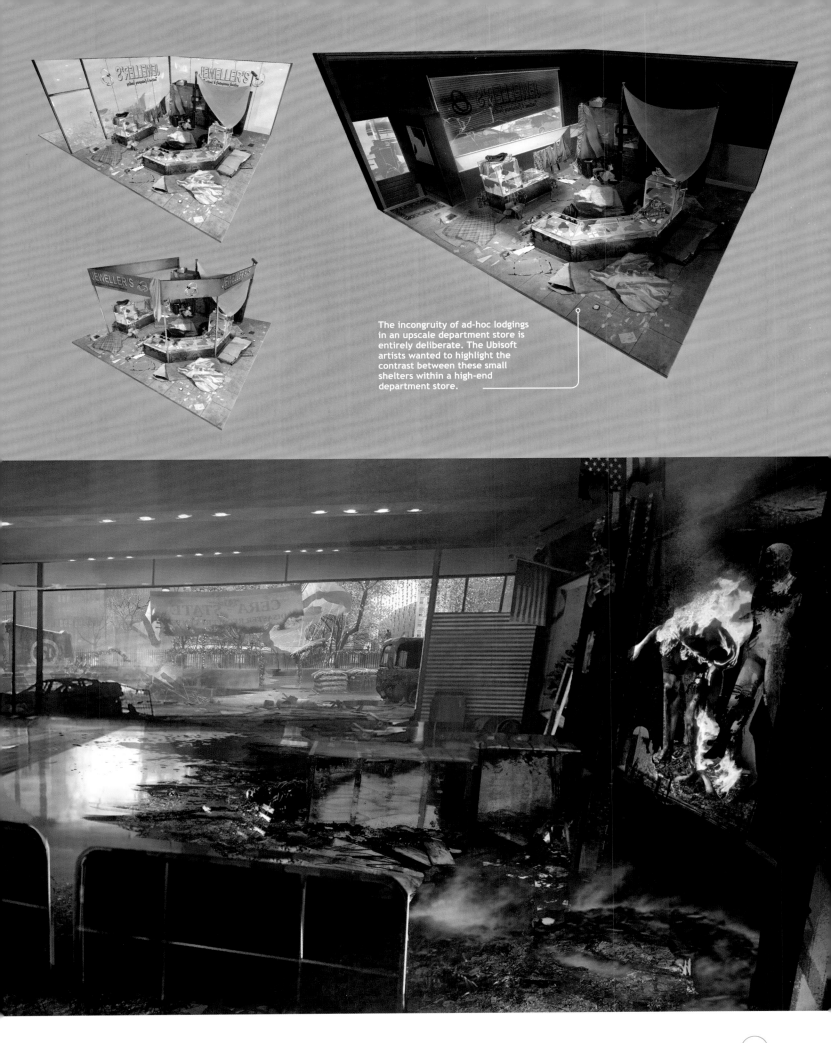

The incongruity of ad-hoc lodgings in an upscale department store is entirely deliberate. The Ubisoft artists wanted to highlight the contrast between these small shelters within a high-end department store.

## CHURCH

A welcoming light beckons from a partially open church door. Spiritual matters are brought to the fore when the chances of meeting one's maker are so dramatically increased. Too many others have more Earthly concerns, however, such as personal gain and survival at all costs. Hence the aggressive measures to protect the church from those who are perhaps less than righteous. The painted plea begs for assistance, but none is forthcoming.

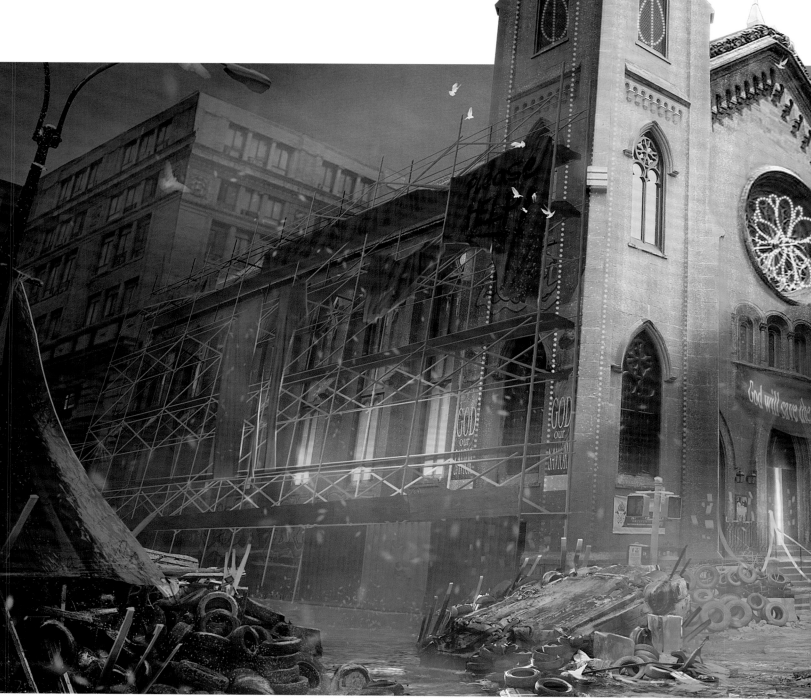

A church might be a place of peace and introspection under different circumstances, although perhaps not in the midst of a viral outbreak. For the artists, it was interesting to explore what role a church might have in a situation like this. They imagined a lot of people would go there for support and aid, but at some point would probably become overwhelmed and overrun.

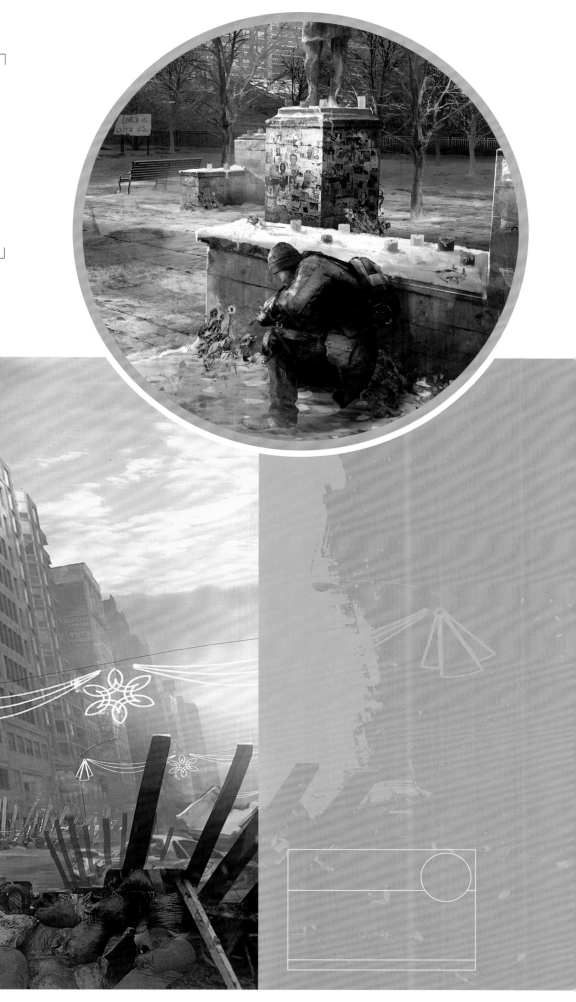

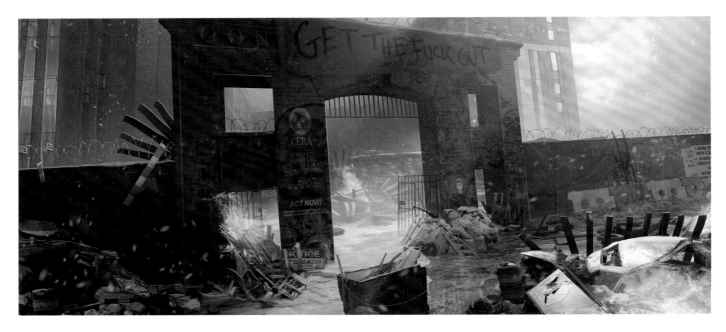

## WARRENGATE POWER PLANT

Not all NYC locations need to be familiar or iconic for their dramatic potential to be realized. Smoke still billows from this power plant chimney stack, but lit windows suggest trouble within.

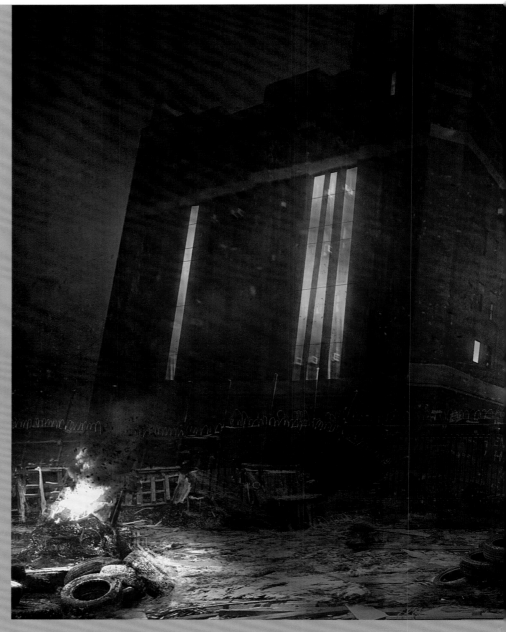

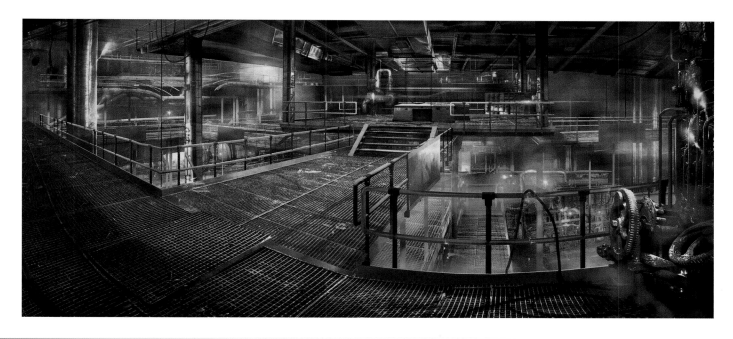

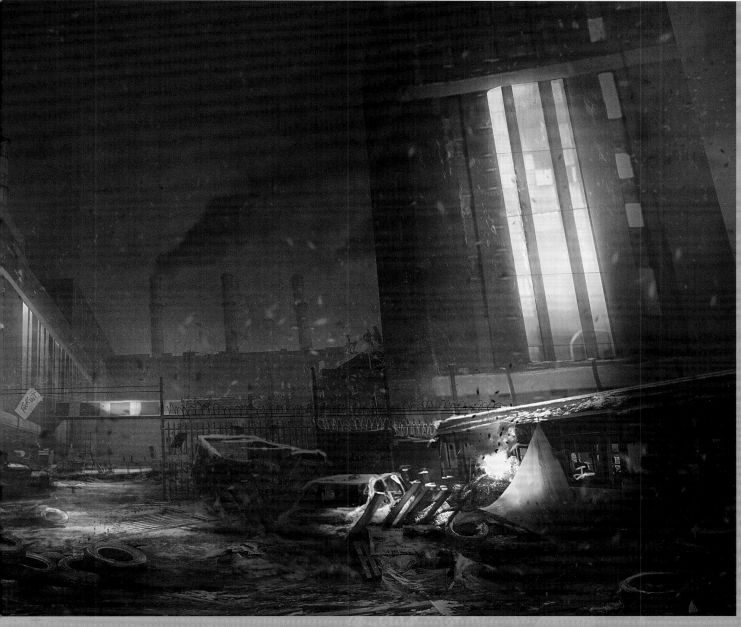

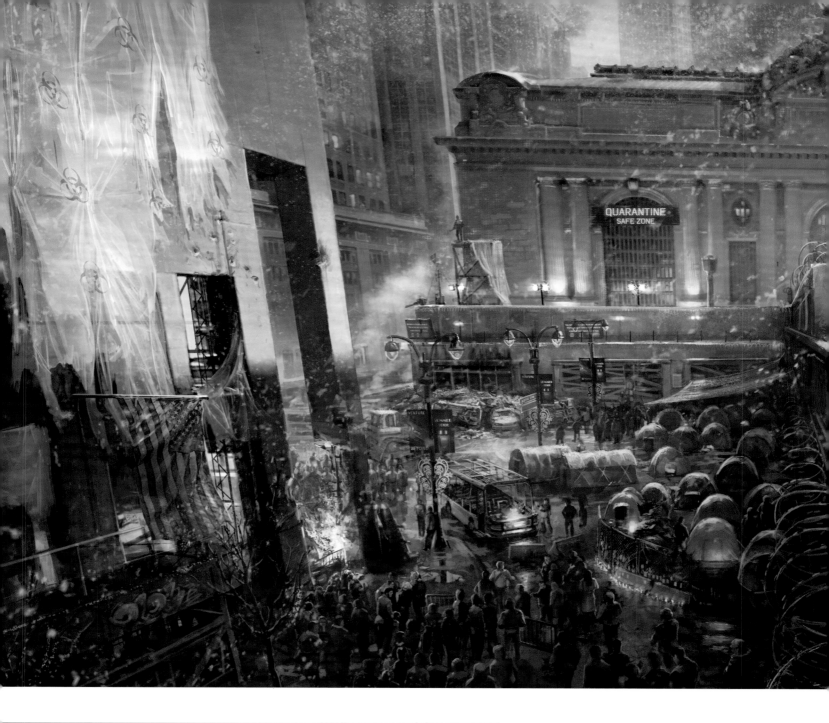

## GRAND CENTRAL CHECKPOINT

Civil unrest brews outside Grand Central Checkpoint, although there is little chance of catching a train away from the virus, and the armed guards make sure of it. The station is one of New York's most recognizable landmarks; it too plays an important part in moving the narrative along. Rodrigo Cortes explains further: "One of the great things with New York is that it has been used so prominently in movies and TV that most people are familiar with it, to an extent. This was crucial for us to convey one of our main themes – the fragility of society. By taking a place people are familiar with it becomes easier to show the effects of a collapsing society. As an added benefit, New York has many iconic and interesting places to explore too, which is awesome for an open world game!"

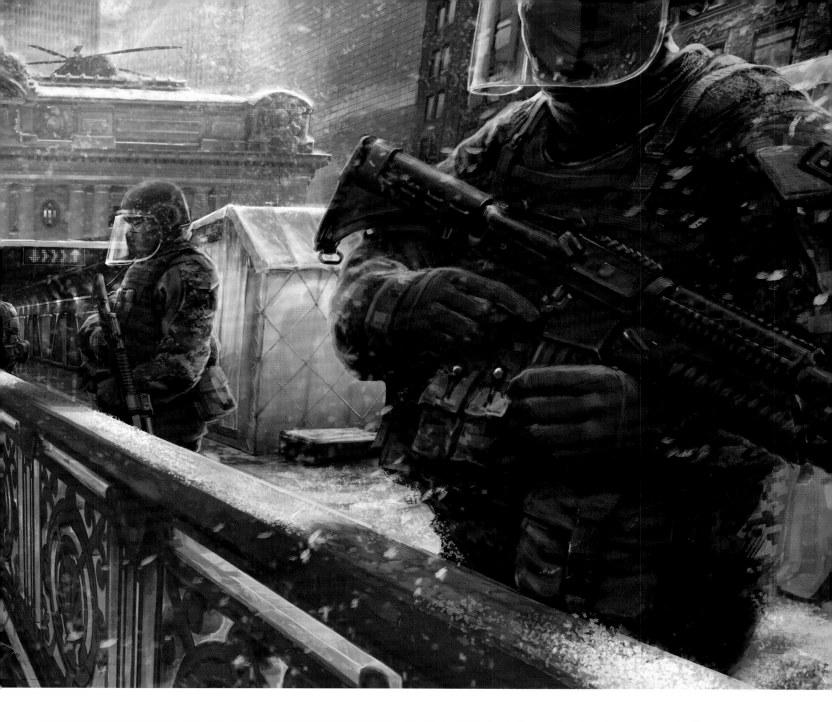

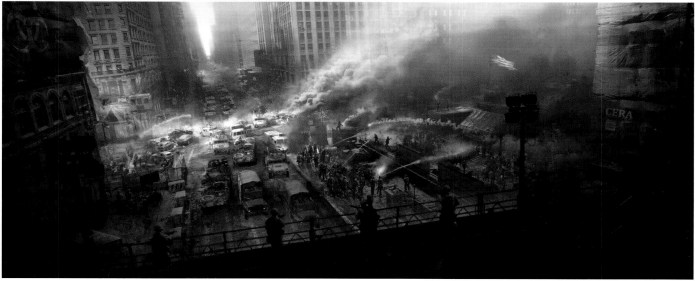

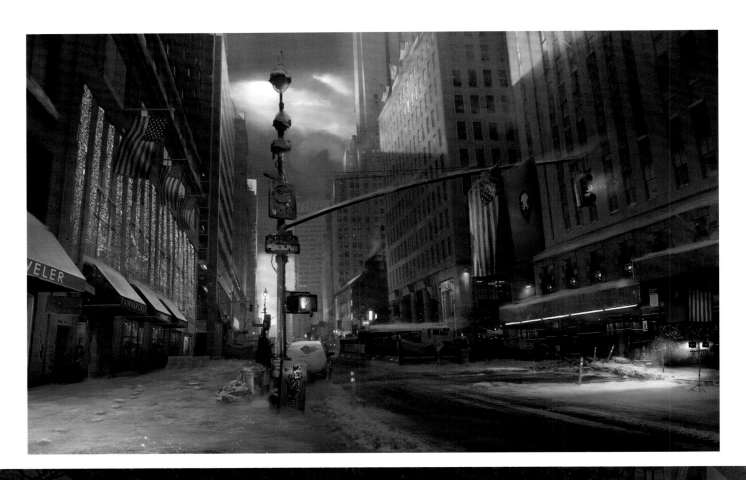

## DISTRICT ART DIRECTION

Each of the New York neighborhoods has its own characteristics, but establishing these differences was challenging when most are snow-covered and ruined to an extent. "We gave each district a specific art direction in order for the player to understand what part of the city they are in," explains Tom Garden. "It also helps us to push certain themes or moods within the environment."

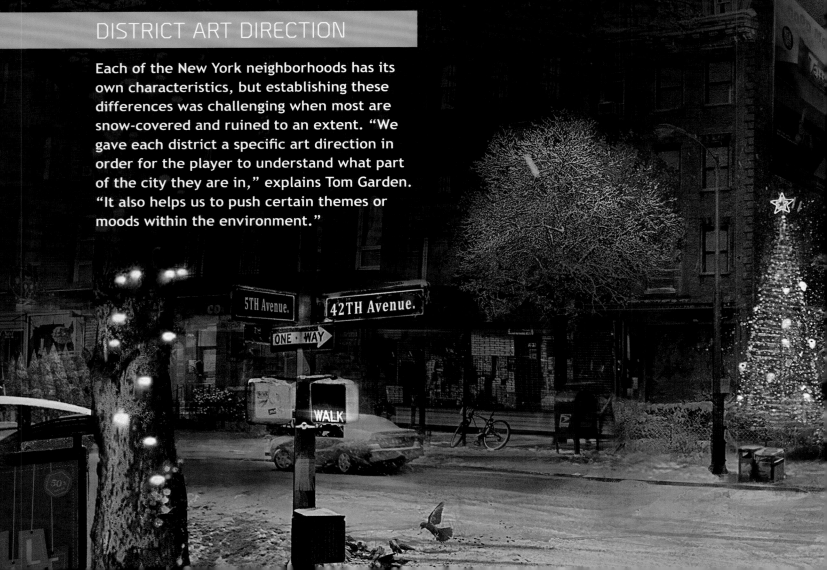

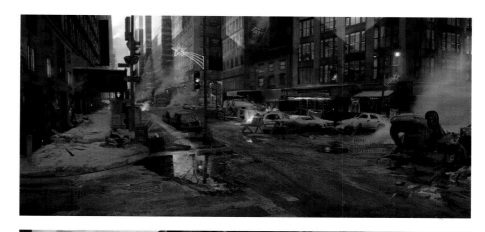

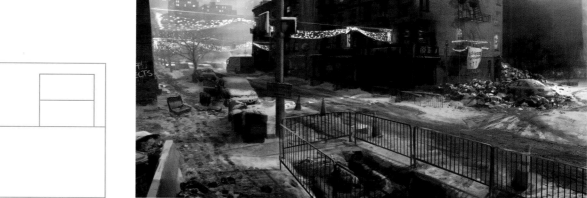

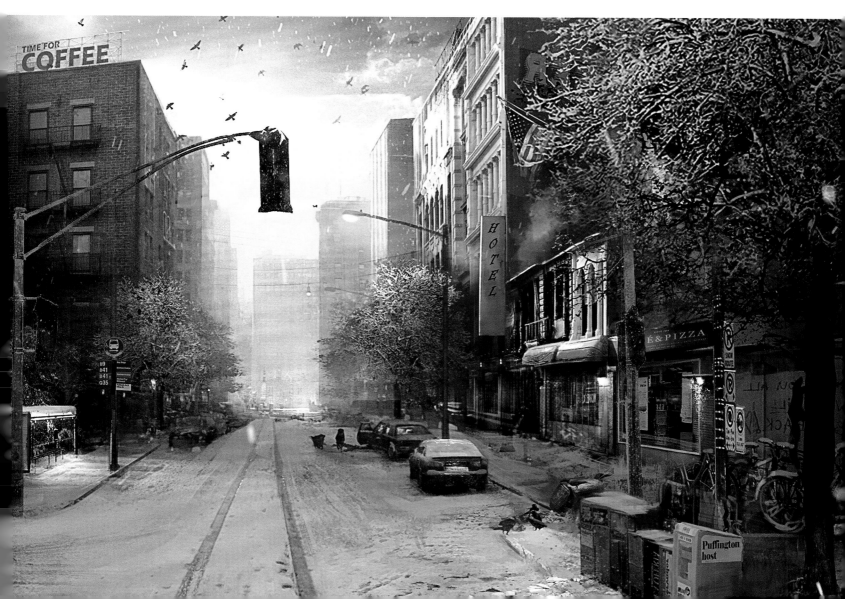

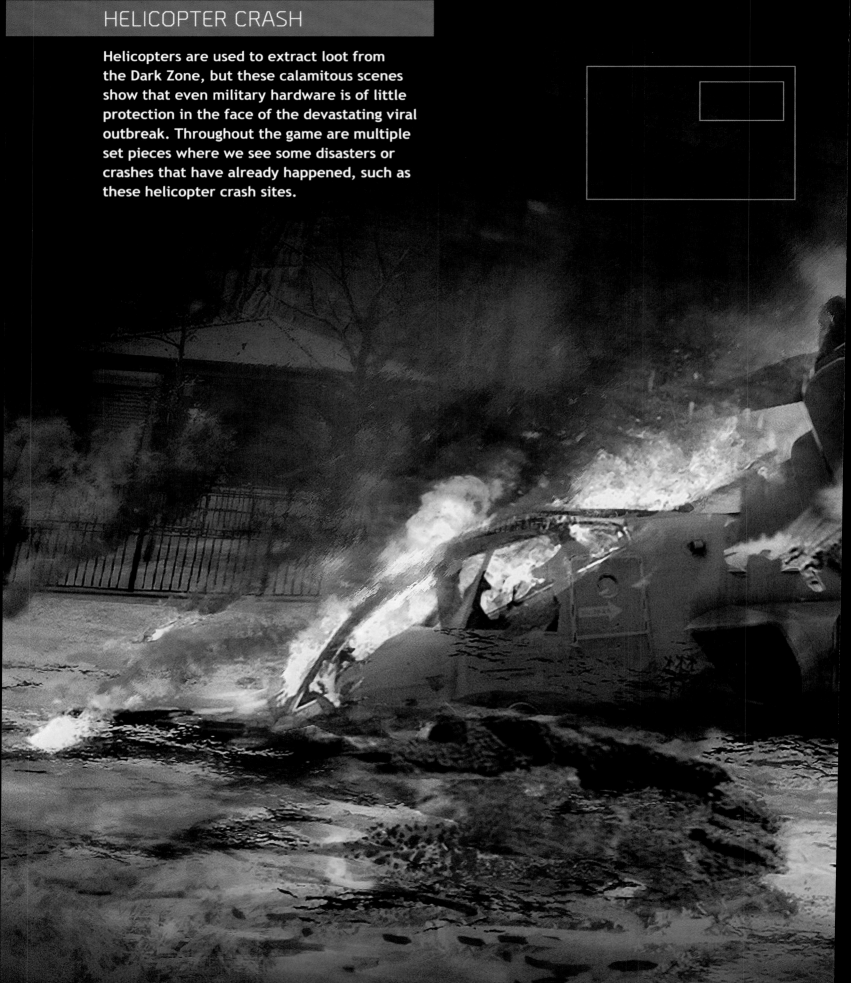

# HELICOPTER CRASH

Helicopters are used to extract loot from the Dark Zone, but these calamitous scenes show that even military hardware is of little protection in the face of the devastating viral outbreak. Throughout the game are multiple set pieces where we see some disasters or crashes that have already happened, such as these helicopter crash sites.

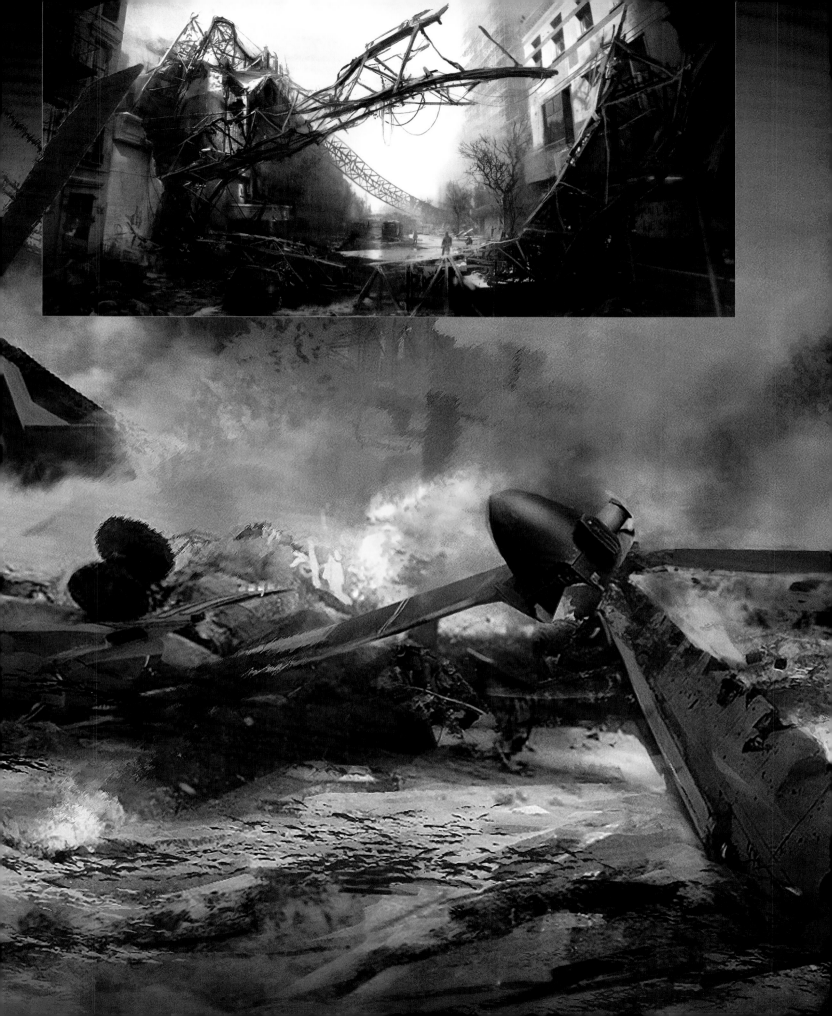

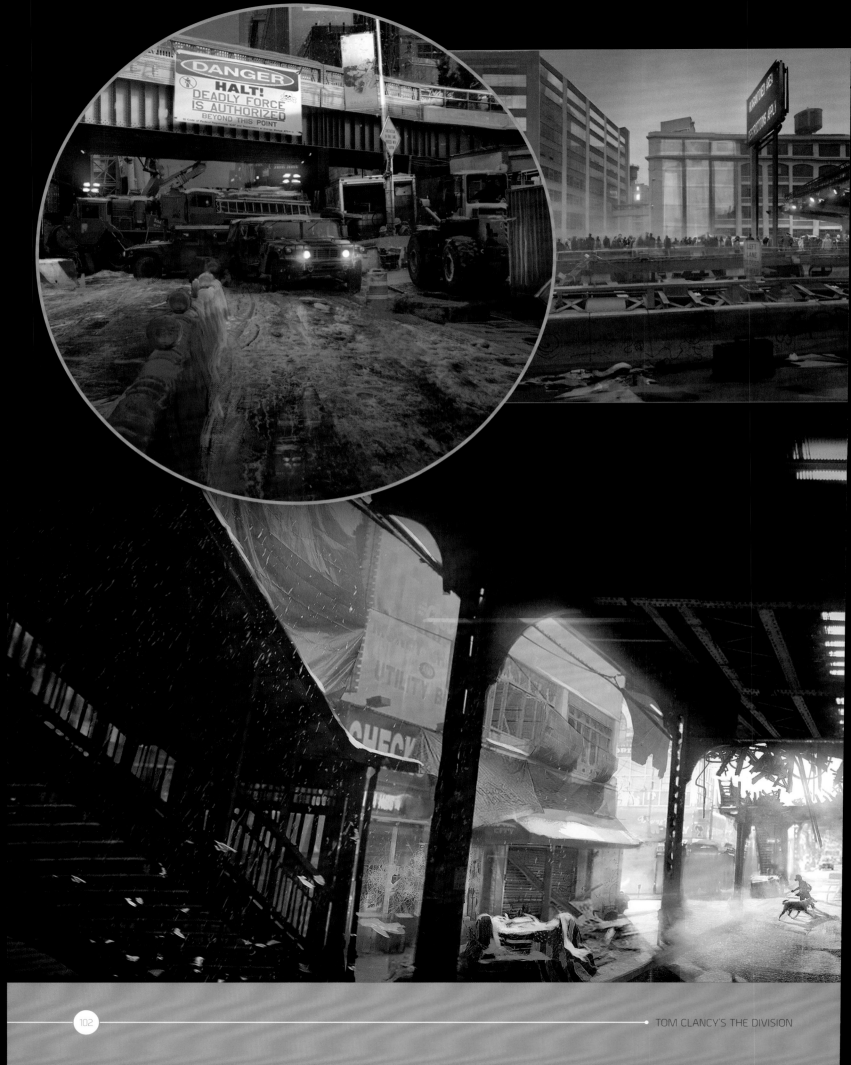

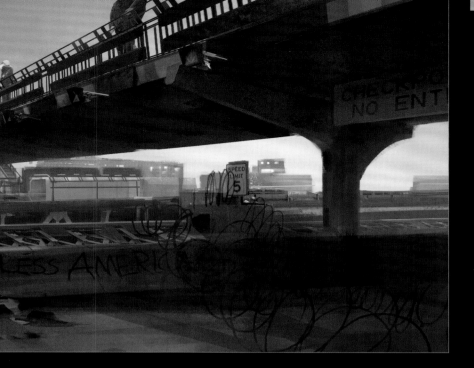

Vehicles choke the road and survivors mass beneath a bridge, but no more trains will run on the Third Avenue Line.

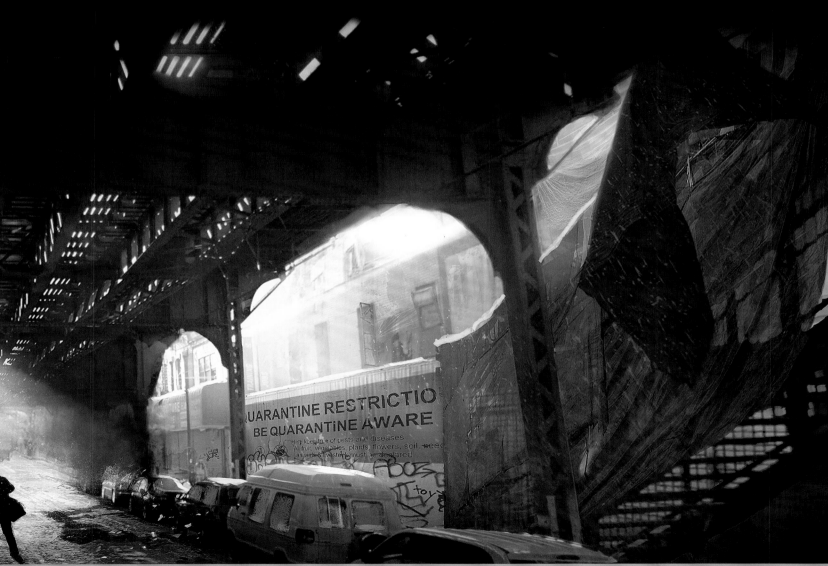

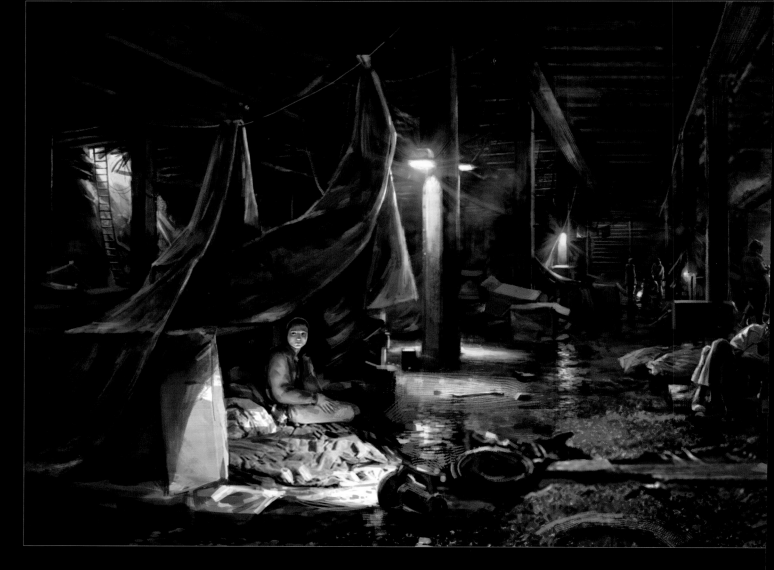
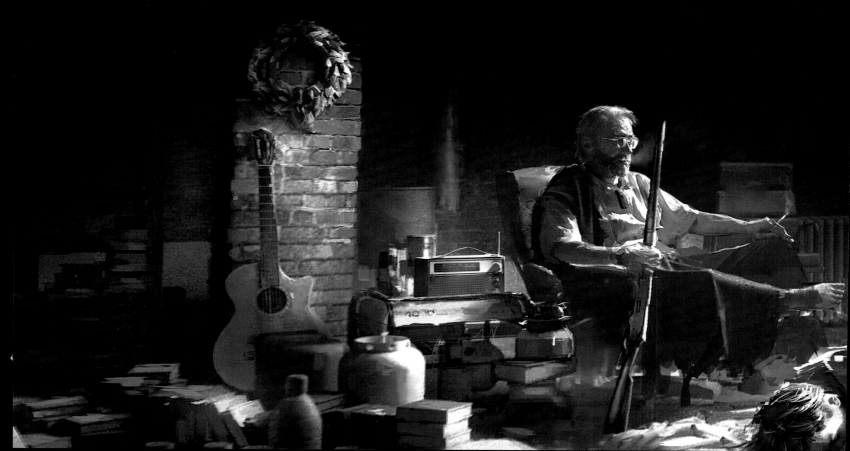

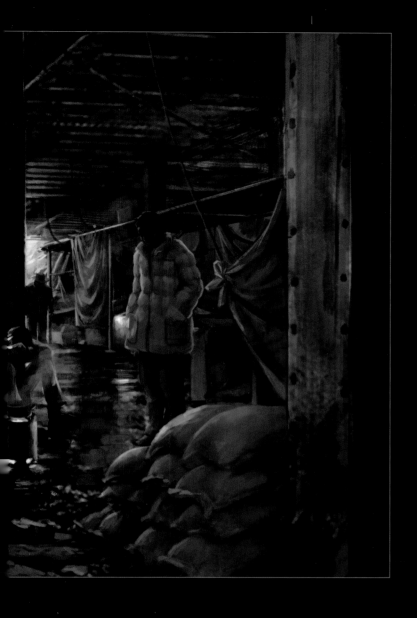

Survivor families make shelter as best they can, but the festive ivy wreath and few home comforts only serve to underline their tragic predicament. "The motif of The Christmas That Never Was is an integral part of the setting and the world the player will explore," explains Rodrigo Cortes. "It is a reminder of what we take for granted and the basic functions of our society. By moving around in these settings, the drastic changes and implications of the disaster become so much more apparent. It is something the player will frequently encounter in a way that makes total sense."

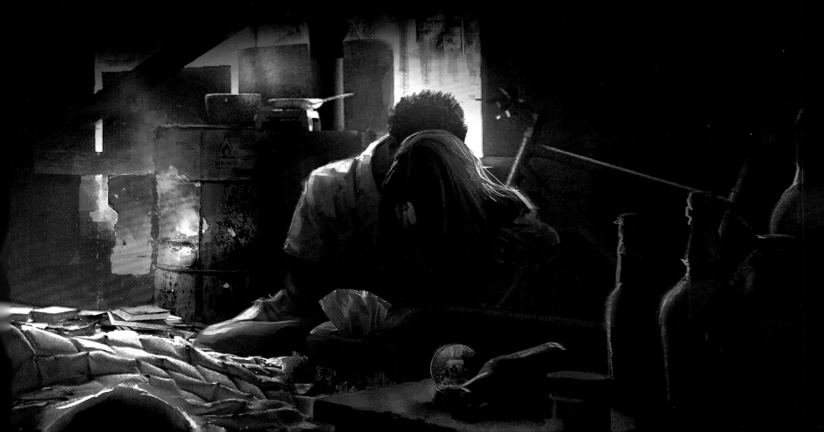

## SAFE HOUSE

Organized and unthreatening scenes such as these will be a welcome sight for beleaguered Division agents, although they are rare among the chaos and ruin that has swamped the rest of the city. "Safe houses provide spots on the map where players can restock, get new missions and group up. We wanted them to feel cosy as they are not setup by officials, but by civilians," says Tom Garden.

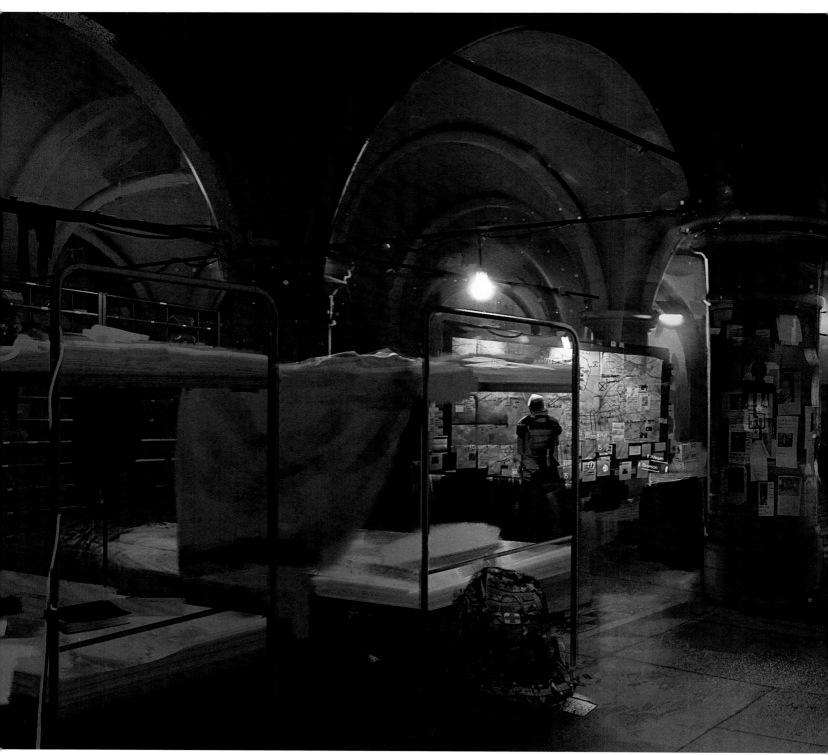

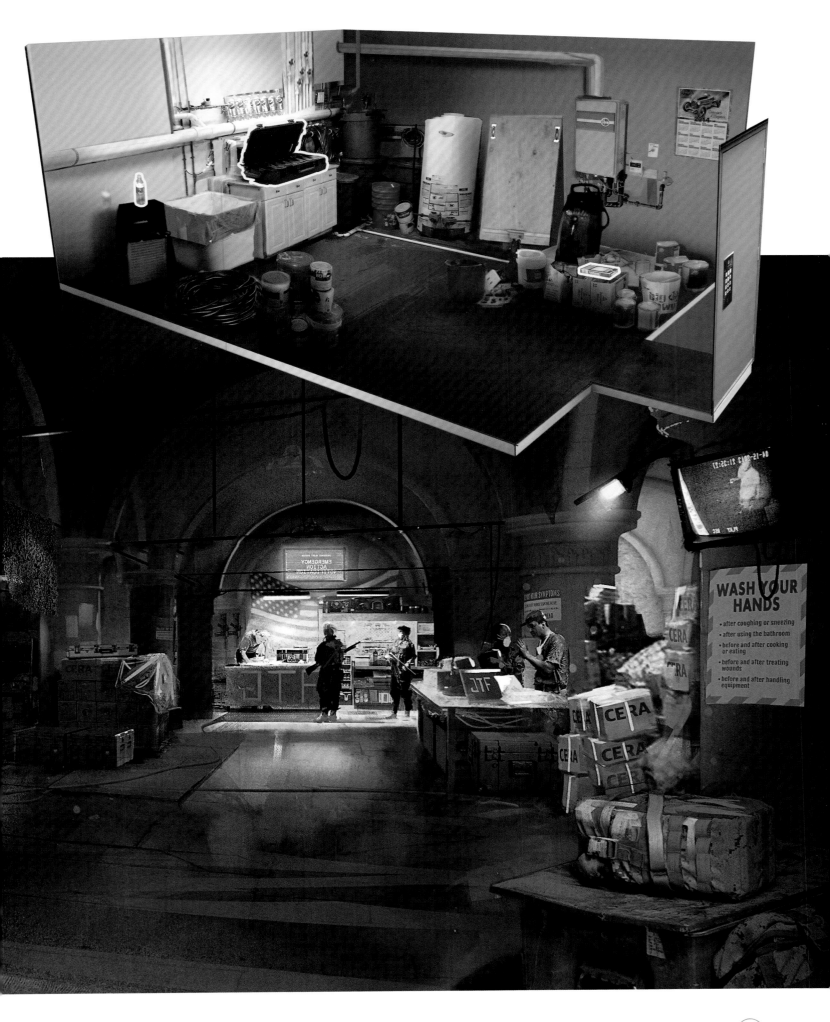

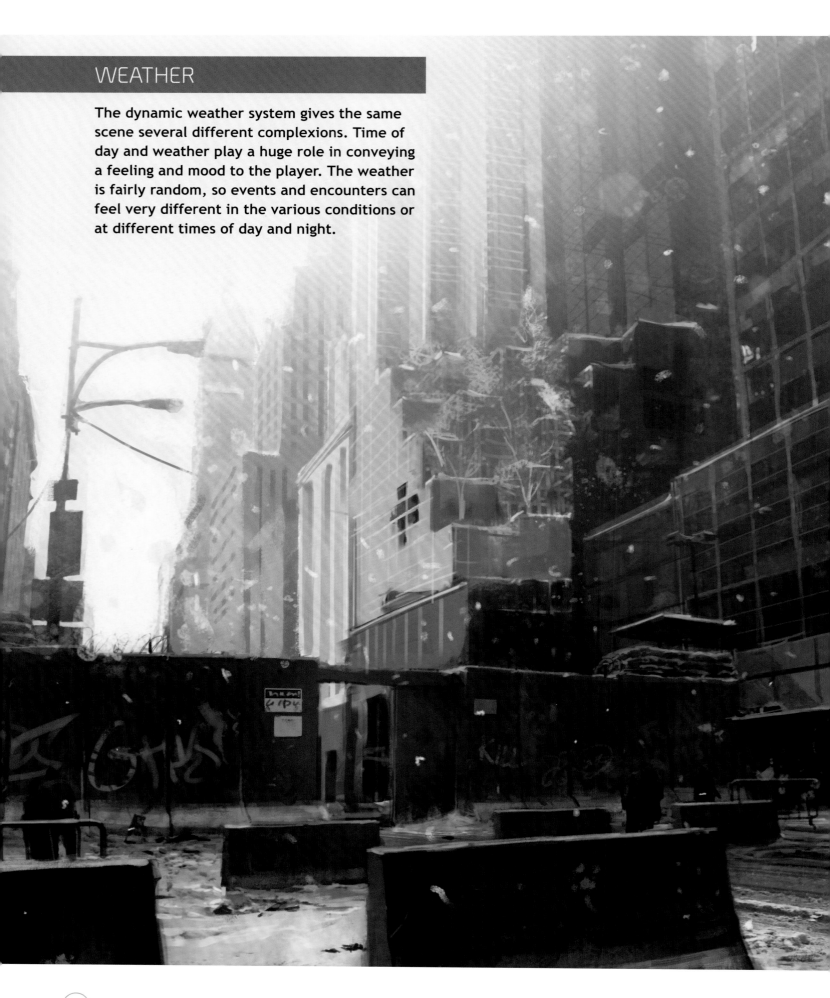

# WEATHER

The dynamic weather system gives the same scene several different complexions. Time of day and weather play a huge role in conveying a feeling and mood to the player. The weather is fairly random, so events and encounters can feel very different in the various conditions or at different times of day and night.

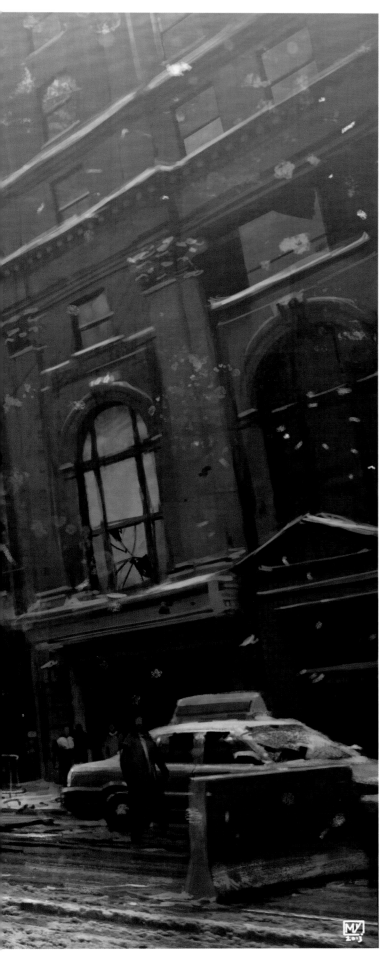

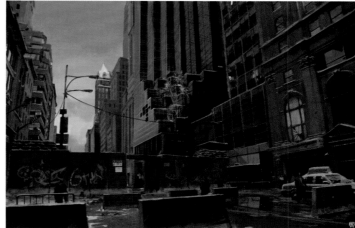

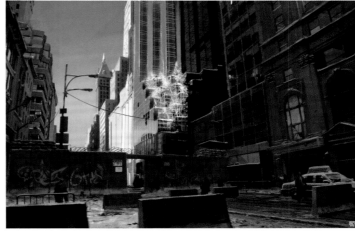

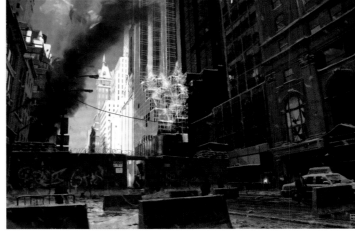

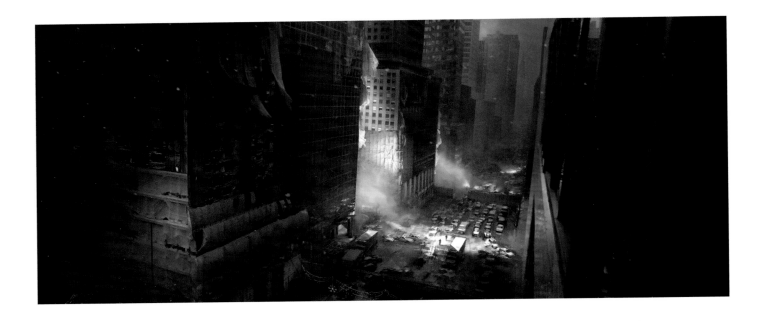

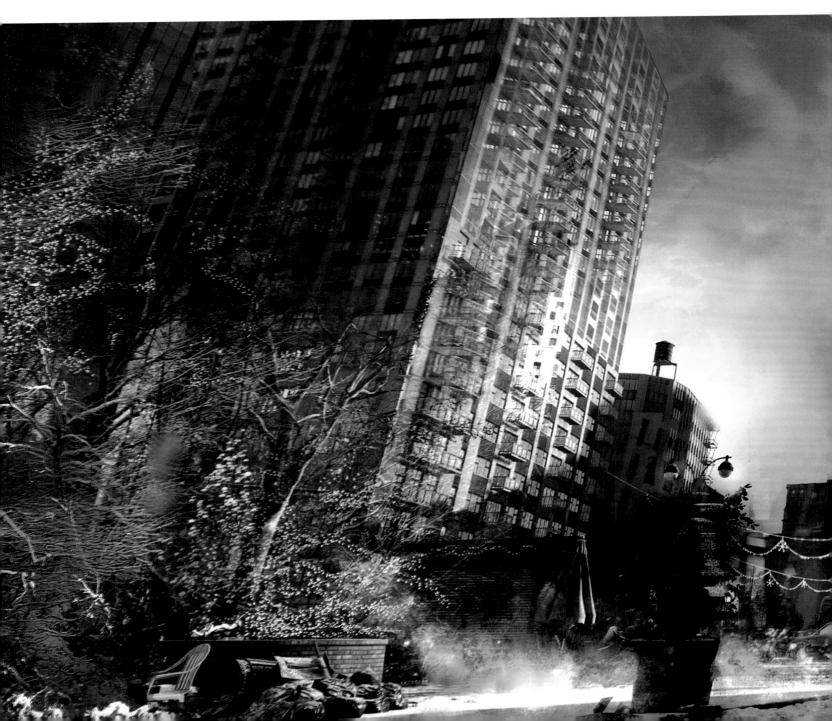

*Left*: The gridlock on the streets of Manhattan is unlikely to unravel in the near future. *Below*: The 22 storey Flatiron Building presents an imposing and characterful profile on the junction of Fifth Avenue and Broadway, and is one of New York's earliest skyscrapers. "Having some of New York's most iconic structures was really fun to play with, to see what state they would be in," adds Tom Garden.

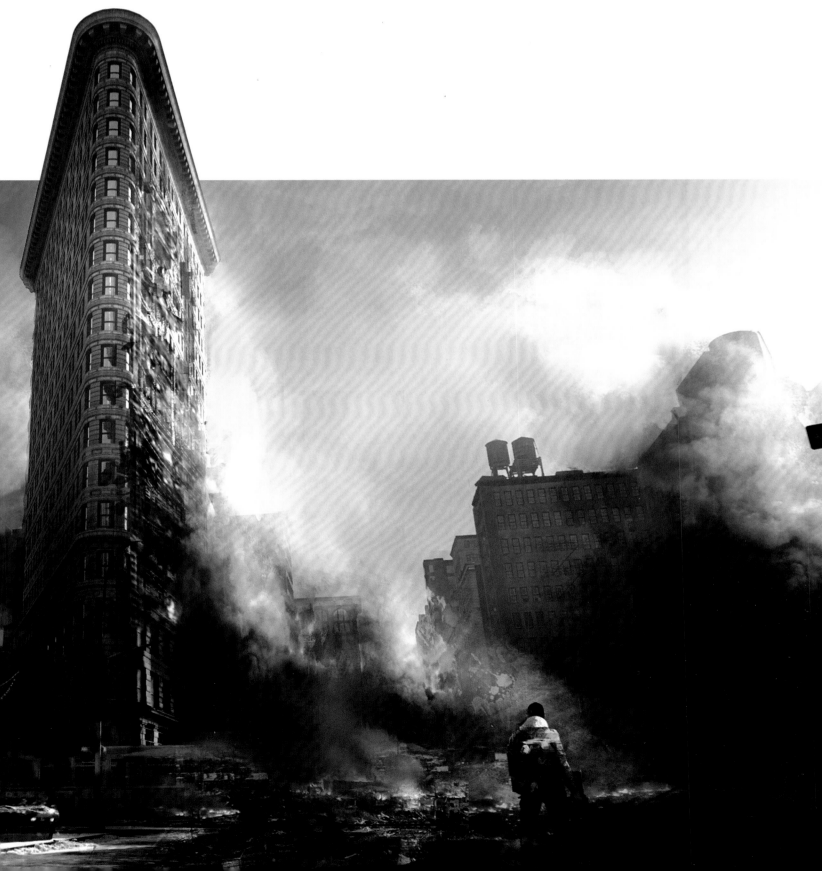

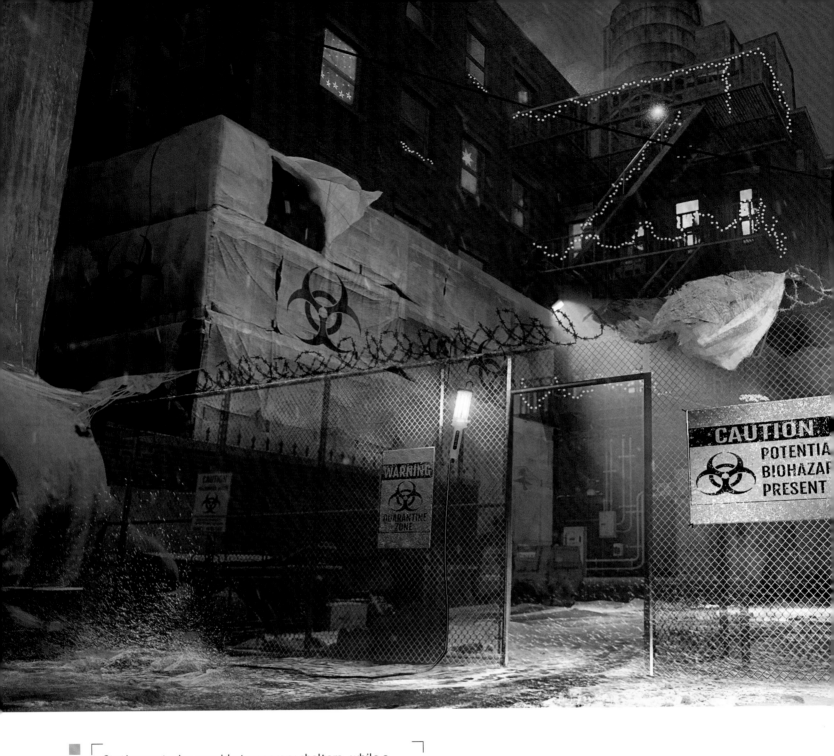

Stationary trains provide temporary shelters, while a single string of Christmas lights offers proof that the human spirit prevails in the unlikeliest quarters. Forlorn scenes such as these provide a plausible context for the game, as Rodrigo Cortes explains. "Everything is pure fantasy, in the sense that it is a 'what if' scenario based on a world that we know and can relate to. The fact that it looks realistic is part of what makes the experience so compelling. Often in games a big problem is to create a setup people understand. It is important to do this because that's the foundation for your story. We get some of these things for free, thanks to the realistic setting, and it also poses some interesting challenges, of course, but that is part of the fun!"

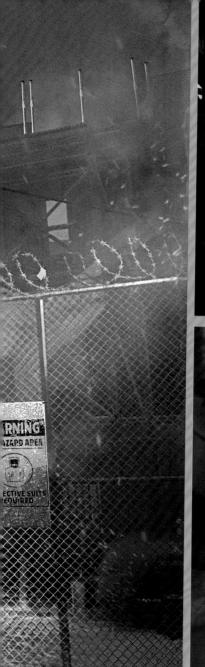

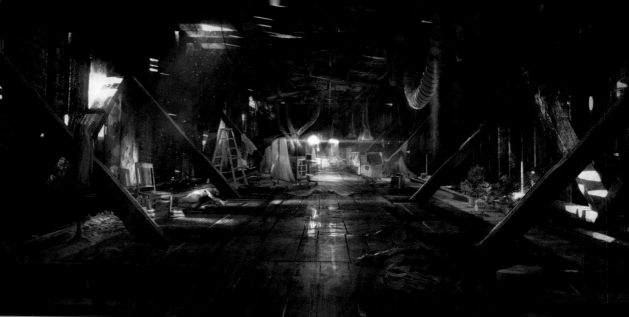

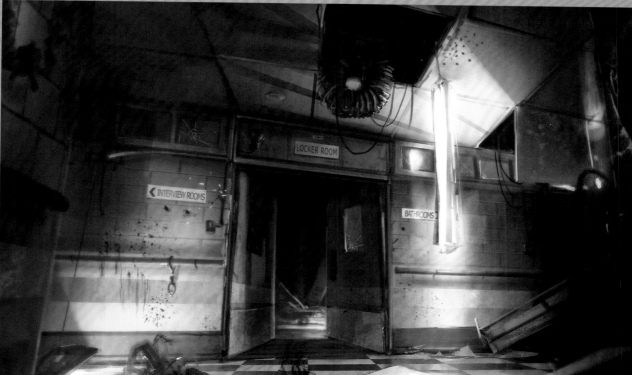

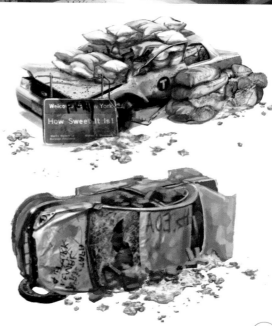

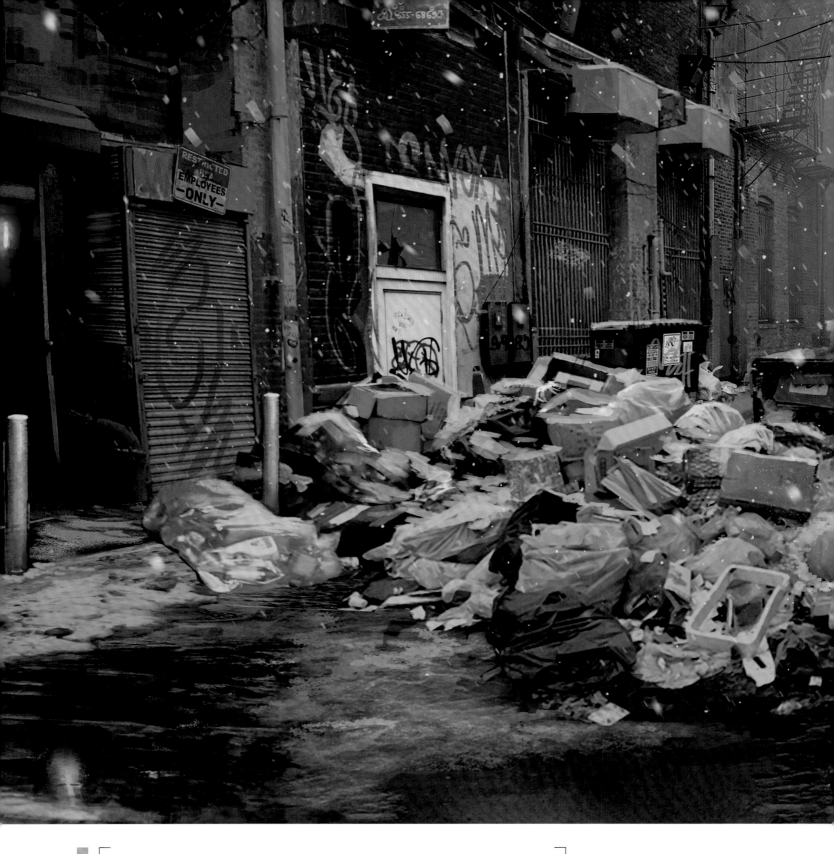

Public services have ceased in the wake of the outbreak and huge piles of refuse sacks have built up within days. These mountains of garbage recall the infamous Christmas Trash Strike of 1981 and the events of winter 1978, when repeated ice storms prevented street cleaners from doing their jobs for two months. There are obvious textural benefits, though, and the falling snow may yet obscure some of the ugliness of the scene. Even so, those who remain in New York would gladly endure any kind of industrial or weather-related turmoil in preference to the ongoing pandemic.

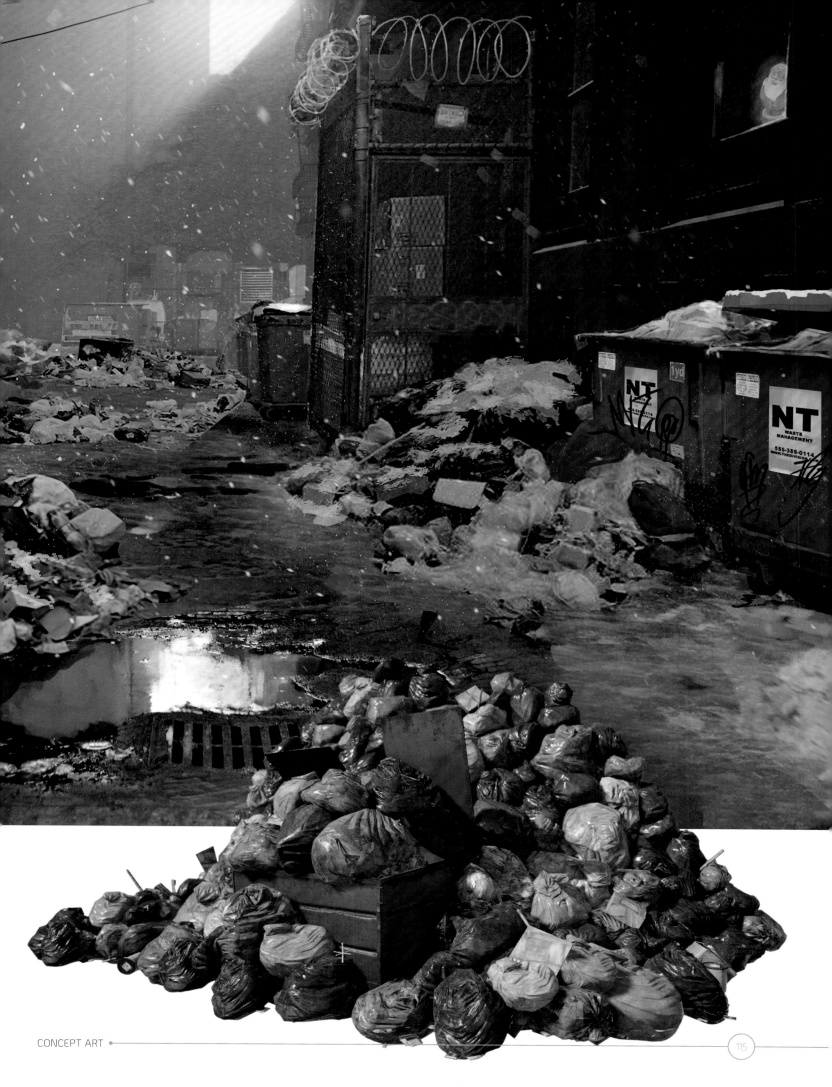

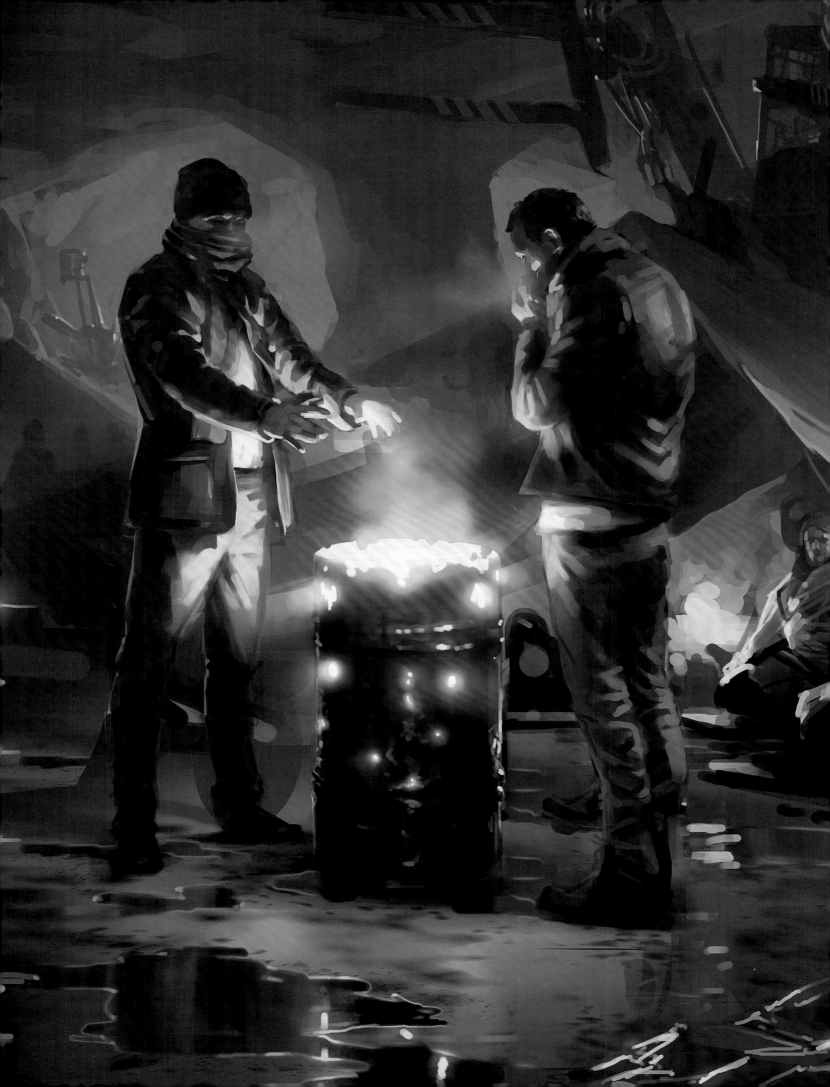

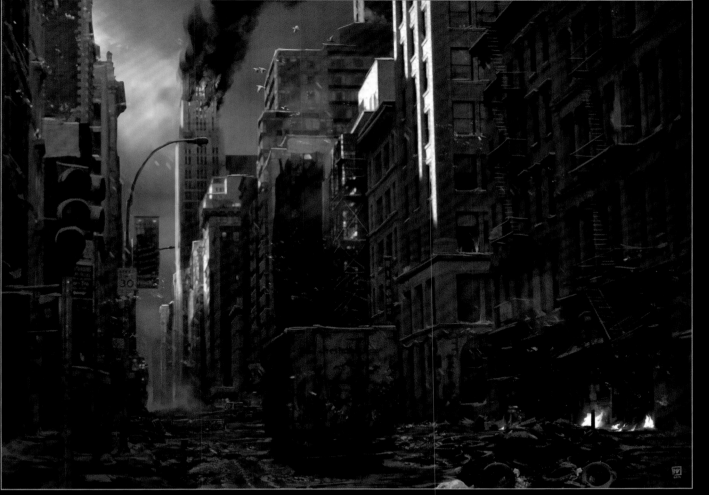

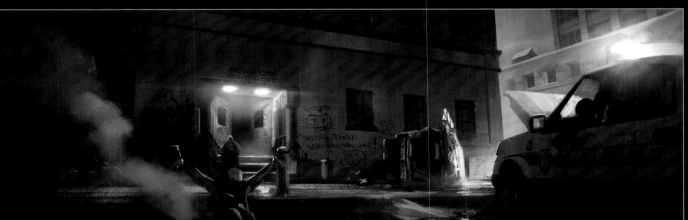

A flaming brazier brings warmth to the scene on the left, yet it is still a chilling reminder of the conditions that have beset the NYC populace. Players will soon realize the horrors that have driven these citizens from their homes. This makeshift camp offers a few comforts, though; scant insulation from the elements, but at least there is strength in numbers when citizens band together for protection and company. Elsewhere, a skyscraper burns downtown and general wreckage renders the streets impassable. The driver of the broken down cruiser lies slumped across his steering wheel and has probably arrested his last criminal.

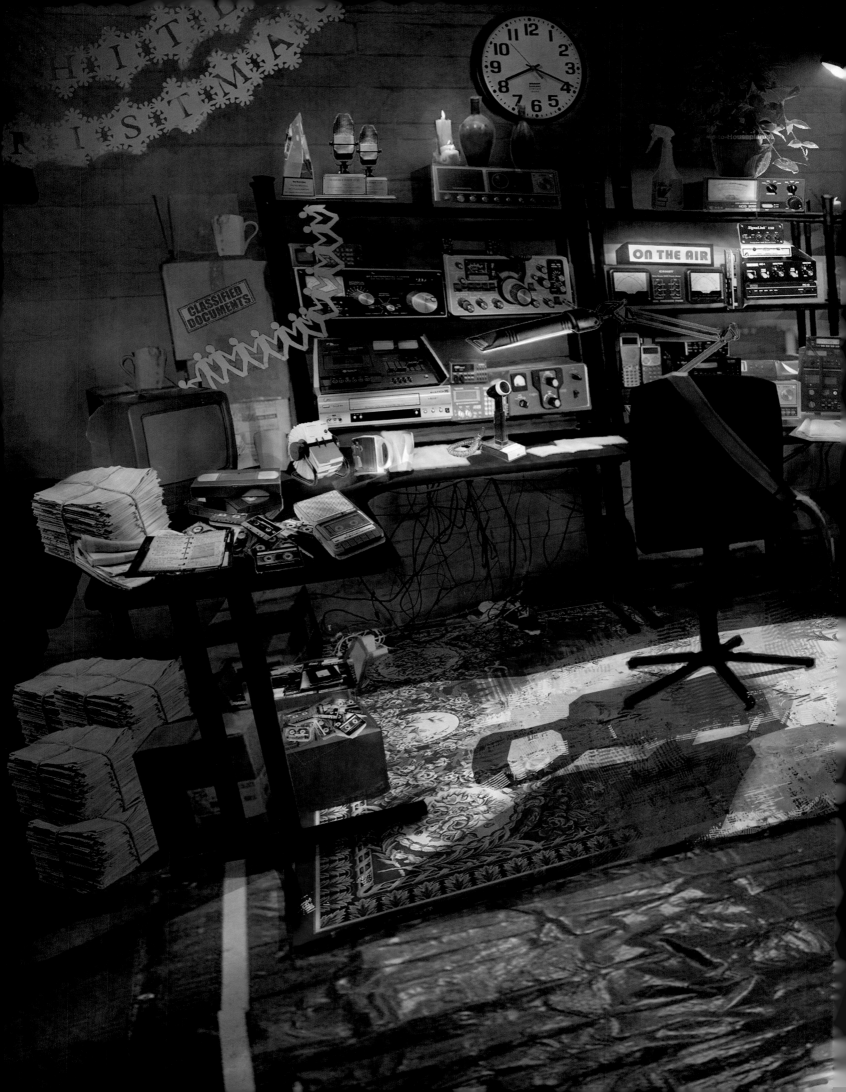

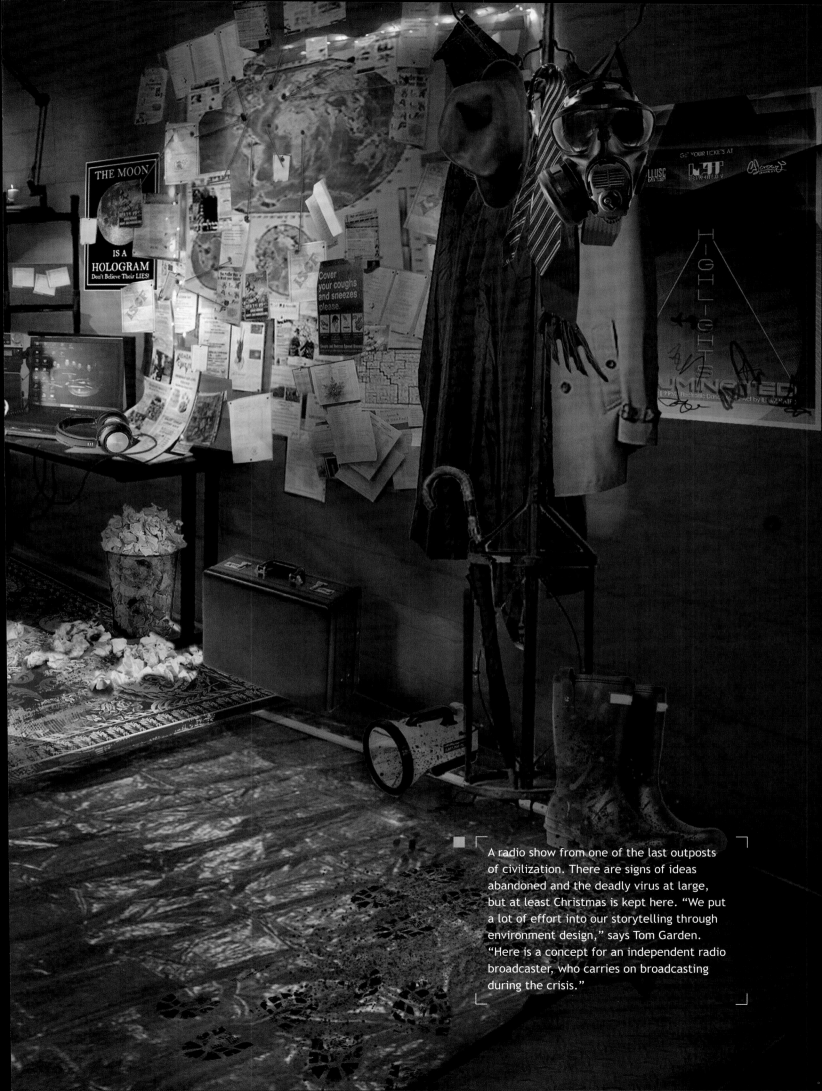

A radio show from one of the last outposts of civilization. There are signs of ideas abandoned and the deadly virus at large, but at least Christmas is kept here. "We put a lot of effort into our storytelling through environment design," says Tom Garden. "Here is a concept for an independent radio broadcaster, who carries on broadcasting during the crisis."

## CERA

The Catastrophic Emergency Response Agency (CERA) is tasked with resolving disaster situations. Well equipped and well intentioned, they endeavour to eliminate the outbreak with medical facilities and designated quarantine zones. Their authoritarian efforts are not wholly appreciated.

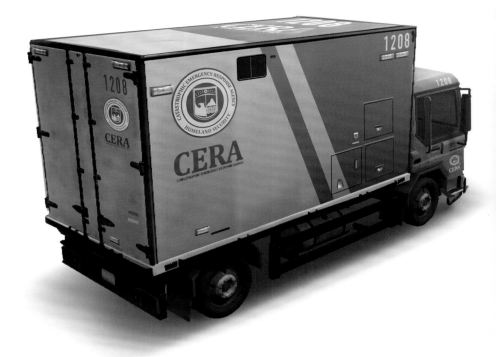

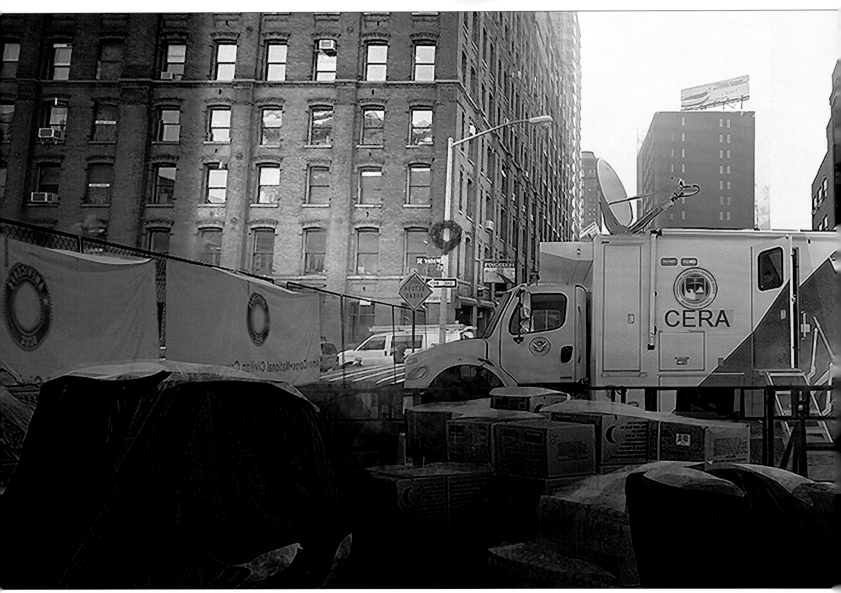

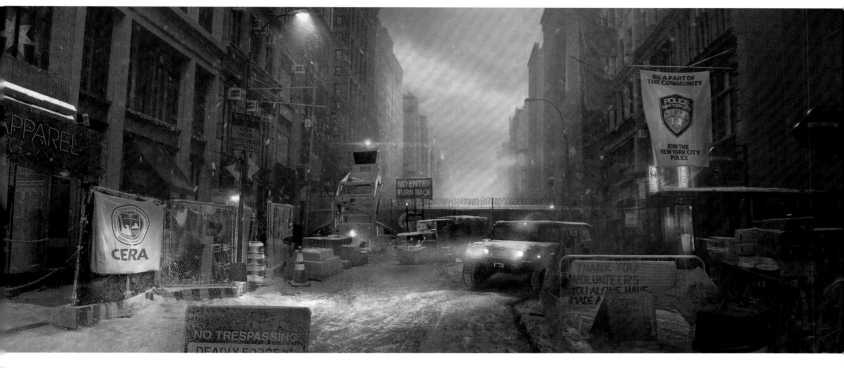

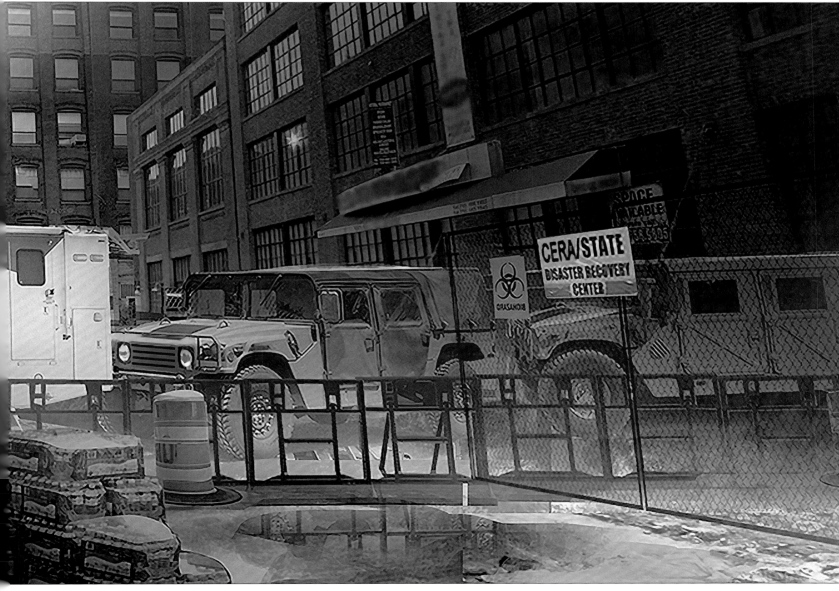

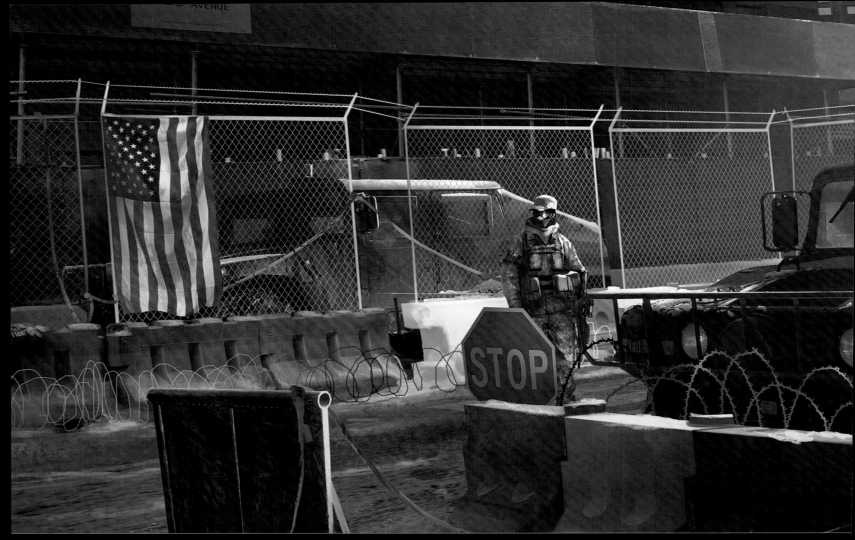

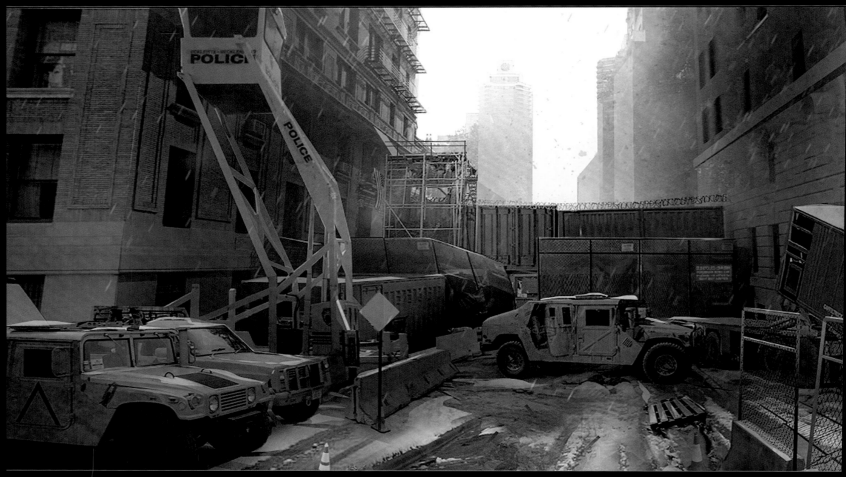

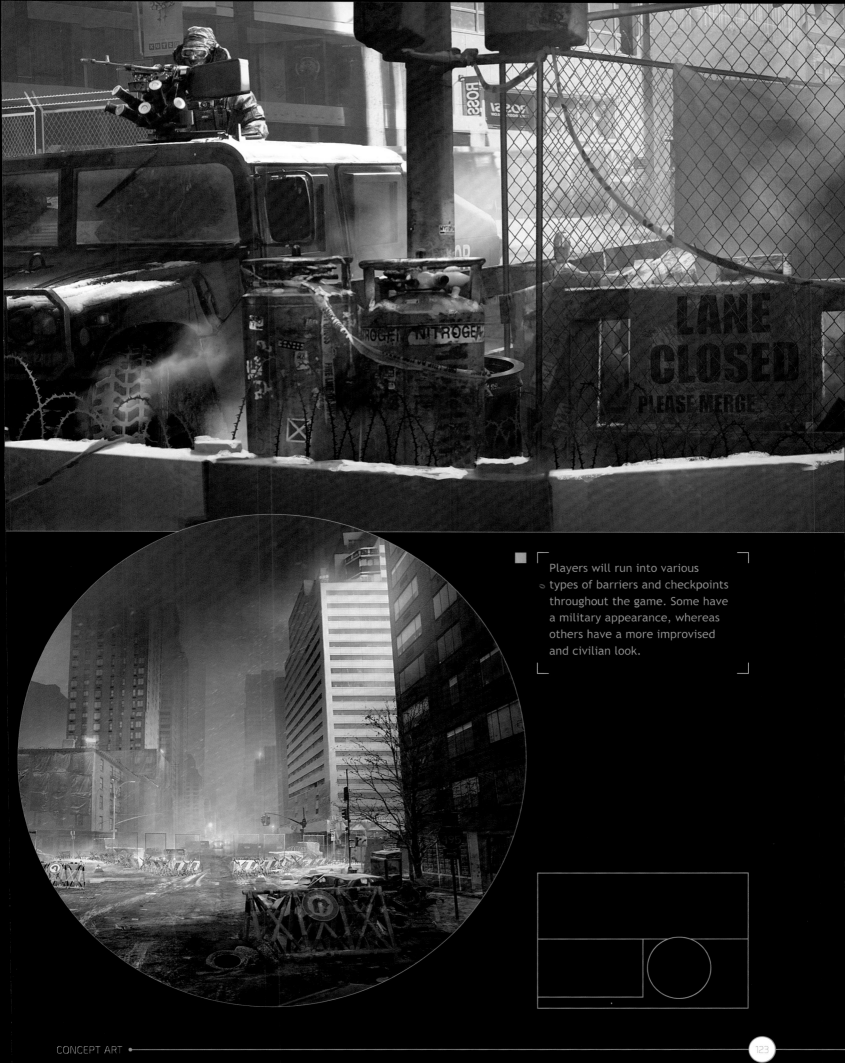

Players will run into various types of barriers and checkpoints throughout the game. Some have a military appearance, whereas others have a more improvised and civilian look.

LANE CLOSED
PLEASE MERGE

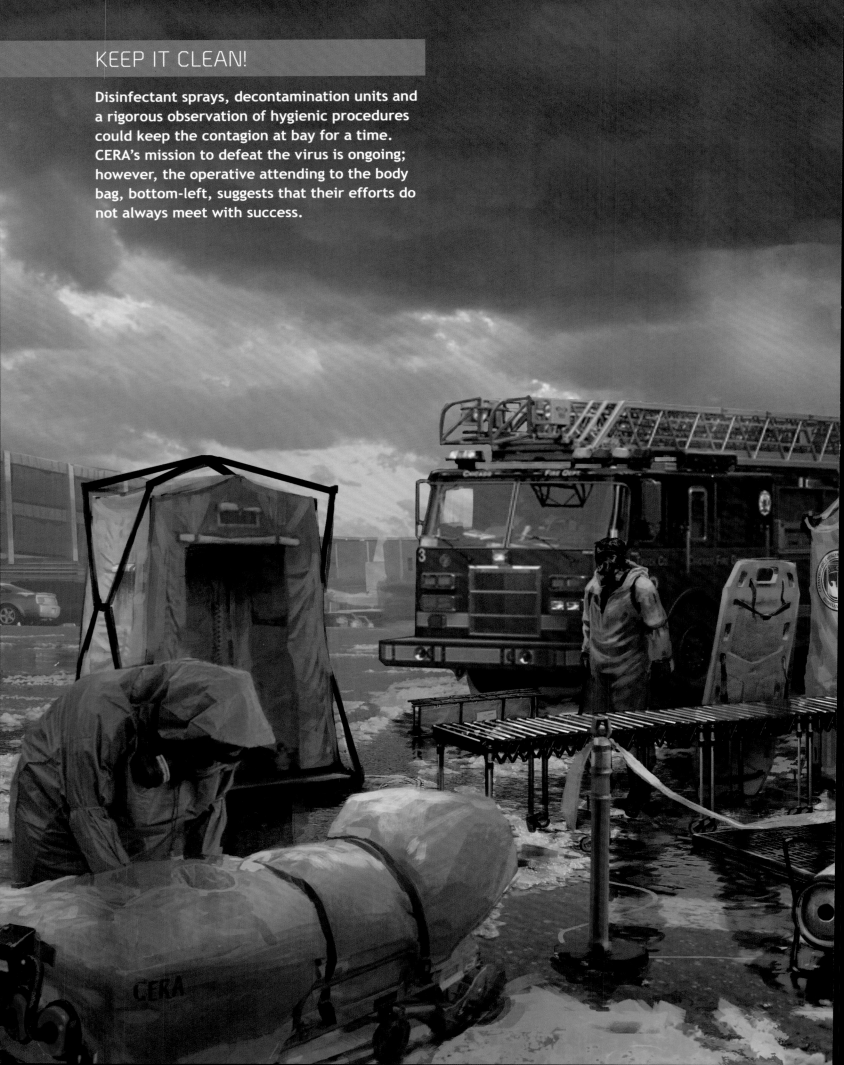

## KEEP IT CLEAN!

Disinfectant sprays, decontamination units and a rigorous observation of hygienic procedures could keep the contagion at bay for a time. CERA's mission to defeat the virus is ongoing; however, the operative attending to the body bag, bottom-left, suggests that their efforts do not always meet with success.

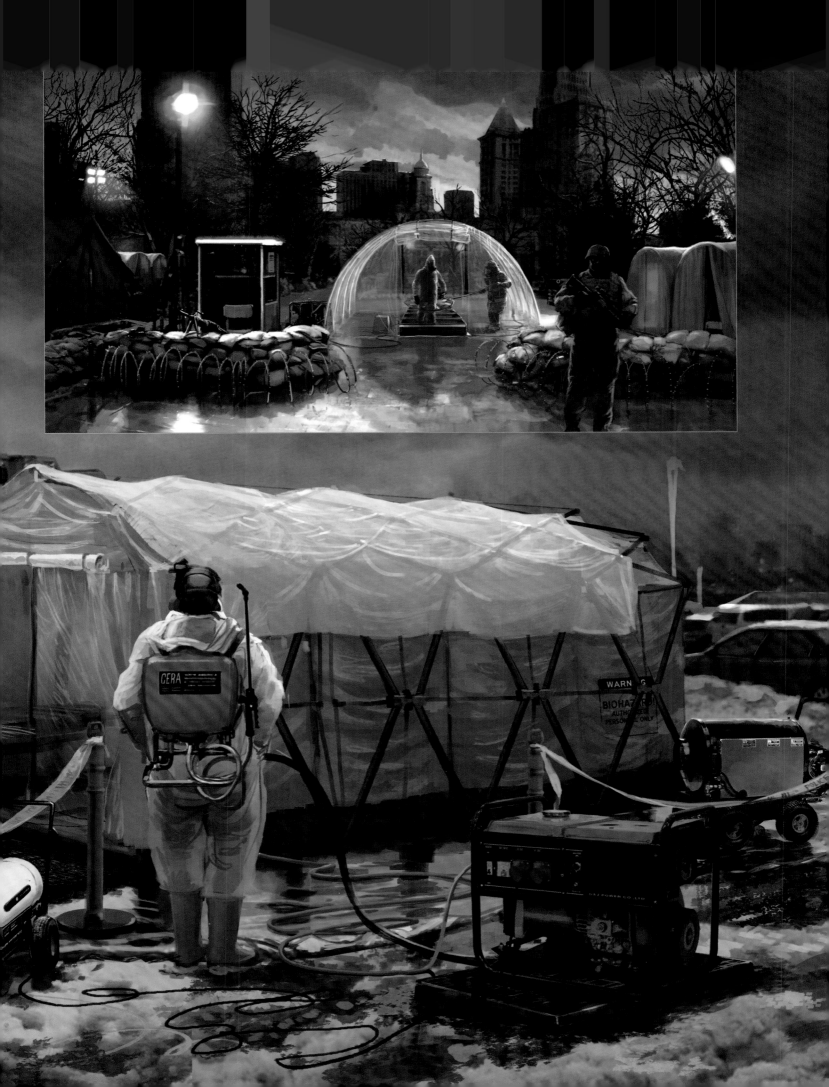

Scenes of disorder and discontent as looters help themselves to whatever they can find in a shopping mall and others make their opinion of CERA known. When creating the interiors, part of the artist brief was that these interiors needed to show the state of the world. There should always be elements of looting, scavenging and desperation. There is a lot of storytelling potential in the way these environments are designed.

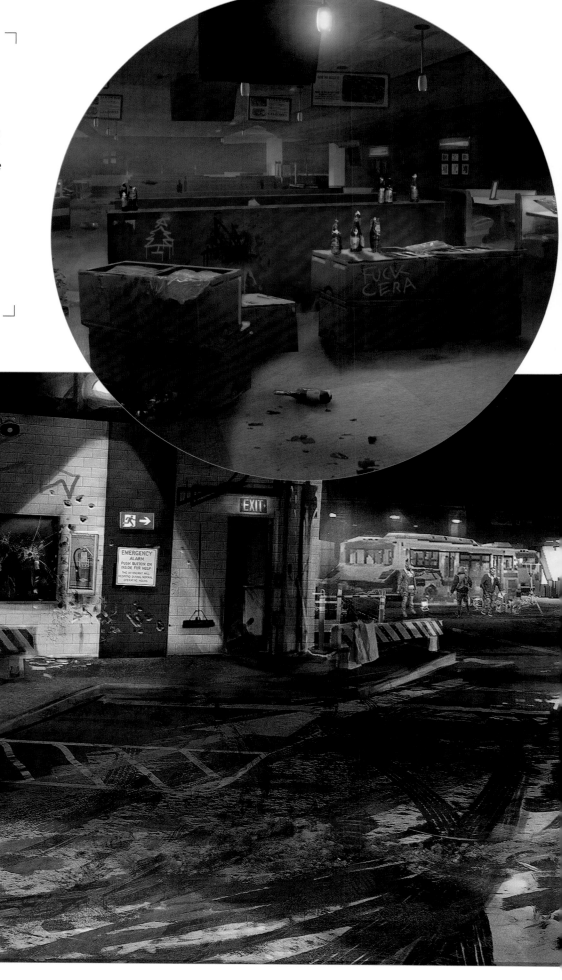

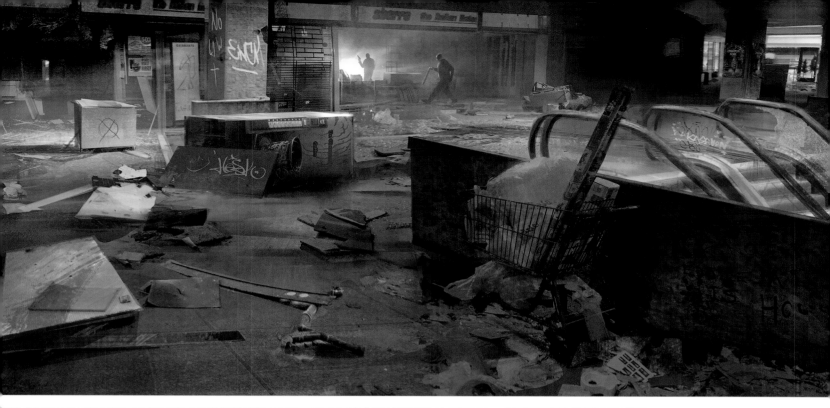

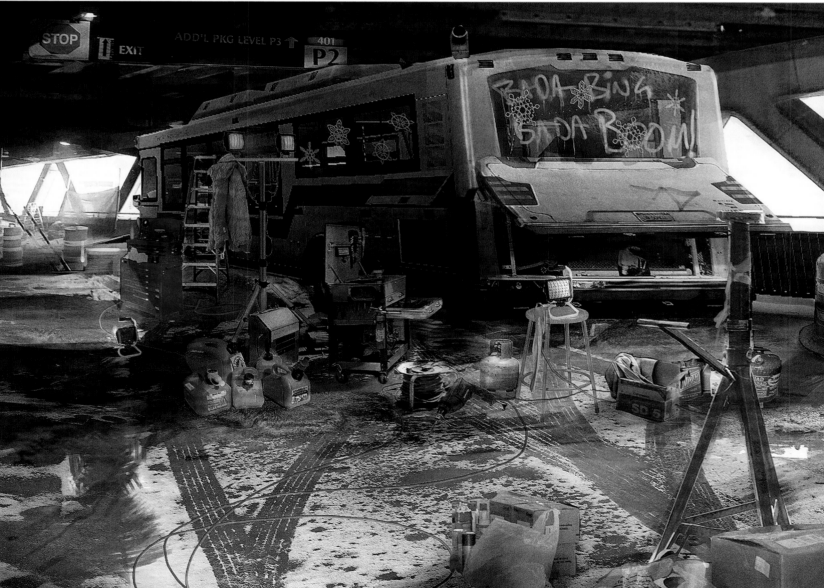

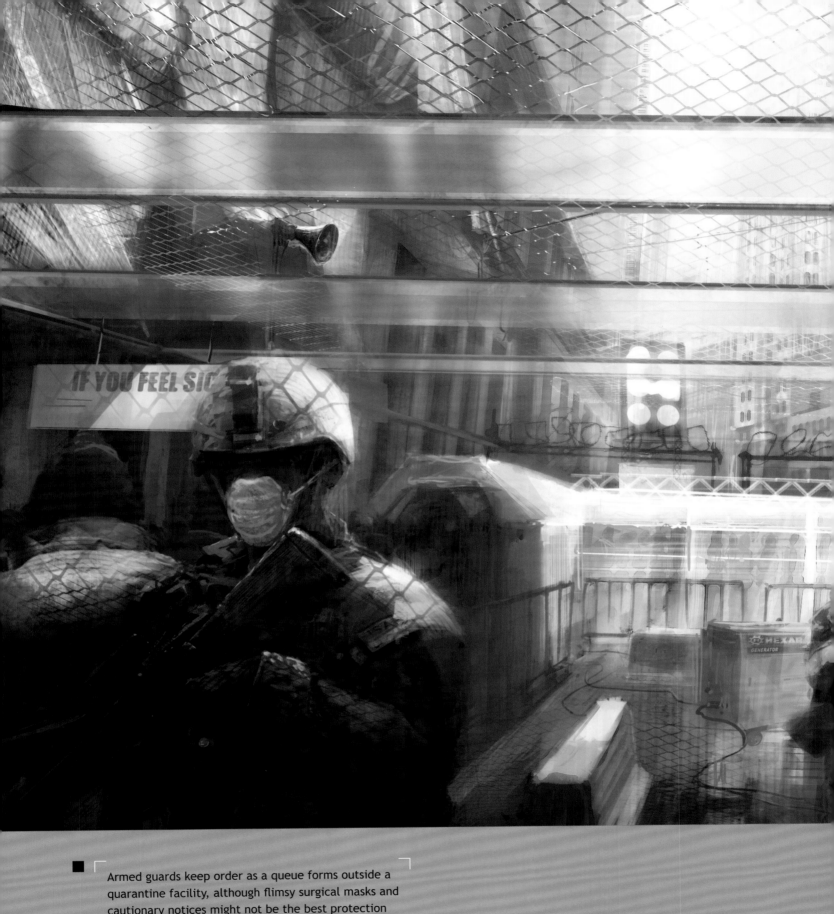

Armed guards keep order as a queue forms outside a quarantine facility, although flimsy surgical masks and cautionary notices might not be the best protection against the infection. The setting is after the major pandemic has hit, so the whole city is a quarantine zone. Obviously some areas will be more affected than others, including the Dark Zone.

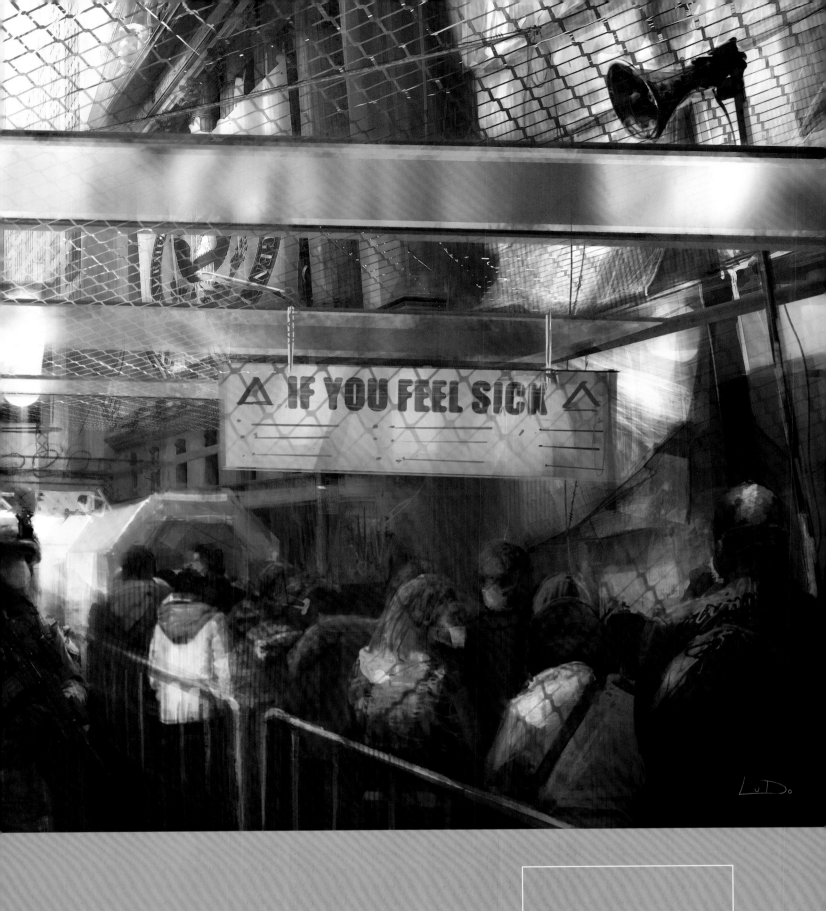

IF YOU FEEL SICK

LuDo.

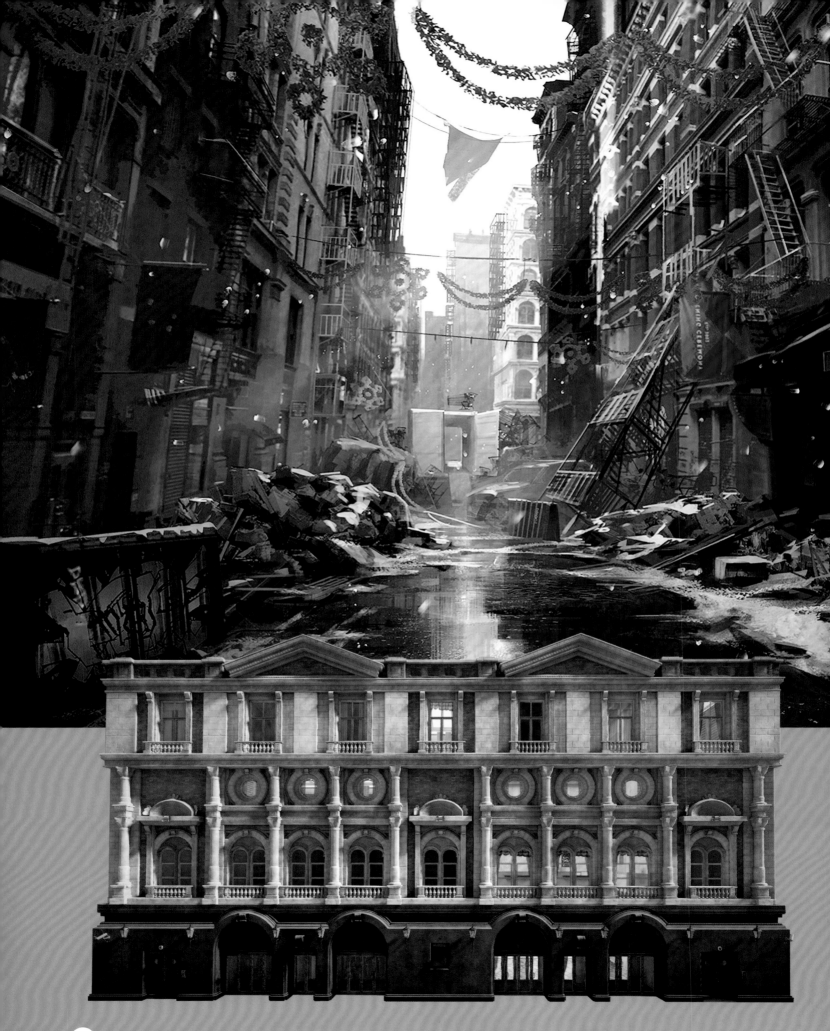

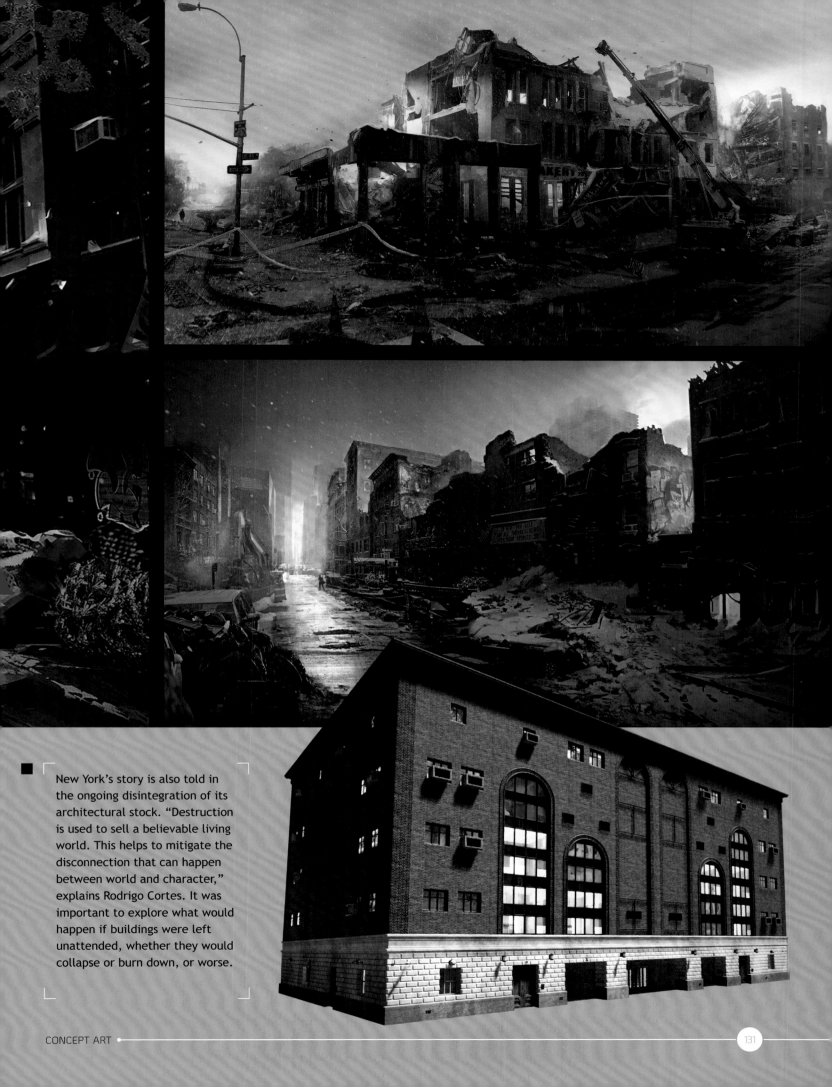

New York's story is also told in the ongoing disintegration of its architectural stock. "Destruction is used to sell a believable living world. This helps to mitigate the disconnection that can happen between world and character," explains Rodrigo Cortes. It was important to explore what would happen if buildings were left unattended, whether they would collapse or burn down, or worse.

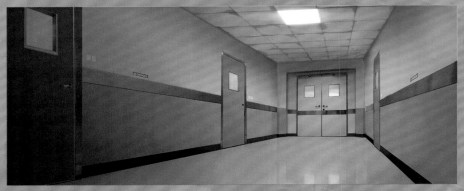

Depicting the disarray can be a tricky process, as Tom Garden explains: "Sometimes it was easiest to think about the basic state of an area, and then carefully push it into the correct look for our setting. It's easy to take it too far into post-apocalypse."

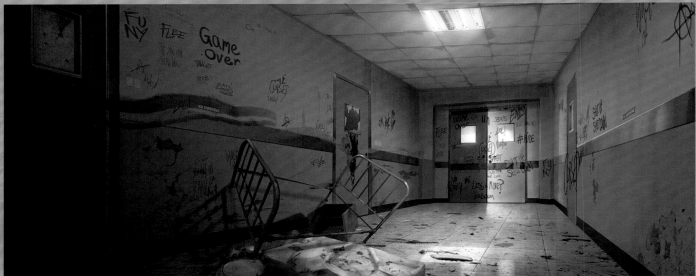

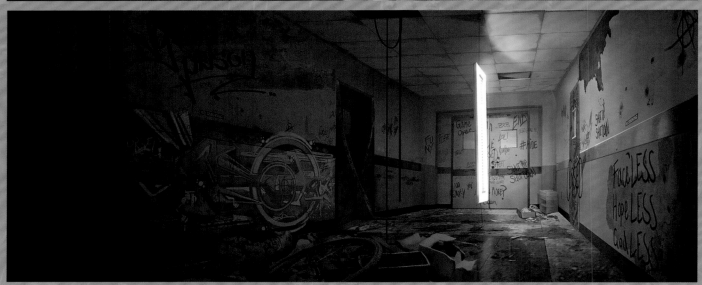

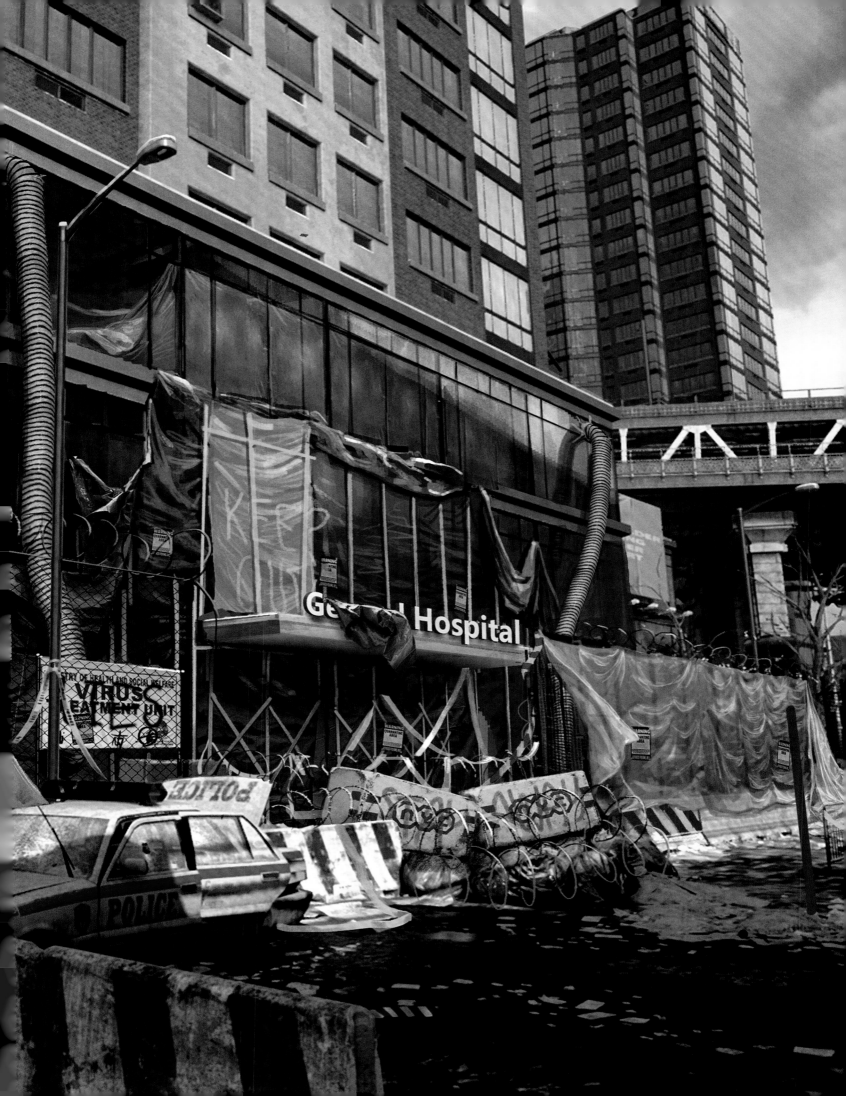

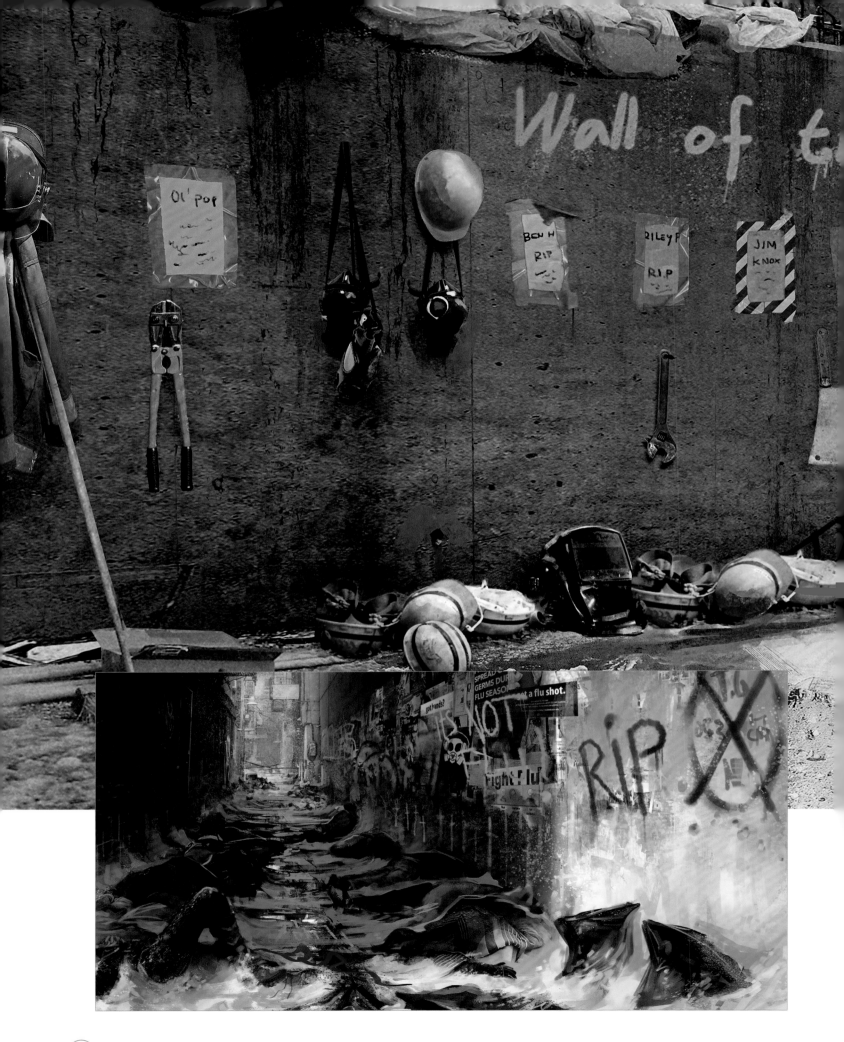

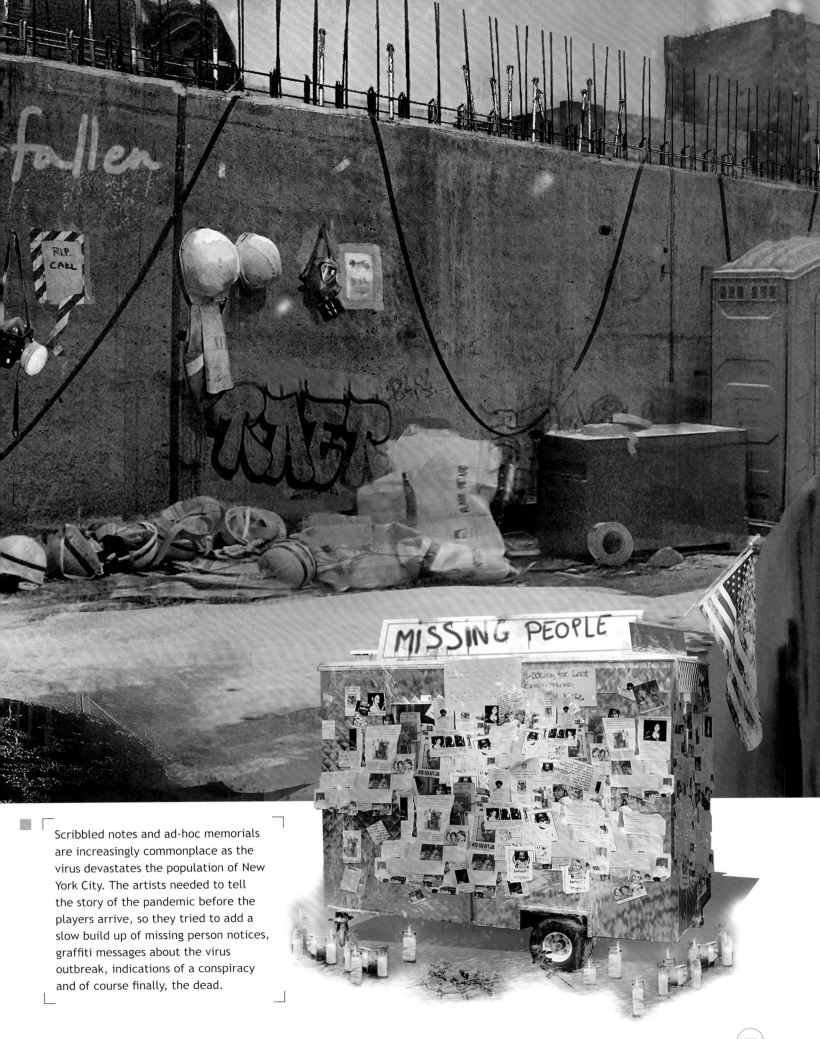

Scribbled notes and ad-hoc memorials are increasingly commonplace as the virus devastates the population of New York City. The artists needed to tell the story of the pandemic before the players arrive, so they tried to add a slow build up of missing person notices, graffiti messages about the virus outbreak, indications of a conspiracy and of course finally, the dead.

CONCEPT ART

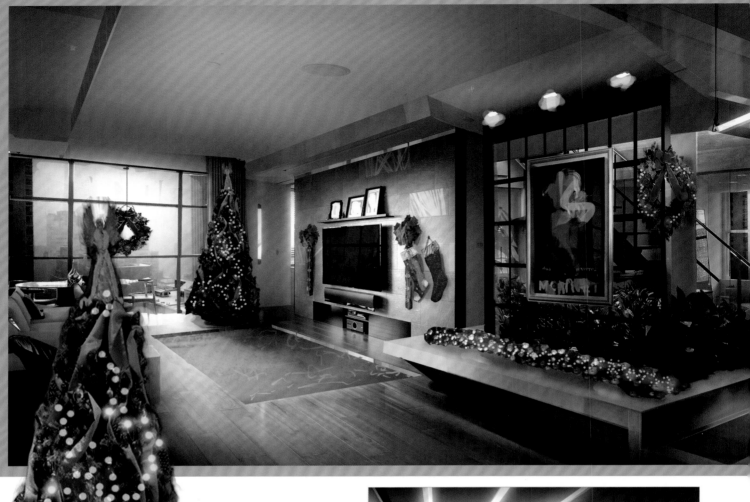

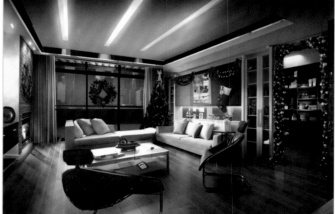

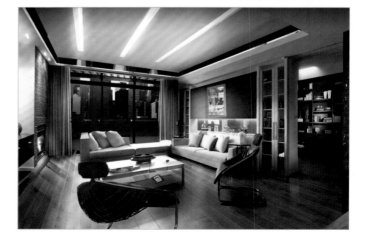

Before and after scenes, as the contagion and prevailing weather reduce New York apartments to snow-blown hovels. The virus kills irrespective of privilege or location. "There will be many interiors in the game, and we wanted to represent different types of homes within a similar template," says Tom Garden. "We experimented with the amount of Christmas decorations and how looted or abandoned they should feel."

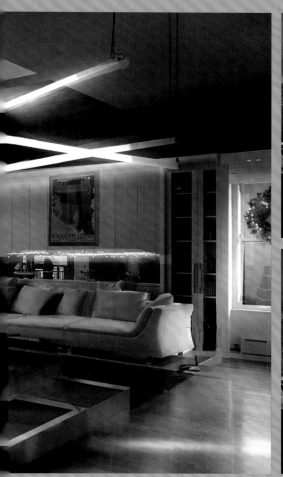
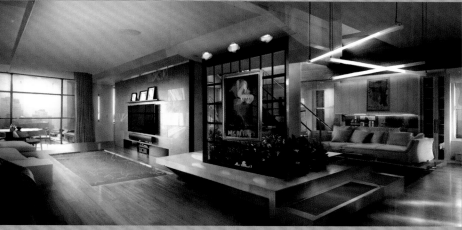
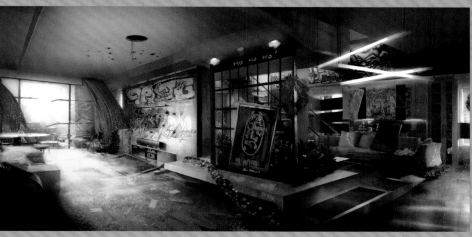
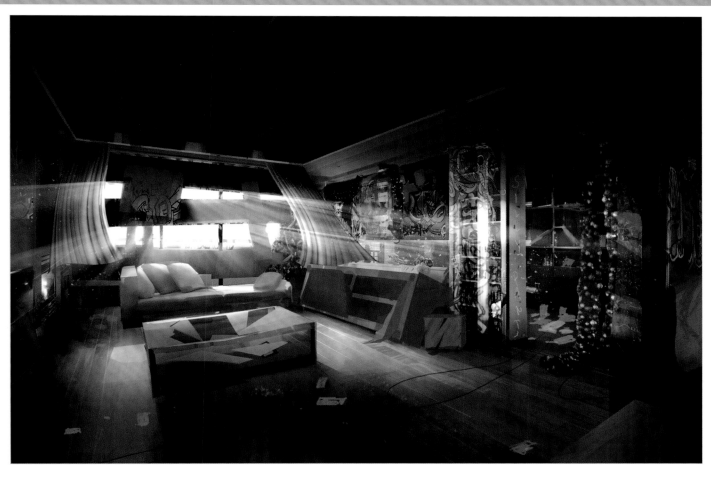

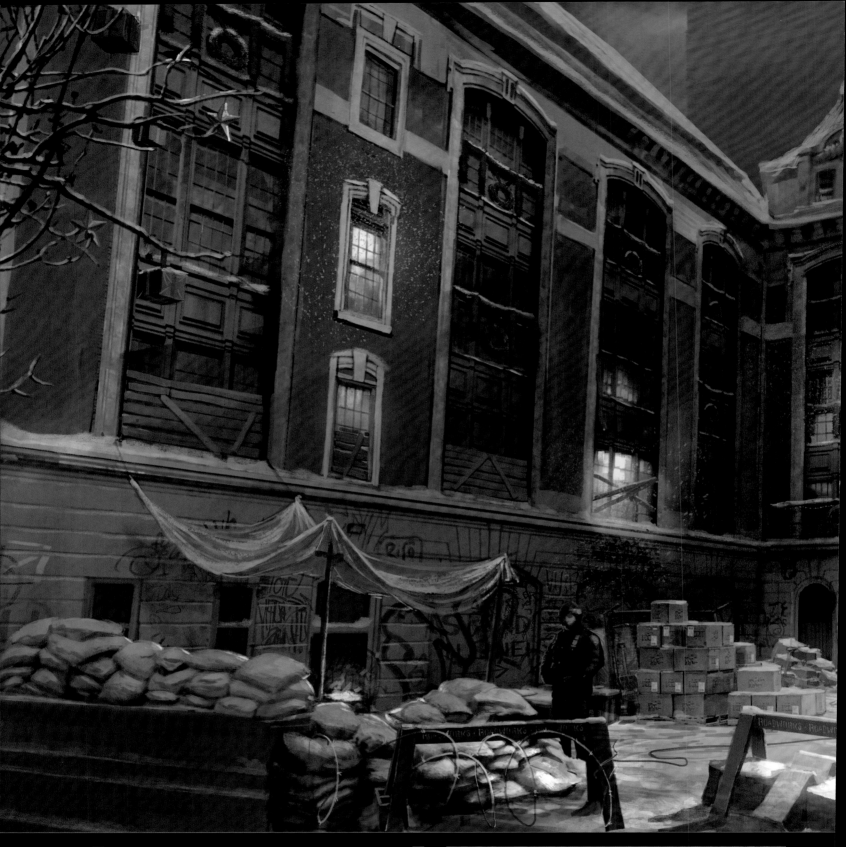

The Joint Task Force (JTF) has been trying to keep the infrastructure afloat in the city. Here the artists tried some visual variations for how the player might see that on a building, varying from a fully functional operation to a rundown abandoned place where only a few remnants of their presence remain.

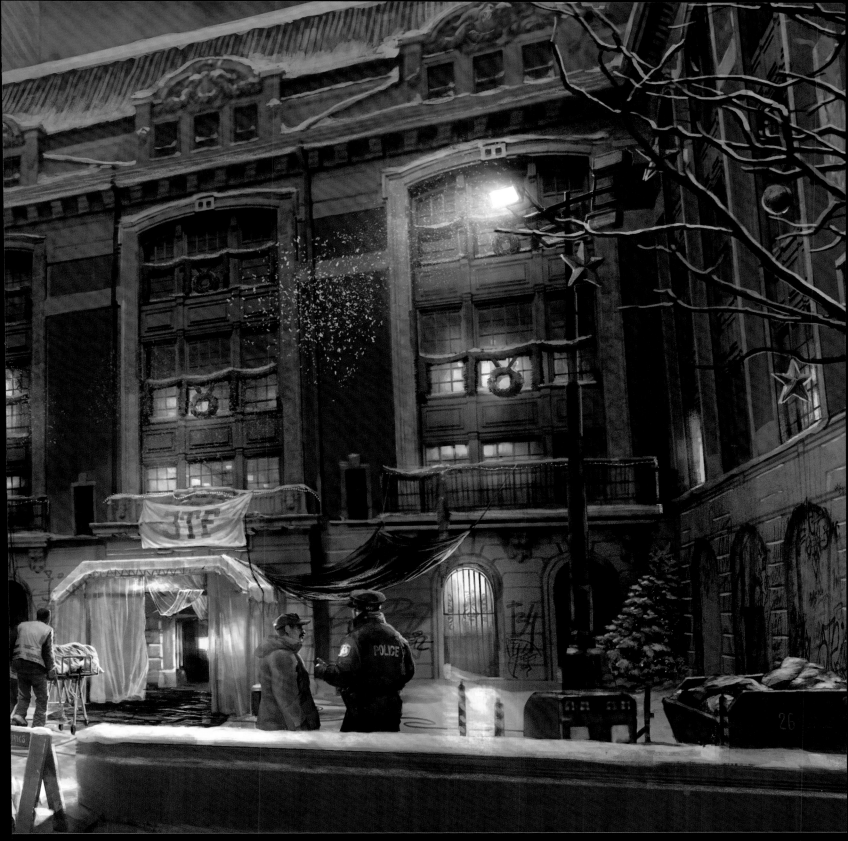

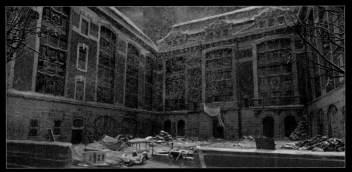

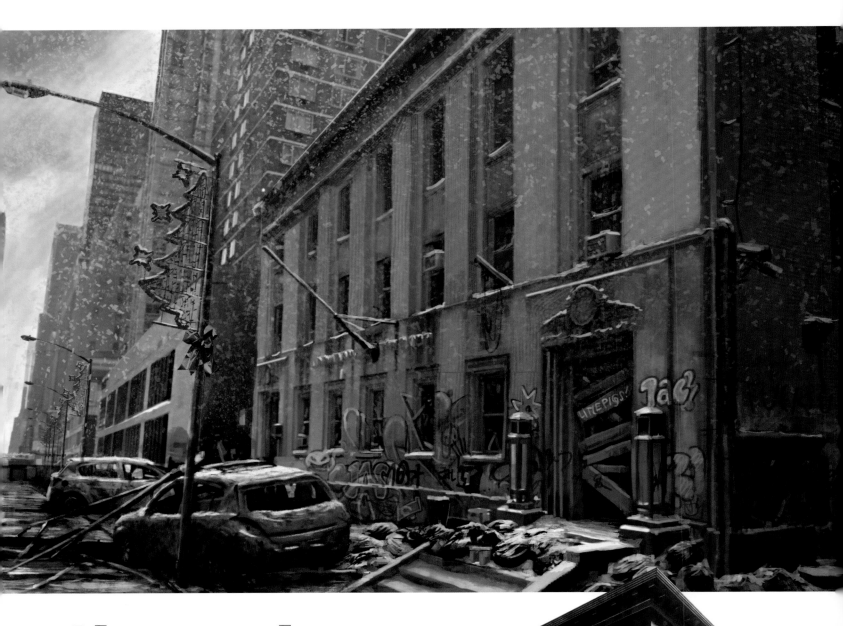

Graffiti stains this boarded-up police station. The ragged scarecrow strung up in the alley would appear to mock the city's once proud protectors. The Massive team expected a lot of people would have barricaded their homes, either by choice or even by the government, sealing off blocks to contain the contaminated.

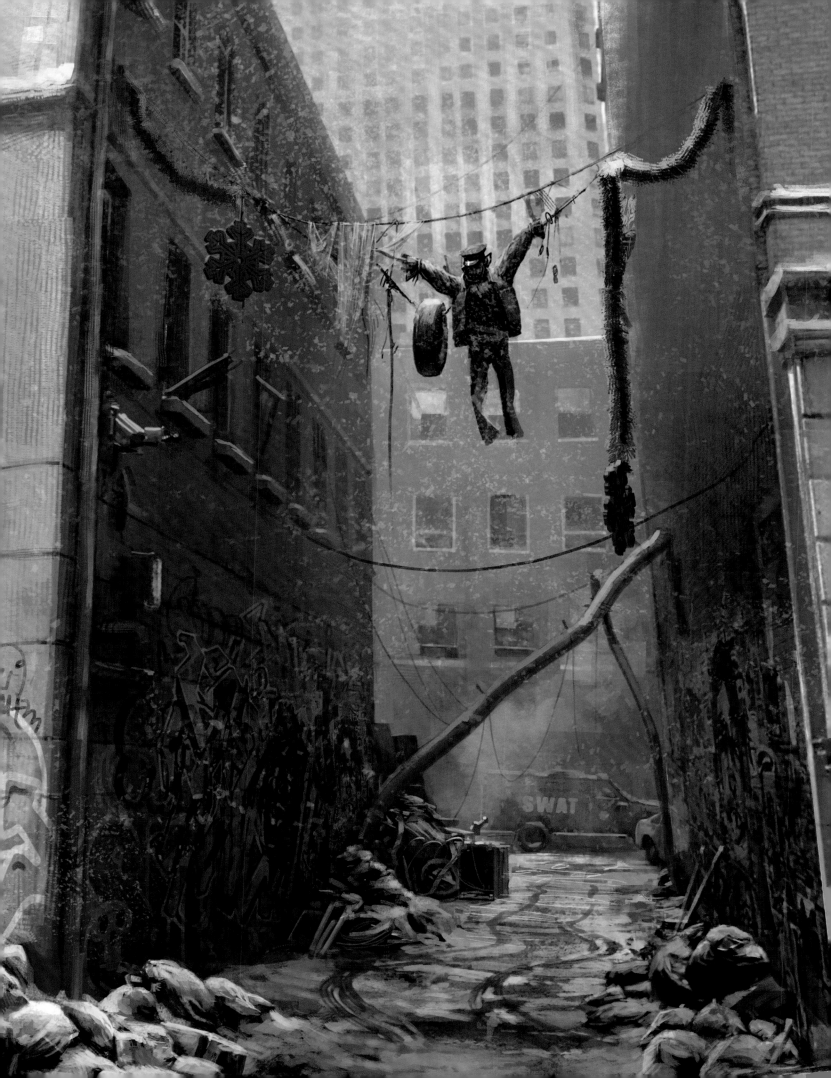

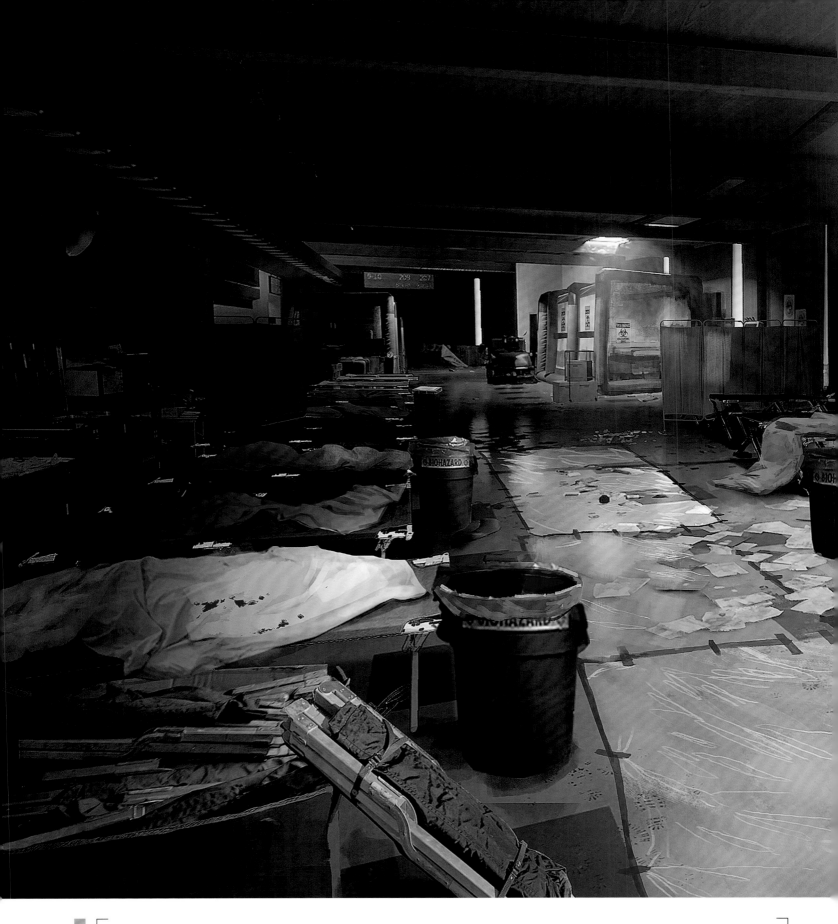

This morbid scene indicates the continuing horror of the outbreak, as the hospitals overflow faster than the efforts to contain the virus. "Makeshift hospitals would pop up in a situation like this. We wanted to get that feeling into the game so we designed some for the world. They need to look functional but also tell the story of the world," says Tom Garden.

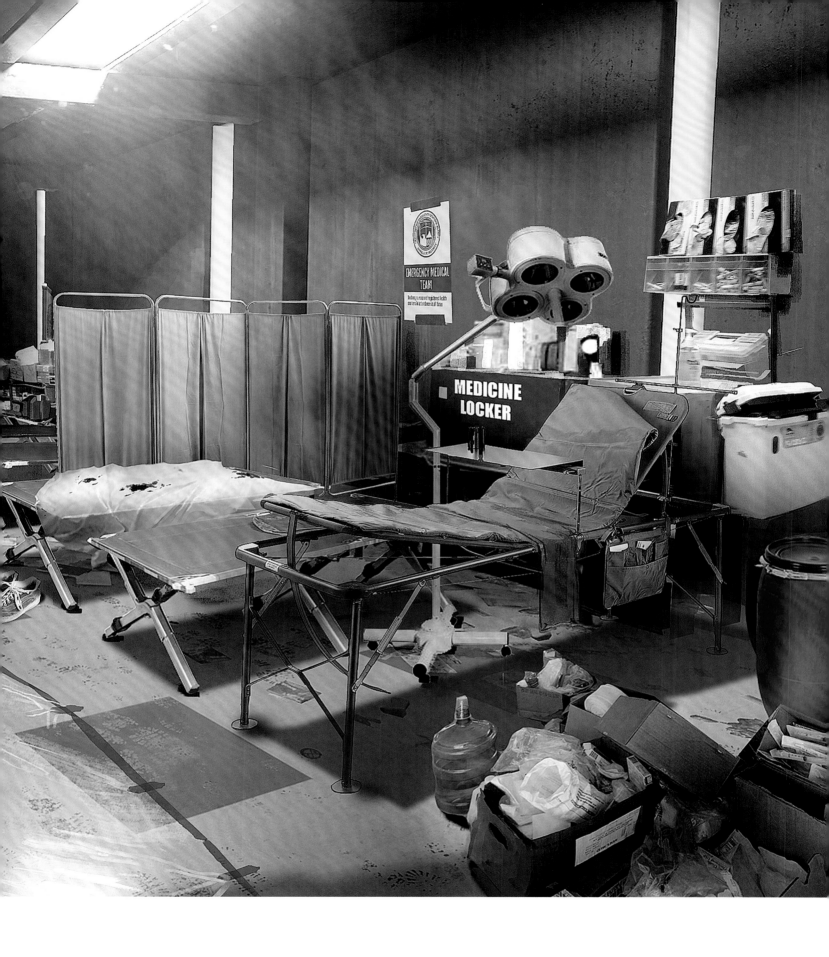

# BELLEVUE

The foreboding edifice of Bellevue Hospital is rendered even more austere in the winter snows. Angels at the gates seem to weep for the patients within, although an ECHO from the now empty chapel suggests that some lasted at least 13 days from the outbreak. The hospital is noted for its pioneering work in maternity, sanitation, tuberculosis and heart surgery. It is pity, then, that such an august institution was unable to withstand the ravages of the Black Friday contagion.

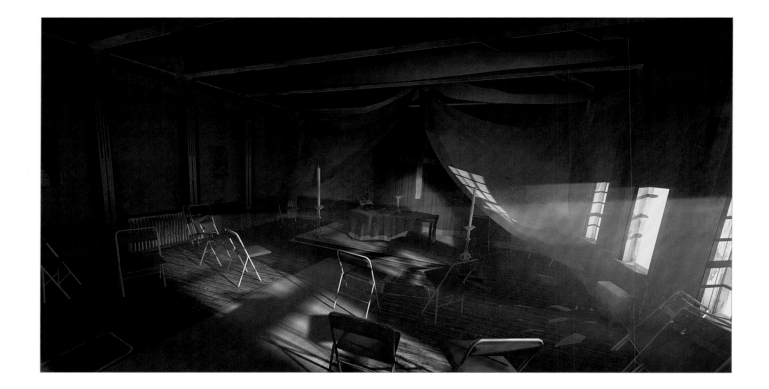

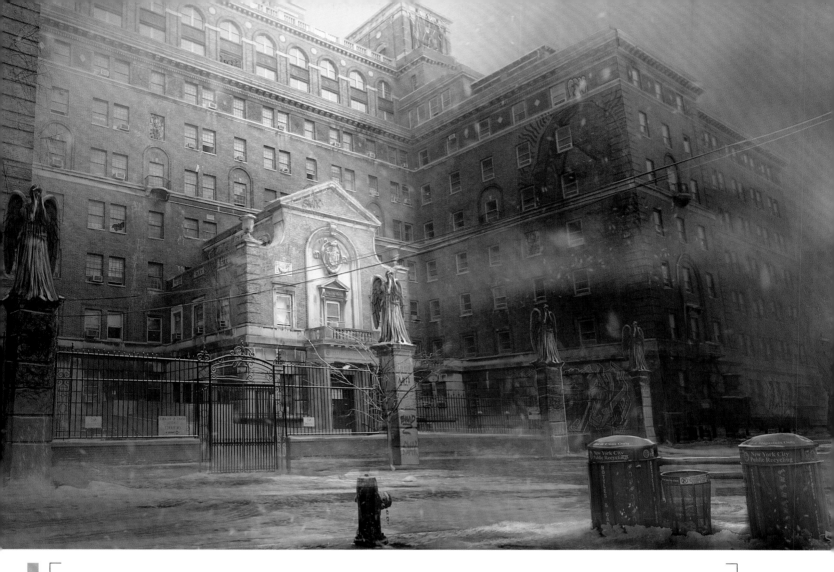

The Bellevue chapel is bereft of its congregation for the time being, although recent events are replayed and a grim calendar counts the passage of time since the virus struck.

In some events the team also placed ECHO sequences that help to tell the story of what happened before.

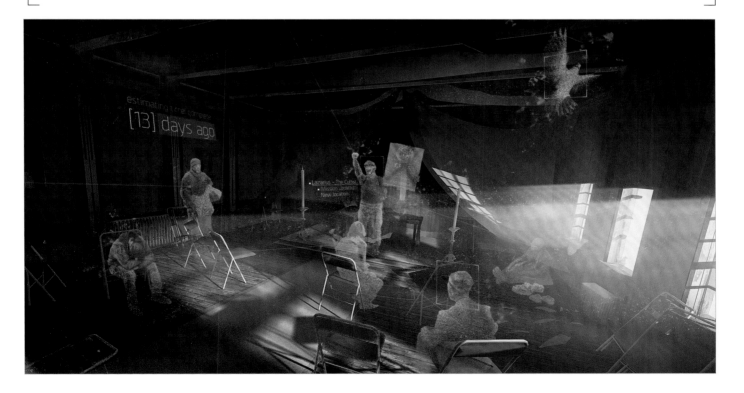

# UNDERGROUND

New York's sewers and Subways connect the city at a subterranean level. Signs above ground declare that many tunnels are off-limits to the general public, although the abandoned suitcase on this page indicates that some have already decided to ignore the official advice.

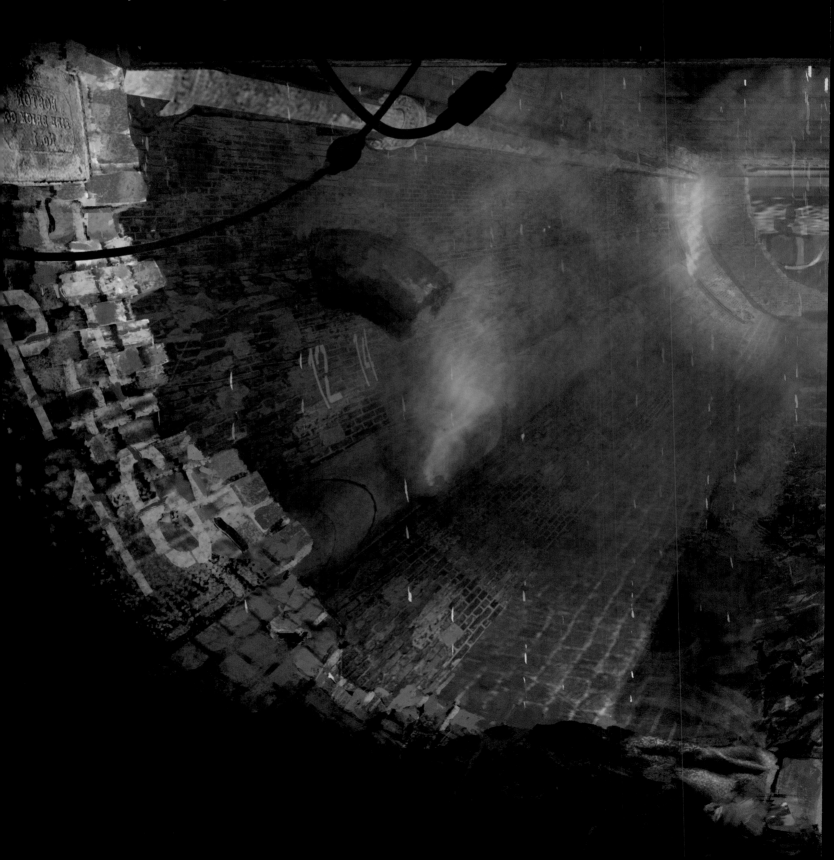

Some areas in the game will take place underground, either on a mission, or discovering a safe house or passageway under the streets. The artists tried to represent the different types of underground that can be found in New York. Tom Garden explains, "For each type we tried to keep the shape, language and style distinct so players would know if they were heading into subways or sewers."

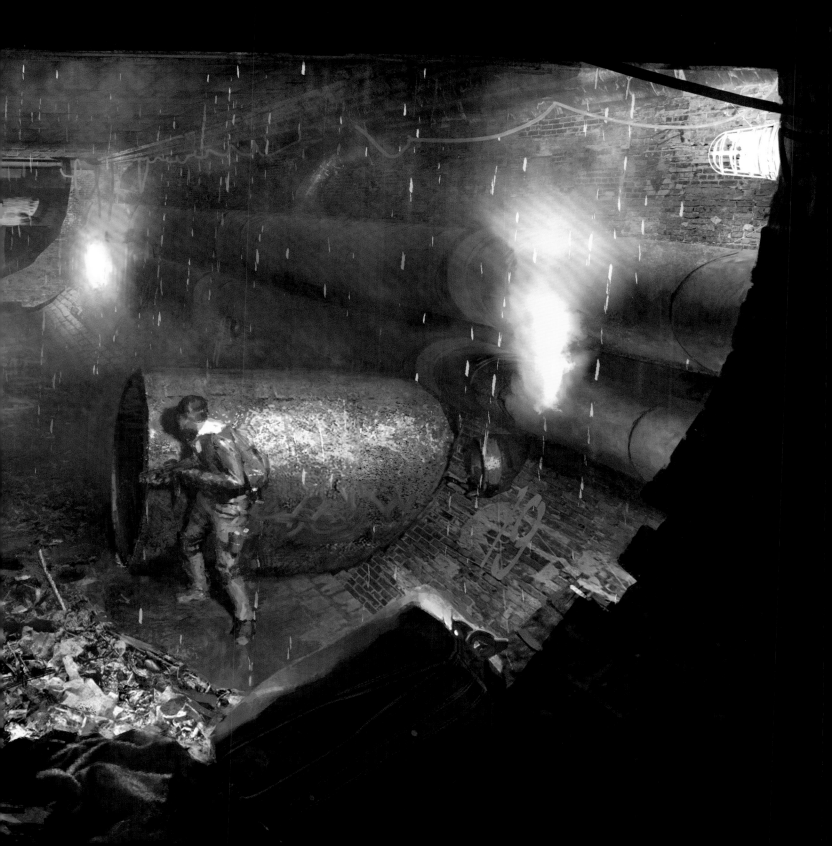

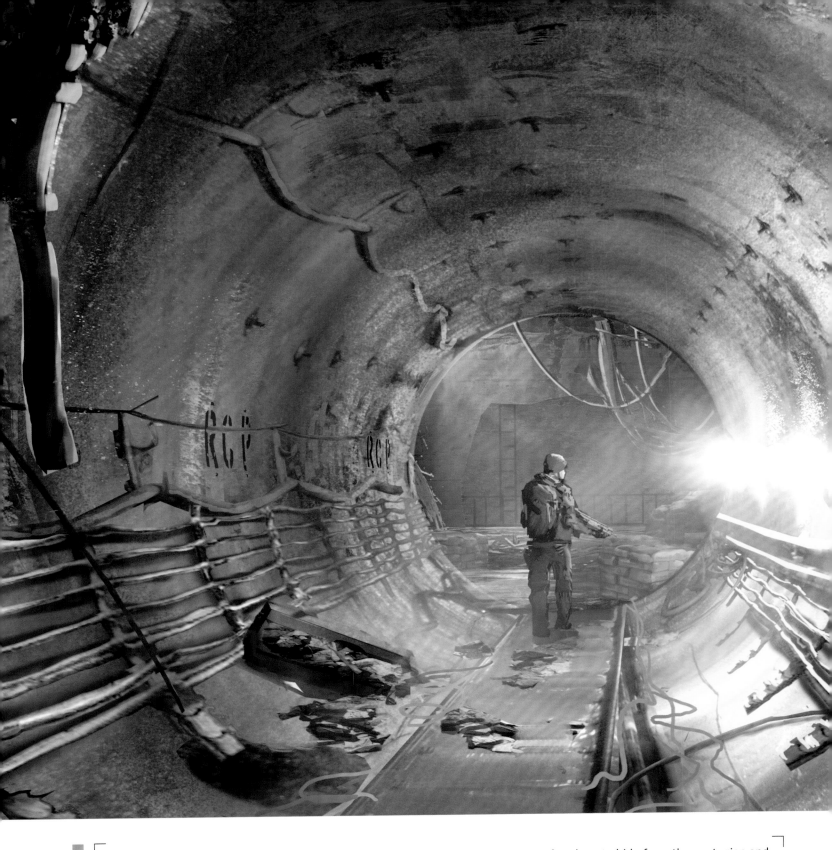

The low sandbag wall suggests that a family or faction has attempted to use this tunnel as a reinforced base. The clothing strewn around the floor could be the results of a recent raid or signs of the former occupants leaving in a hurry. Whatever the case, New York's subways and tunnels add a further dimension to The Division gameplay, as well as providing a much needed refuge from the freezing weather conditions at the surface. That is not to suppose

that they are a safer place to hide from the contagion and the chaos, of course. "We wanted to make the city feel like a living and breathing colossus," says Tom Garden. "Above ground we have wind blowing tarps on scaffolding and steam blowing up through the vents. But beneath the streets we have the opportunity to represent the metaphorical veins and airways of the city."

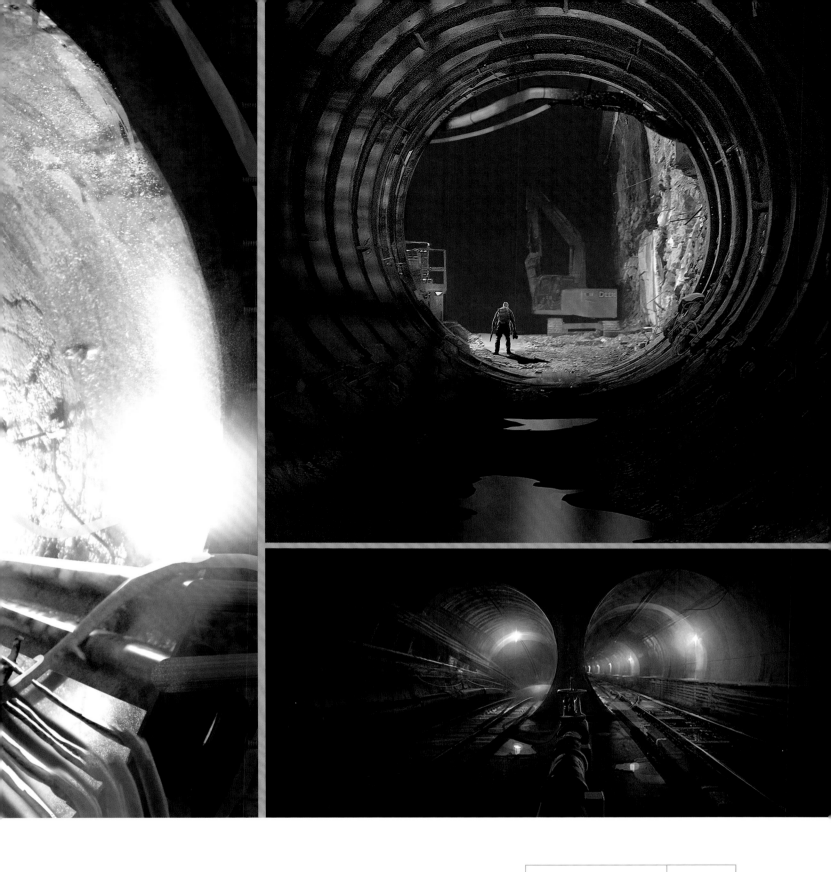
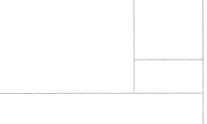

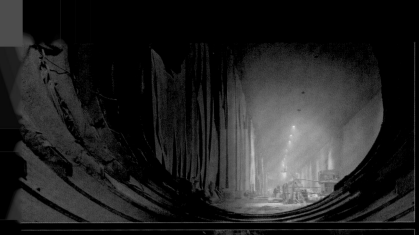

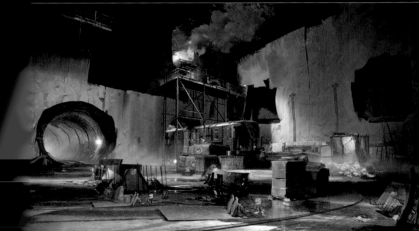

While some tunnels are already designated for transport or effluent, others are still in the midst of completion. With workforces absent or deceased, these subterranean spaces offer a wealth of possibilities. The Passway project mission provided a great space for some epic underground interiors. Underground locations become more of a blank canvas for the art team to play with visually.

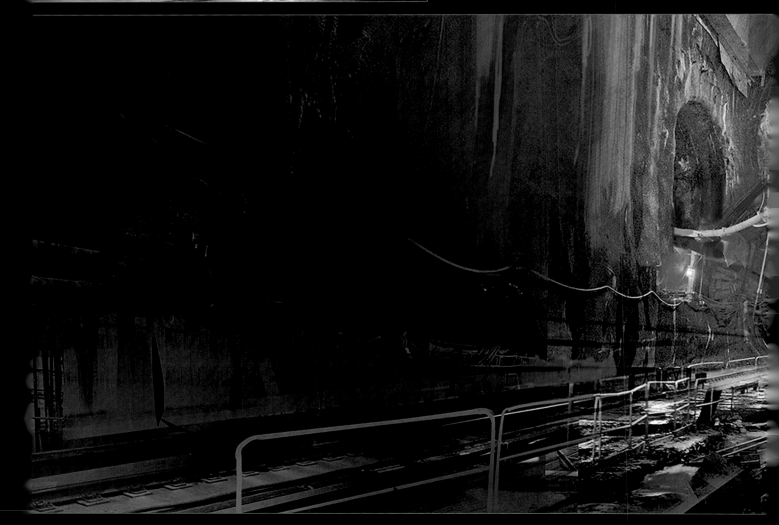

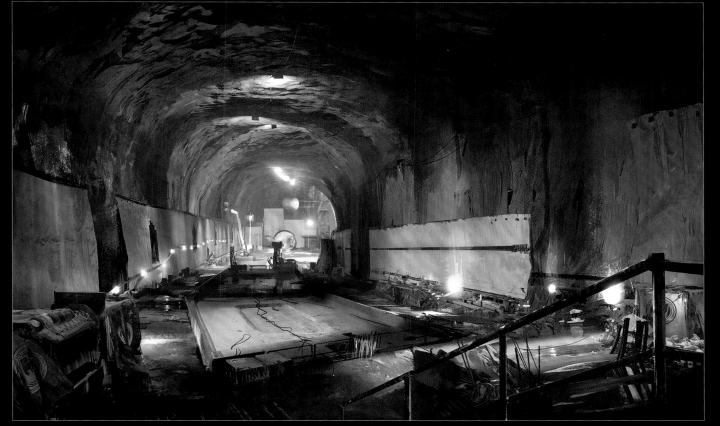
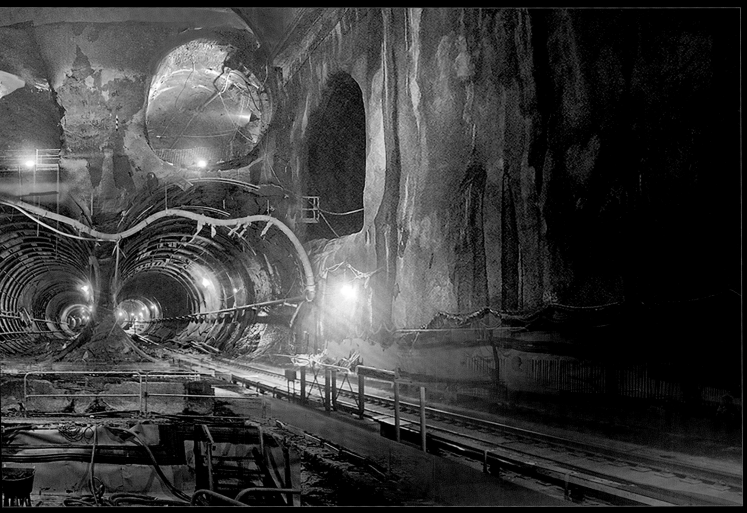

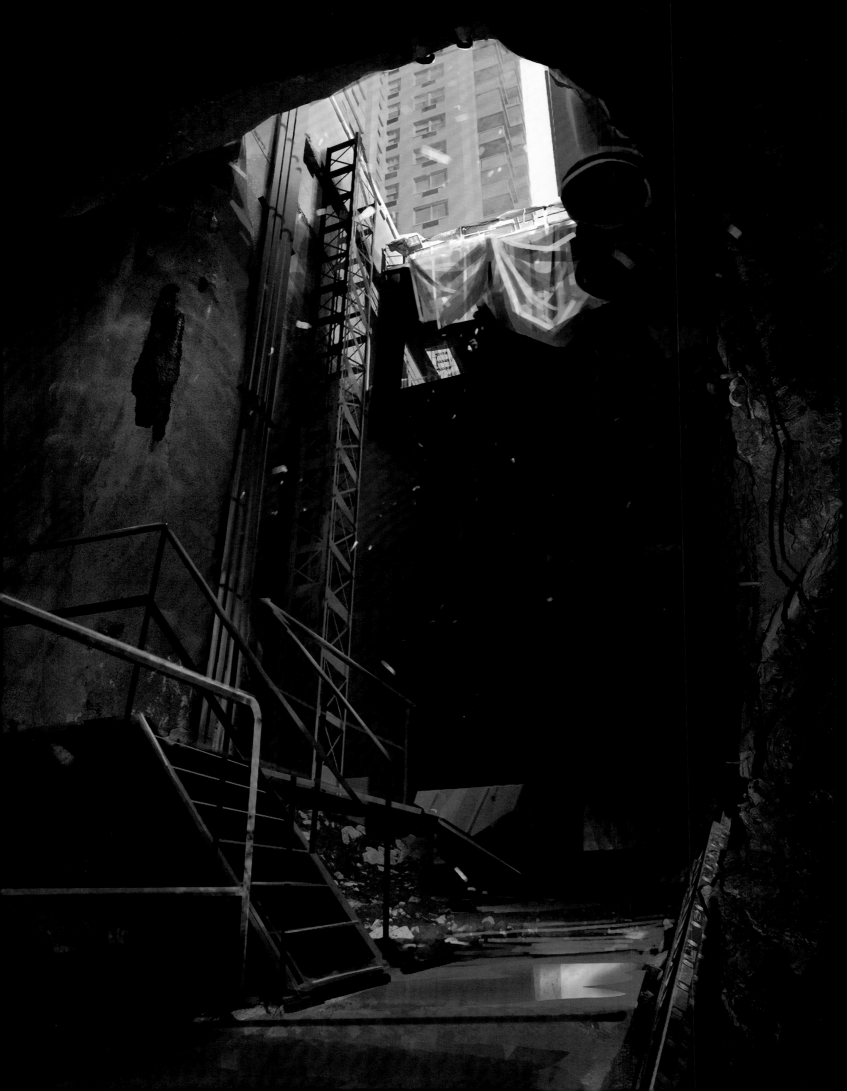

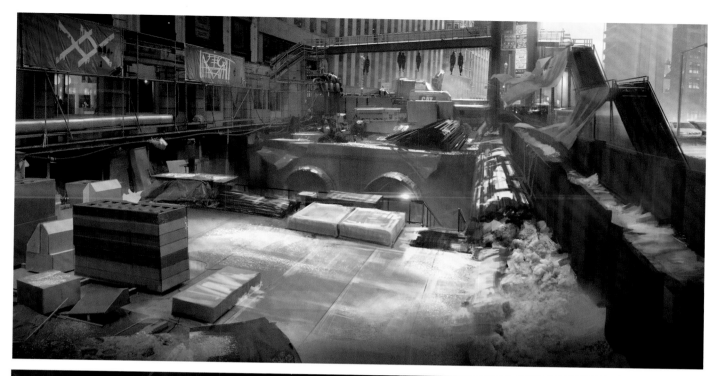

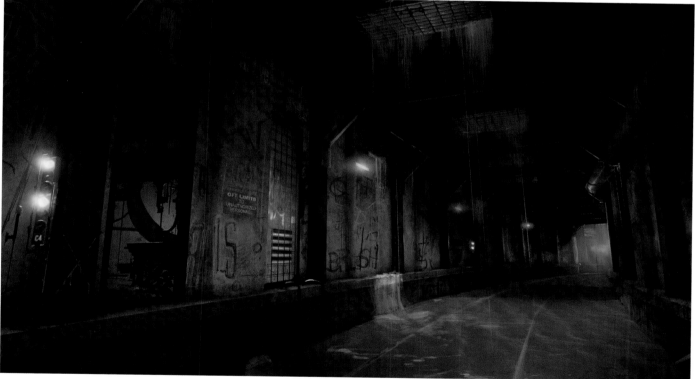

The gloomy depths are brightened with a shaft of daylight and a glimpse of a tall building. In such a way this single image conveys the full highs and lows of The Division gameplay. Vertical structures are synonymous with New York, so the art team worked to establish a nice contrast to this by adding verticality downwards into the earth with the underground locations.

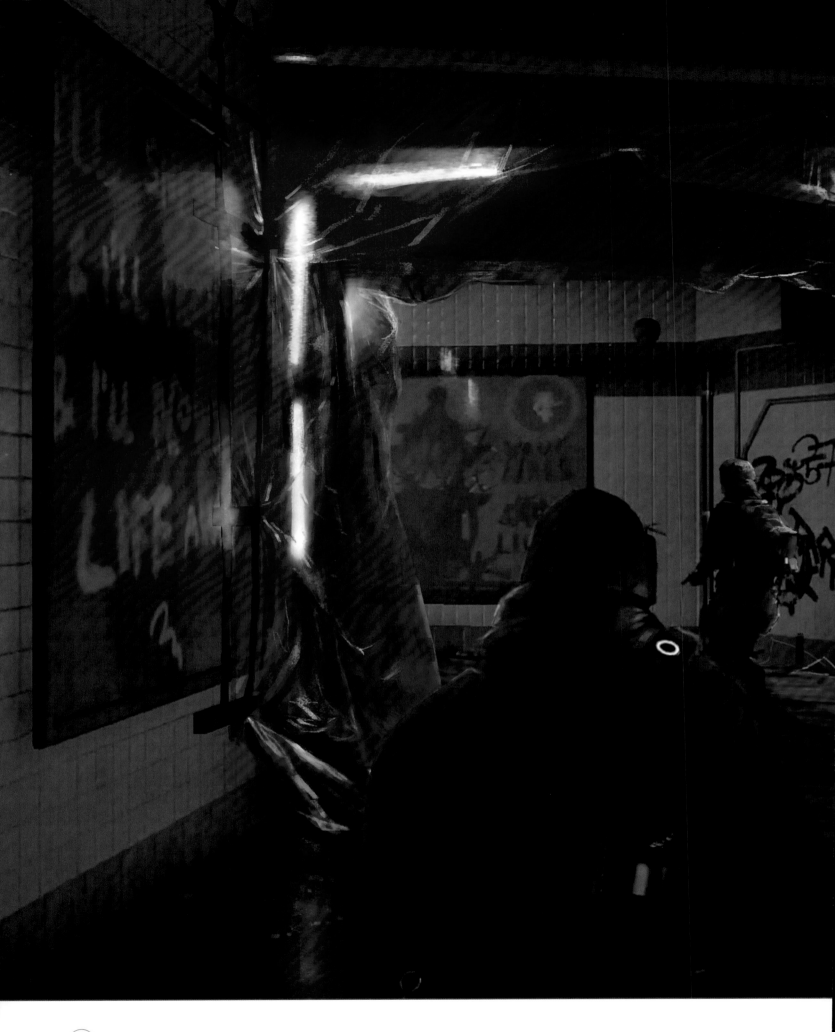

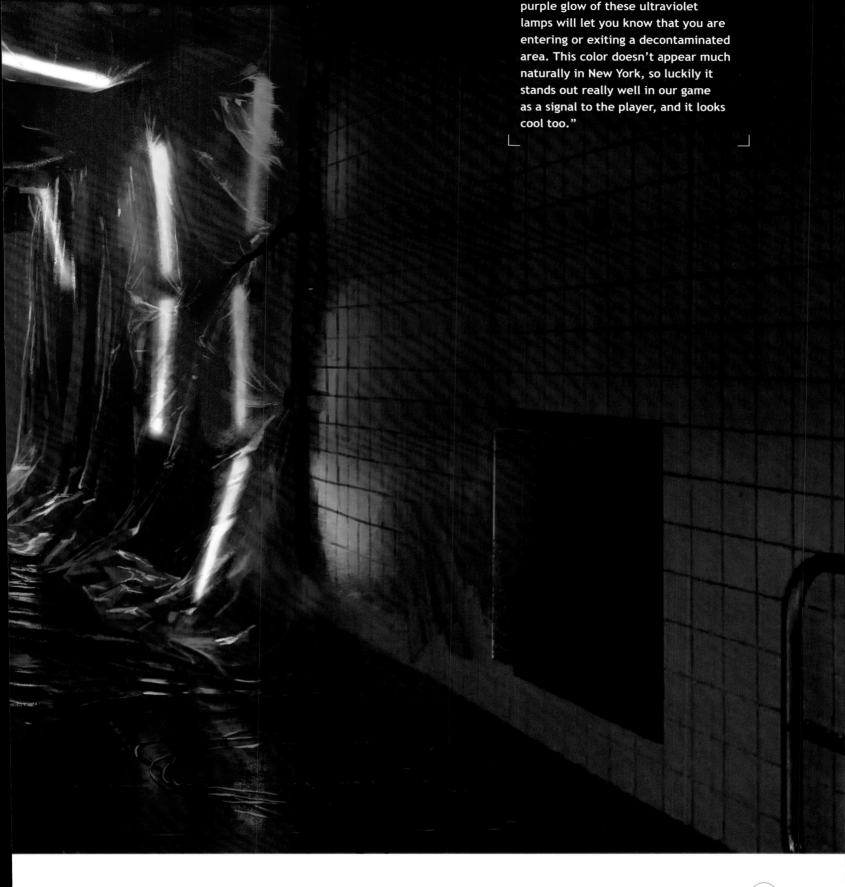

purple glow of these ultraviolet lamps will let you know that you are entering or exiting a decontaminated area. This color doesn't appear much naturally in New York, so luckily it stands out really well in our game as a signal to the player, and it looks cool too."

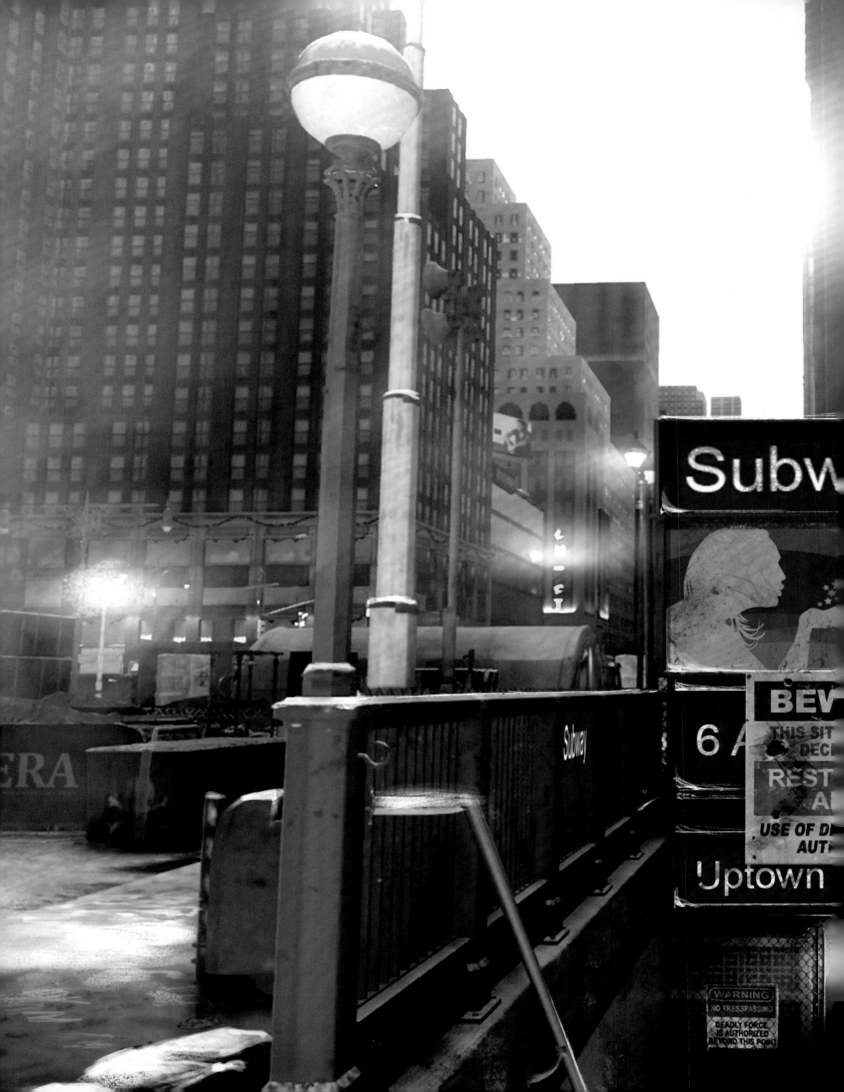

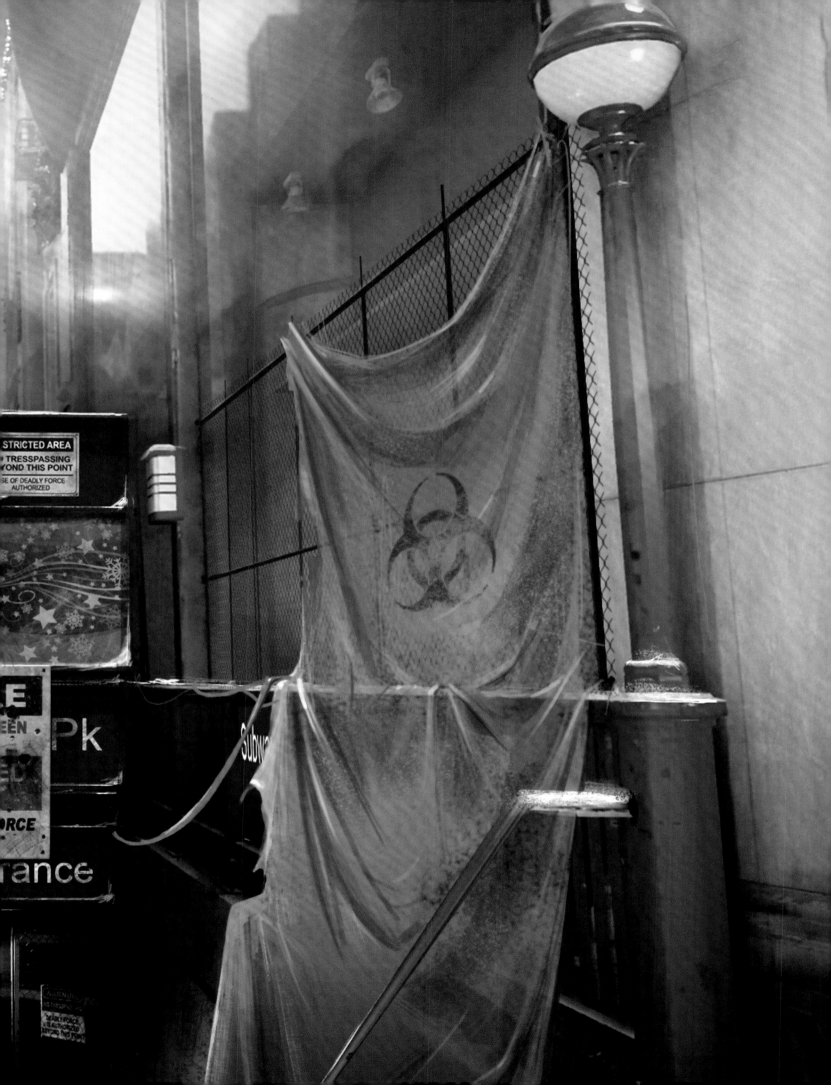

## THE SUBWAY

The New York Subway was once a lifeline of the city, but is now strangled and silent. Its carriages have long provided the canvas for aspiring graffiti writers. More recently, they have doubled as provisional accommodations. The subways of New York are famous worldwide and it was essential for the team to capture that essence within the world.

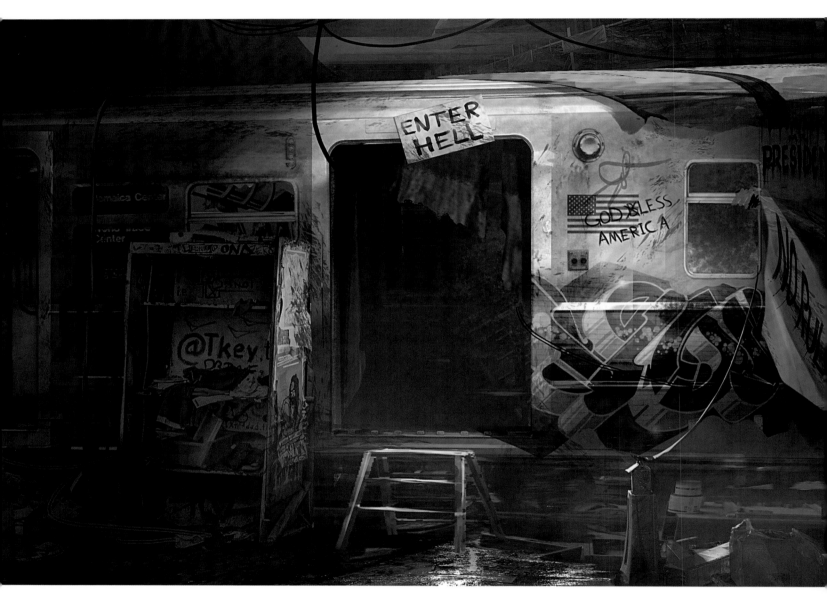

The Subway has become an unholy mess since Black Friday. Its tracks and platforms are strewn with the detritus of those seeking to flee the contagion, but at least the rolling stock has been put to some practical use. Carriage residents are doubtless glad of the refuge the Subway provides, even if the greeting above indicates otherwise. Elsewhere, the Subway retains much of its former character, with colourful graffiti now even more prevalent a decoration for its walls. Much of it pre-dates the viral outbreak, but look closer to find messages that reflect the helplessness that is felt. The artists wanted to tell different stories with the subway. It is at once a place that would see a lot of people passing through, who are trying to escape Manhattan Island, but at the same time, it is also a great place for shelter amongst the empty trains and stations.

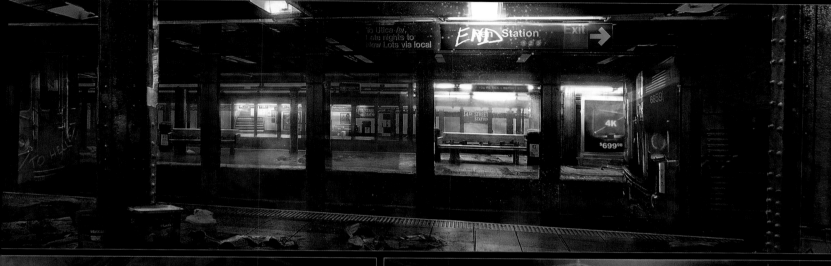

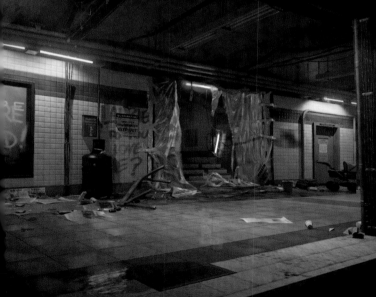

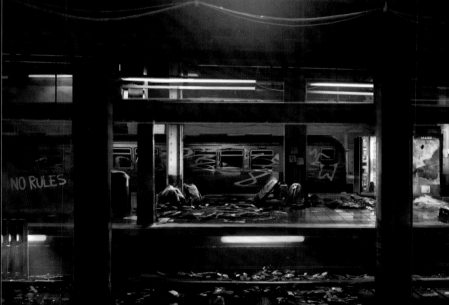

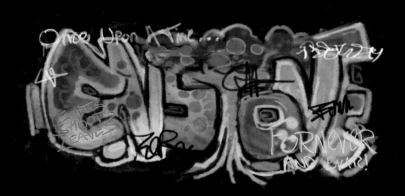

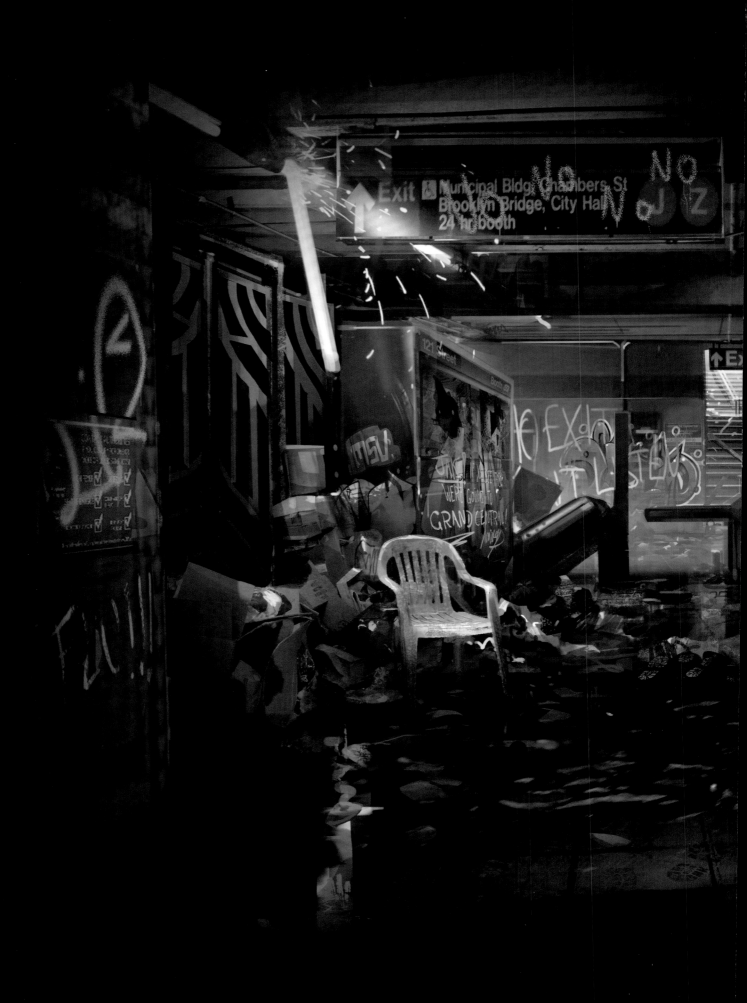

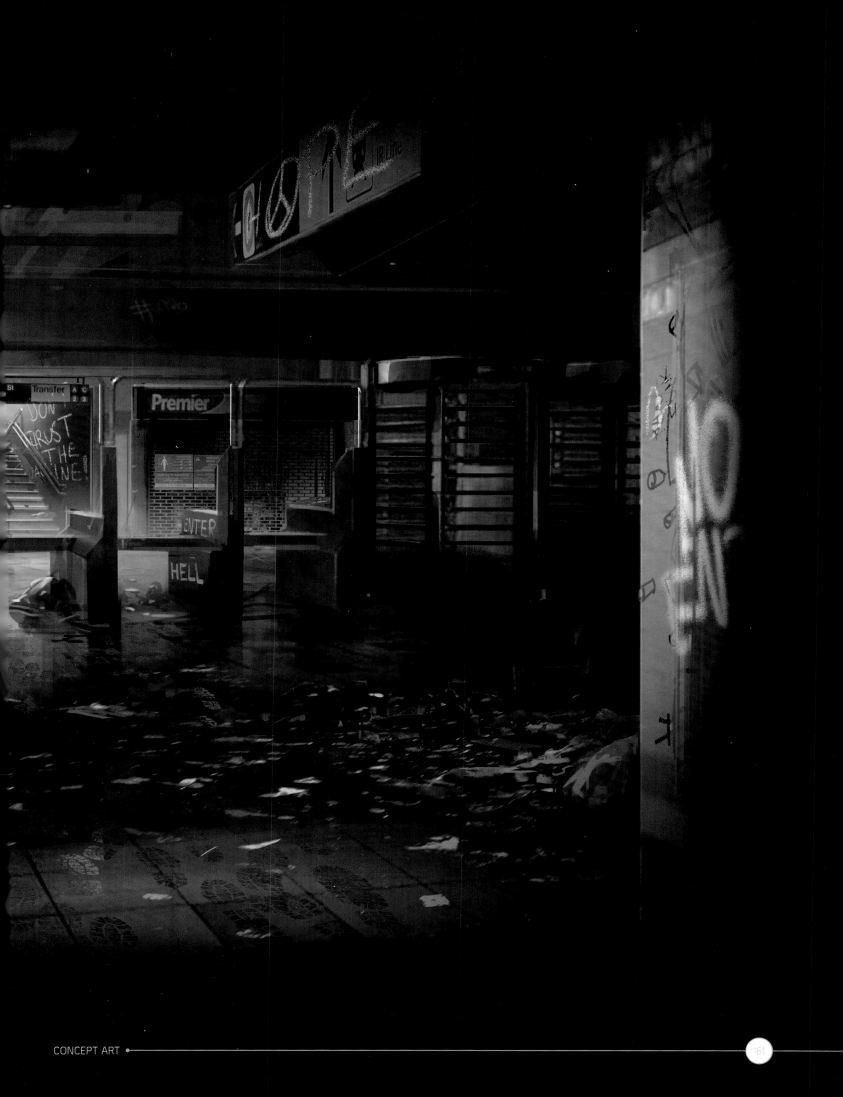

London Underground stations were used as bomb shelters during WWII. New Yorkers have sought safety in their own Subway system too, with shanty homes built in an effort to withstand an explosion of a different kind. "We imagined that some people would create makeshift camps and tap into the resources running beneath the city," says Tom Garden.

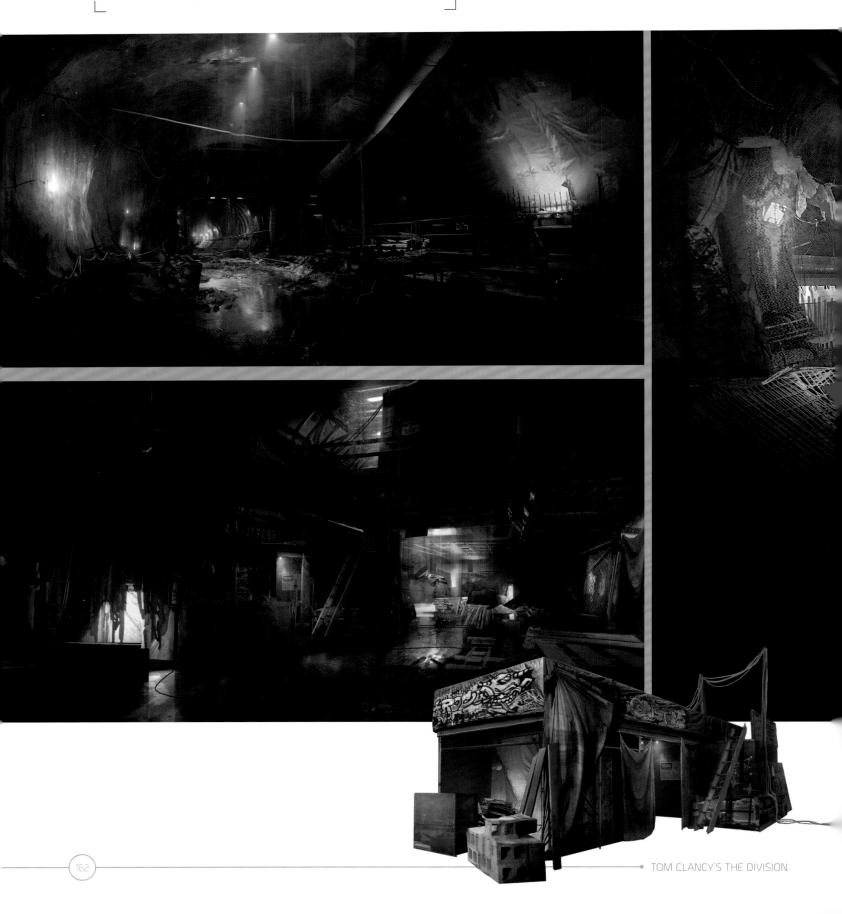

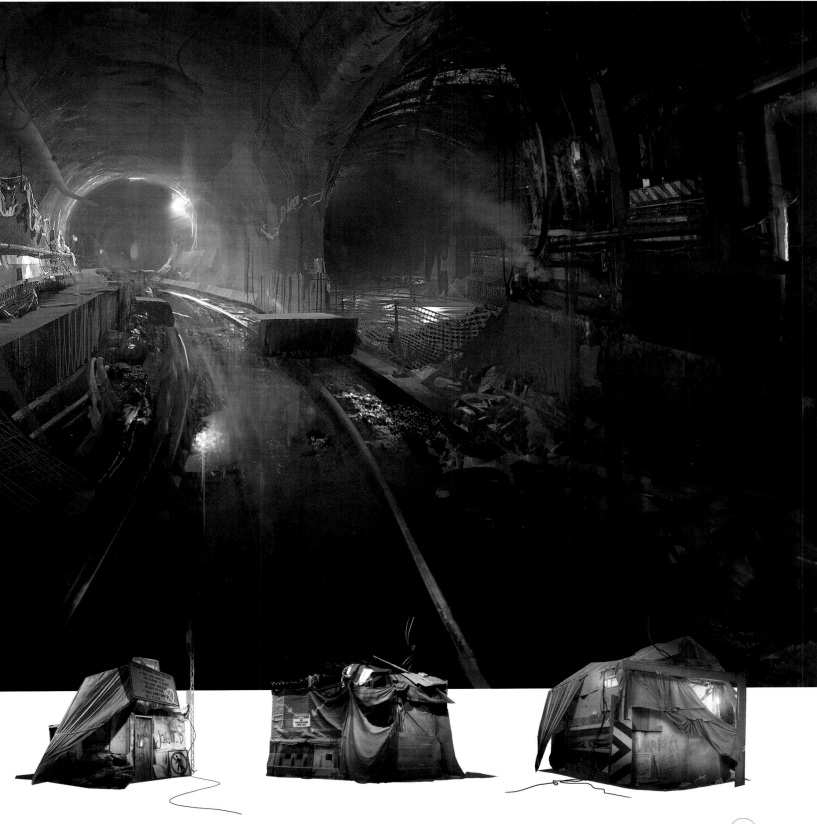

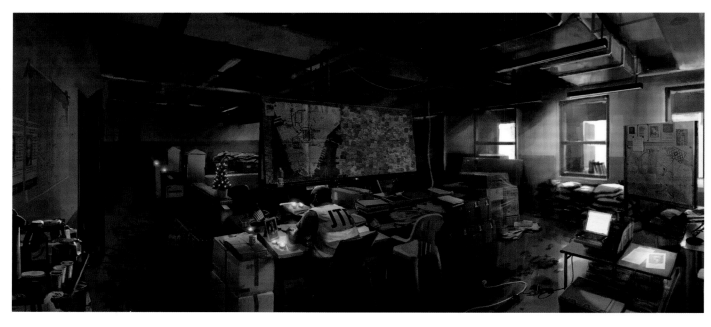

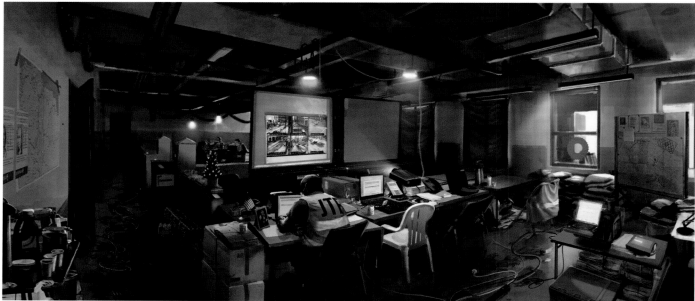

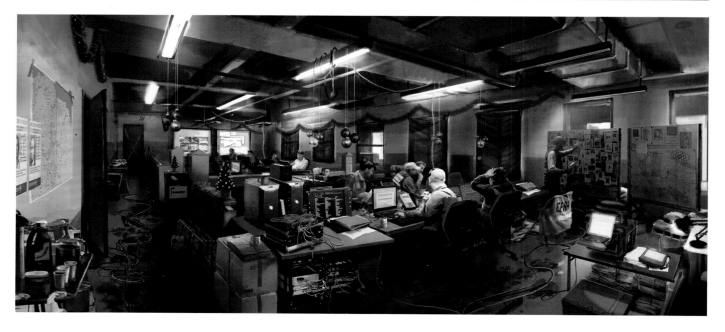

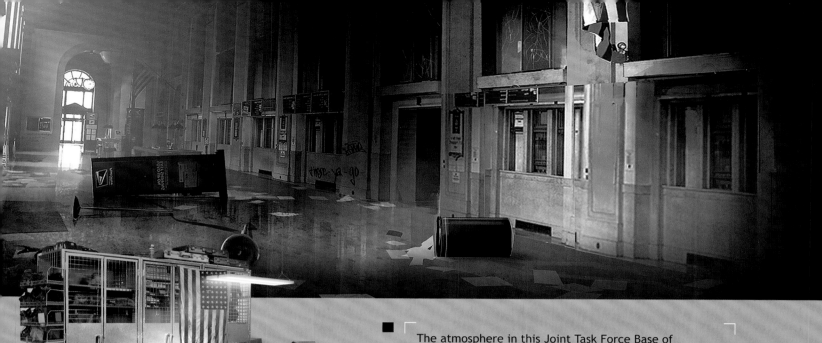

The atmosphere in this Joint Task Force Base of Operations improves considerably as gameplay progresses. "You will see it go from an abandoned outpost to a thriving base," says Tom Garden. "The environment and non-playable characters will change over time too, and the Base of Operations will feel very different when you manage to fully upgrade it."

# THE GRAVES

Mass graves are a necessary measure for the untold numbers of New Yorkers who have fallen prey to the Black Friday pandemic. It's already difficult enough to dig graves in the frozen earth, but there are too few remaining who can operate the necessary machinery anyway.

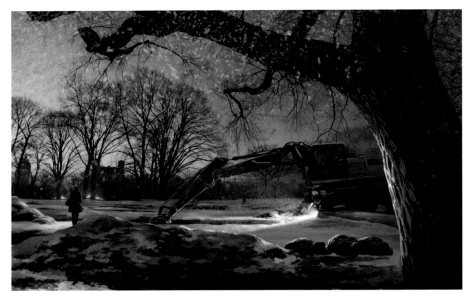

A likely scenario would be that the infected would need to be buried within the city to help maintain quarantine. While researching, the art team turned a few of the parks that feature in the game into these eerie grave sites.

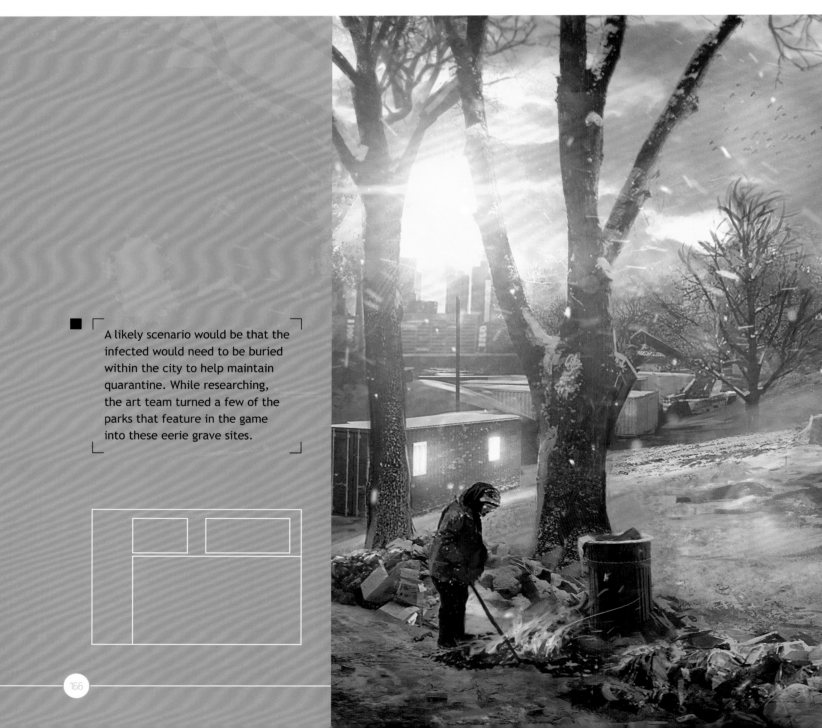

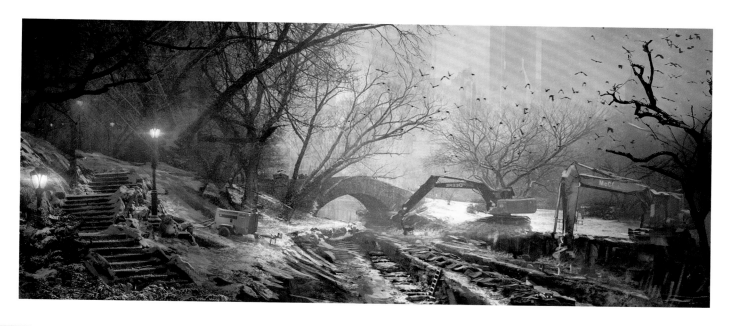

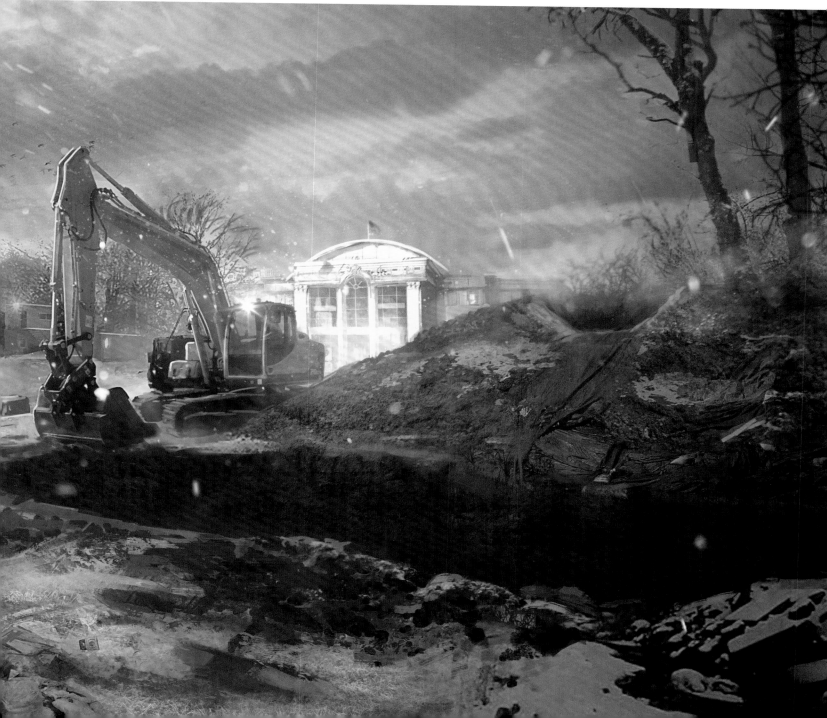

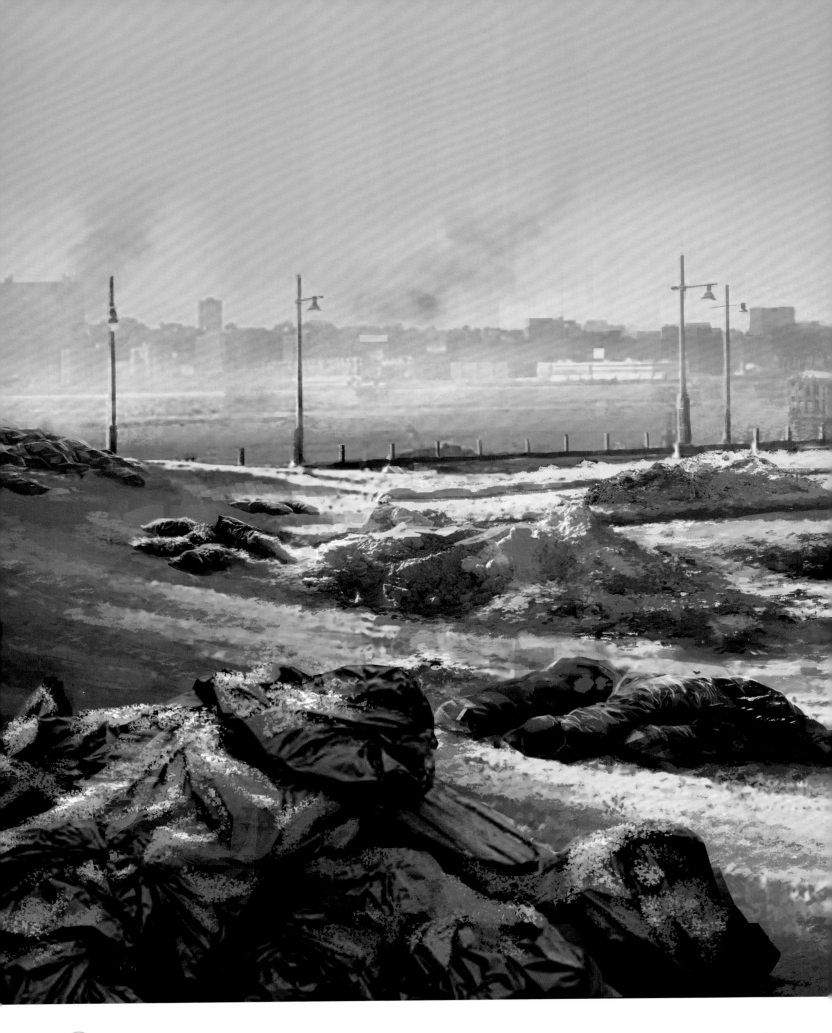

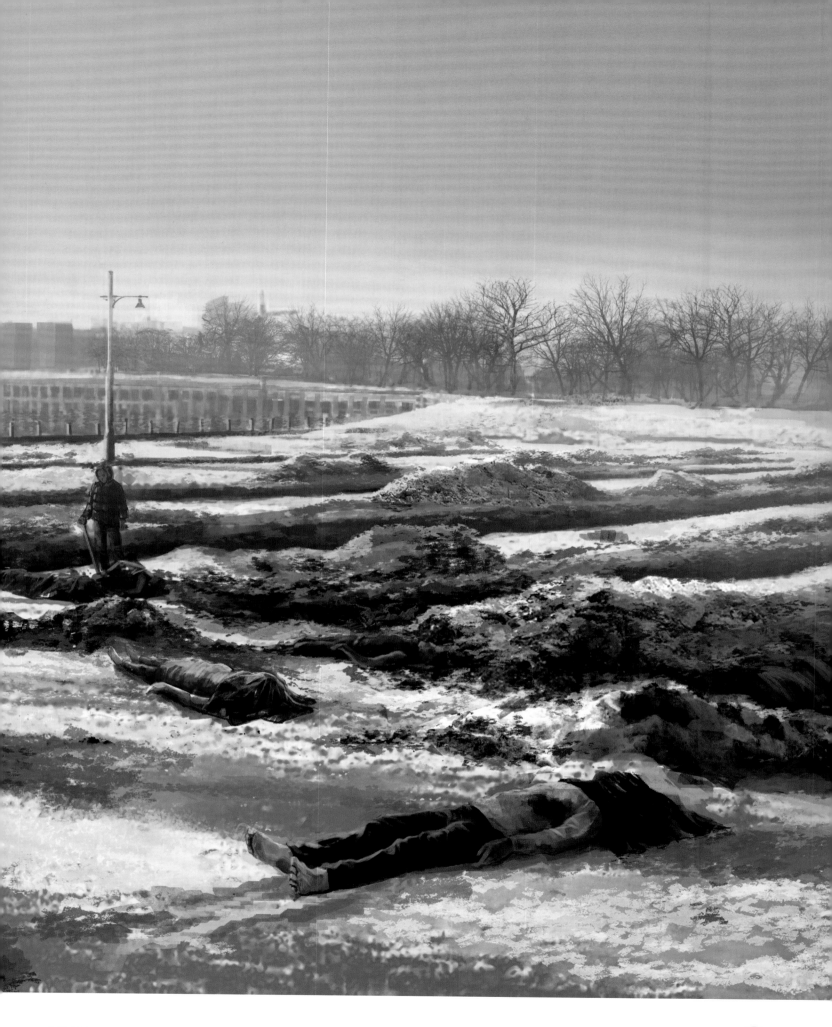

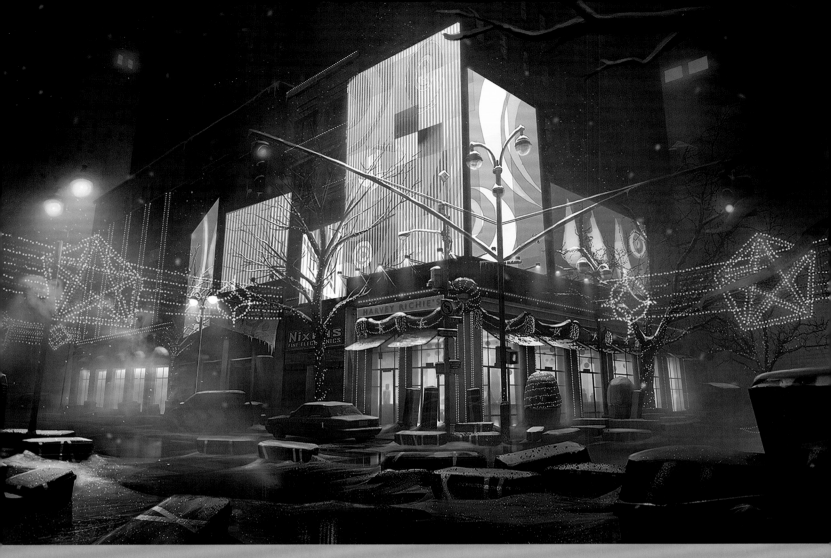

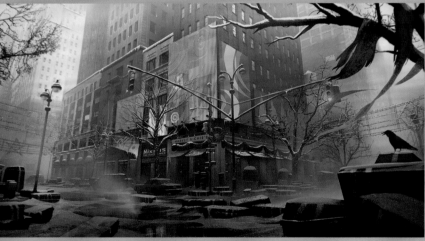

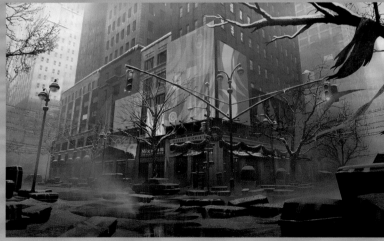

One of the cruellest ironies of the viral epidemic is that New York appears to be operating as usual – on a superficial level, at least. Neon hoardings, street lights and the decorations to mark the Holiday Season stay lit, and the power plants continue to produce electricity. Even stores are open for business for a few days before the outbreak really takes a hold, but it is not very long until citizens begin to die and everything falls apart. The wrecks of burnt-out cars now gridlock the streets, their drivers long fled or deceased, and yet the lights are still on. The night remains a scary time to be abroad in the city, though. The game takes place in the middle of an apocalypse, which means that there will still be some working electricity and some shops will have been functioning up until only a few weeks previously. This helps the artists add a little life into the city and make it feel familiar.

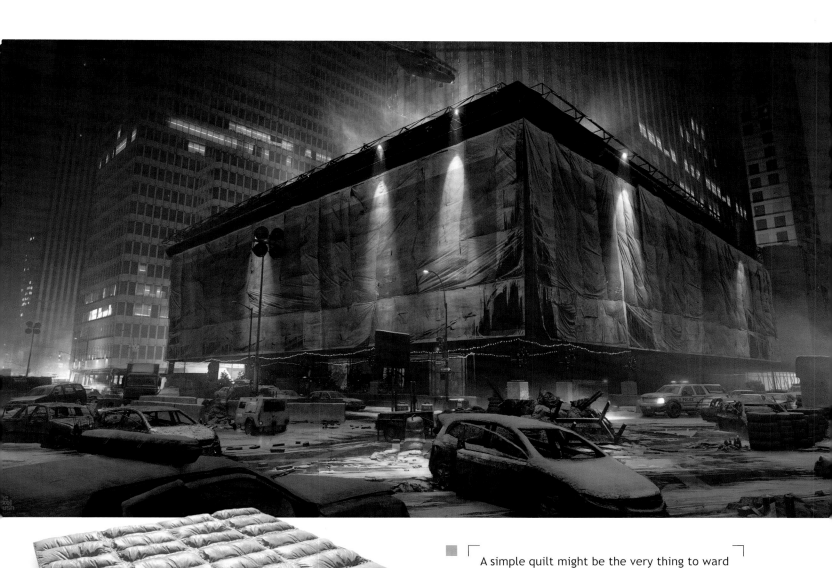

A simple quilt might be the very thing to ward off the winter chill. It is wise to be wary of its provenance, though, since the virus can be transmitted through banknotes, foodstuffs, human touch and more or less anything it comes into contact with.

# DARK ZONE

IN THE CENTER OF MANHATTAN IS A WALLED-OFF AREA FEW DARE TO ENTER. IT USED TO BE A QUARANTINE ZONE, A LAST LINE OF DEFENSE FOR THOSE TRYING TO CONTROL THE CHAOS OF THE BLACK FRIDAY OUTBREAK. THEY BUILT A WALL TO CONTAIN THE SICK BUT SOON THERE WERE TOO MANY. THAT'S WHEN THE POWER WENT OUT ACROSS THE CITY AND THE AREA WAS EVACUATED. THE BEST WEAPONS, THE BEST EQUIPMENT, AND THE ONLY HOPE FOR A CURE WERE LEFT BEHIND. FEW GO IN, FEWER COME OUT. THIS IS THE DARK ZONE.

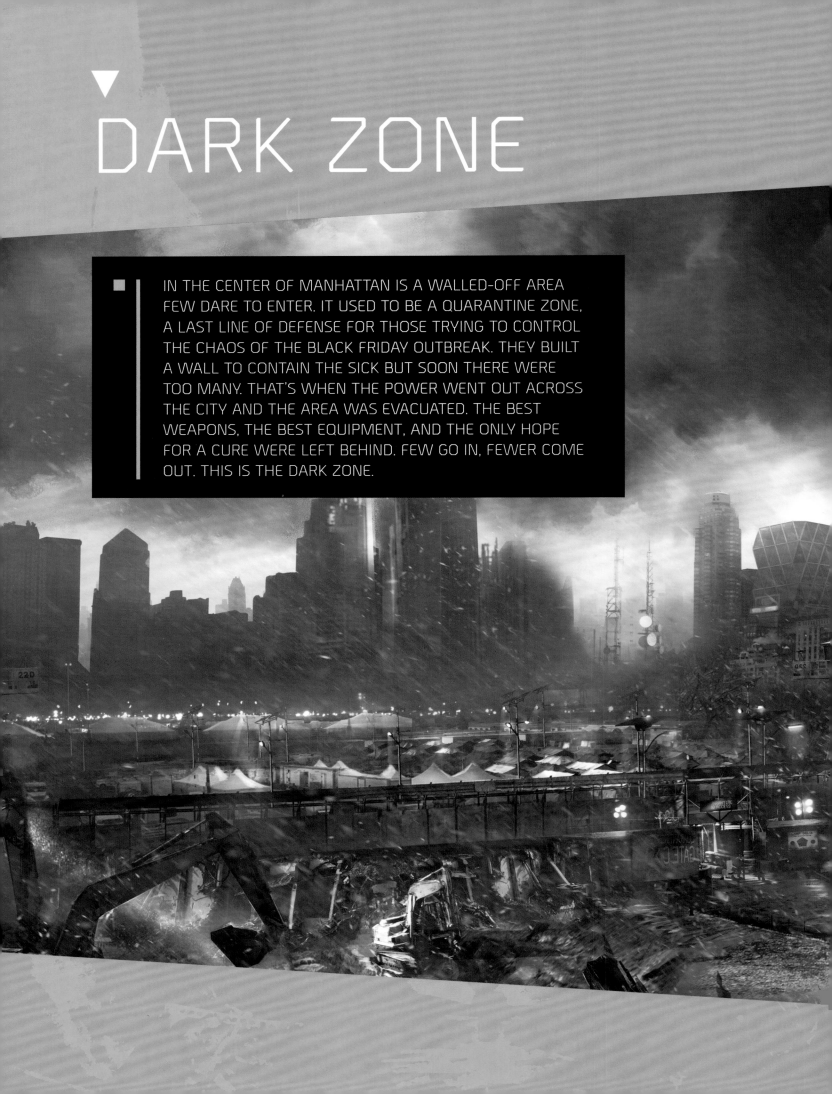

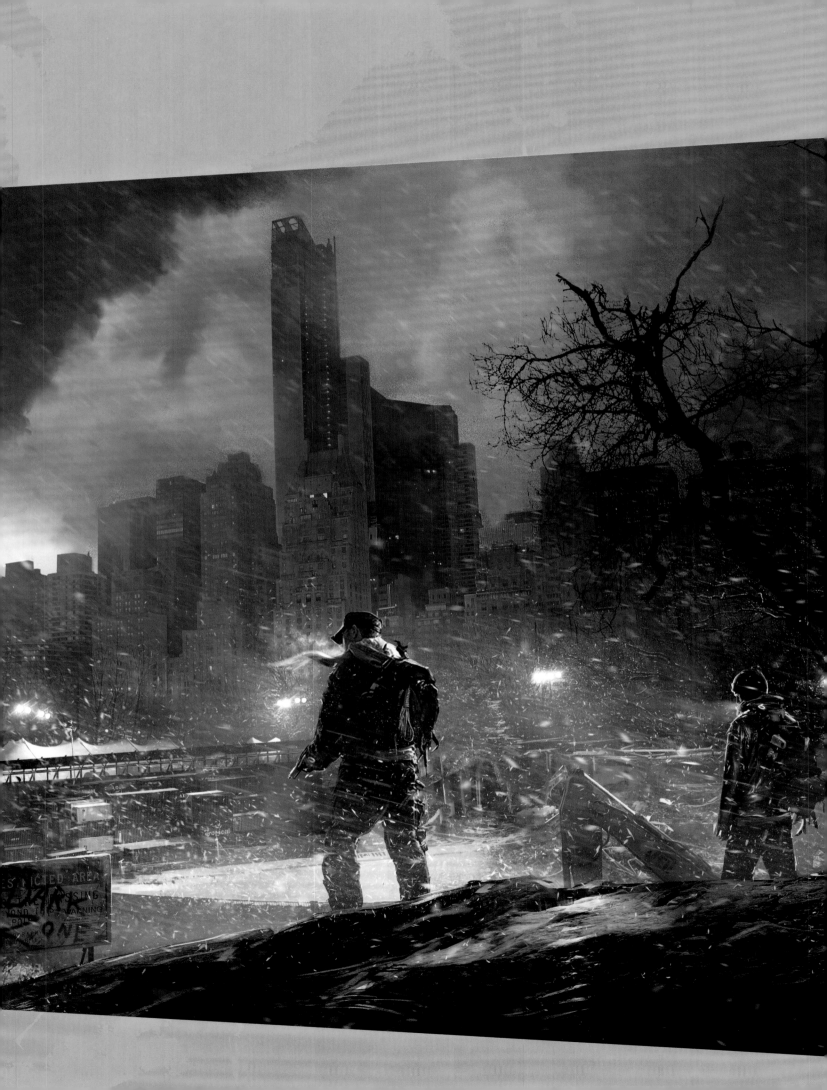

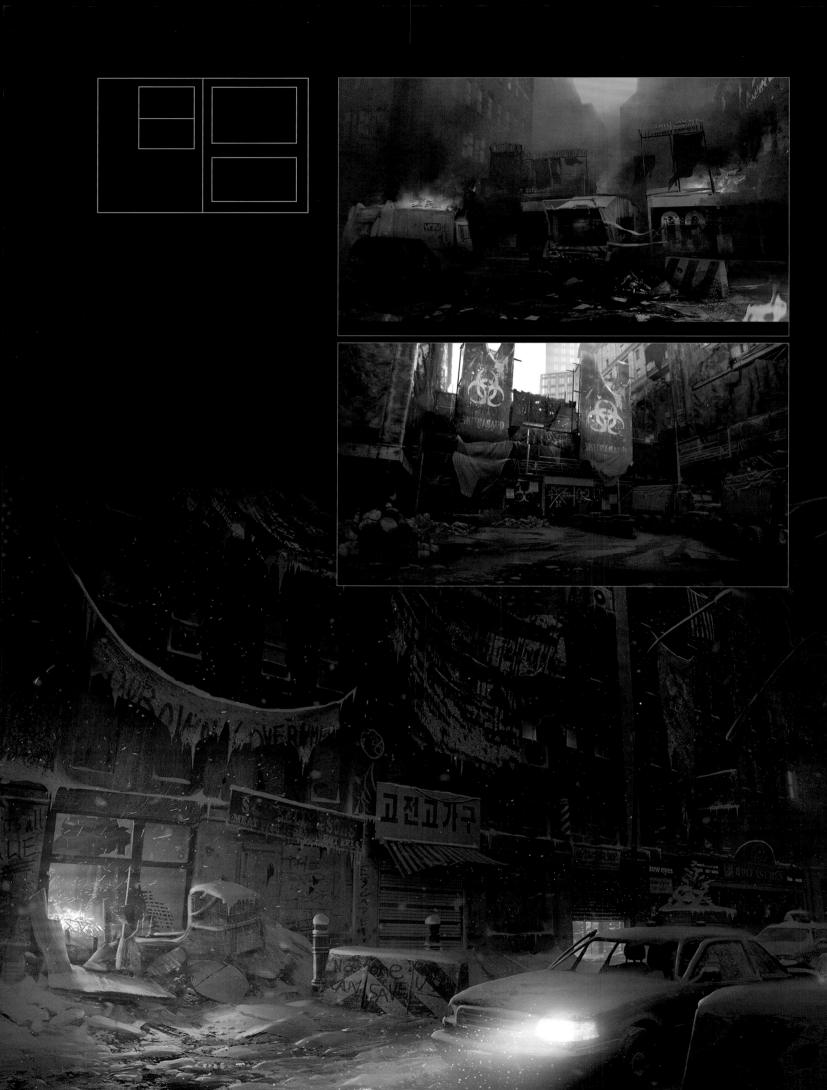

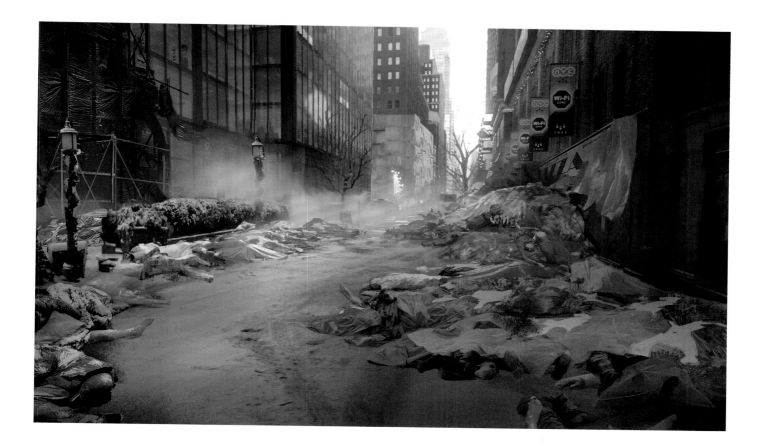

Snow settles on a bullet-riddled helicopter. All is quiet for now, but it won't be long before the silence is interrupted. Art Director for the Dark Zone, Mike Haynes explains, "The main theme in the Dark Zone is DEATH. The gates look imposing and dangerous, warning the player of what lies beyond. Signs, damage to the gates, and micro narratives are used to accent the overall structure. Faction presence and death are present as well. The player should feel as though they are entering a different place that is more dangerous than where they've been.."

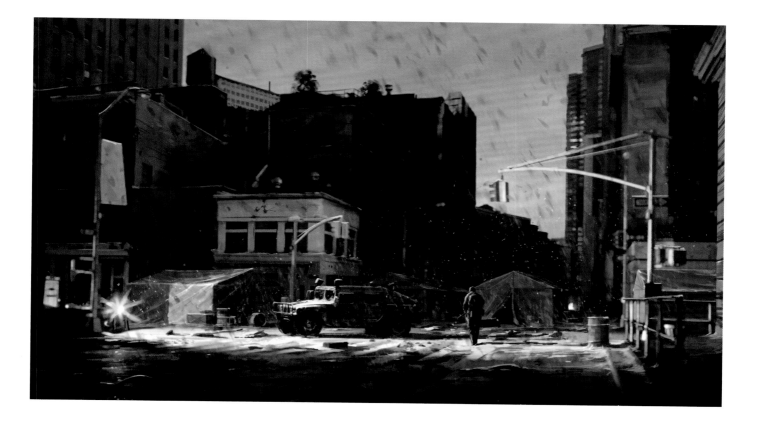

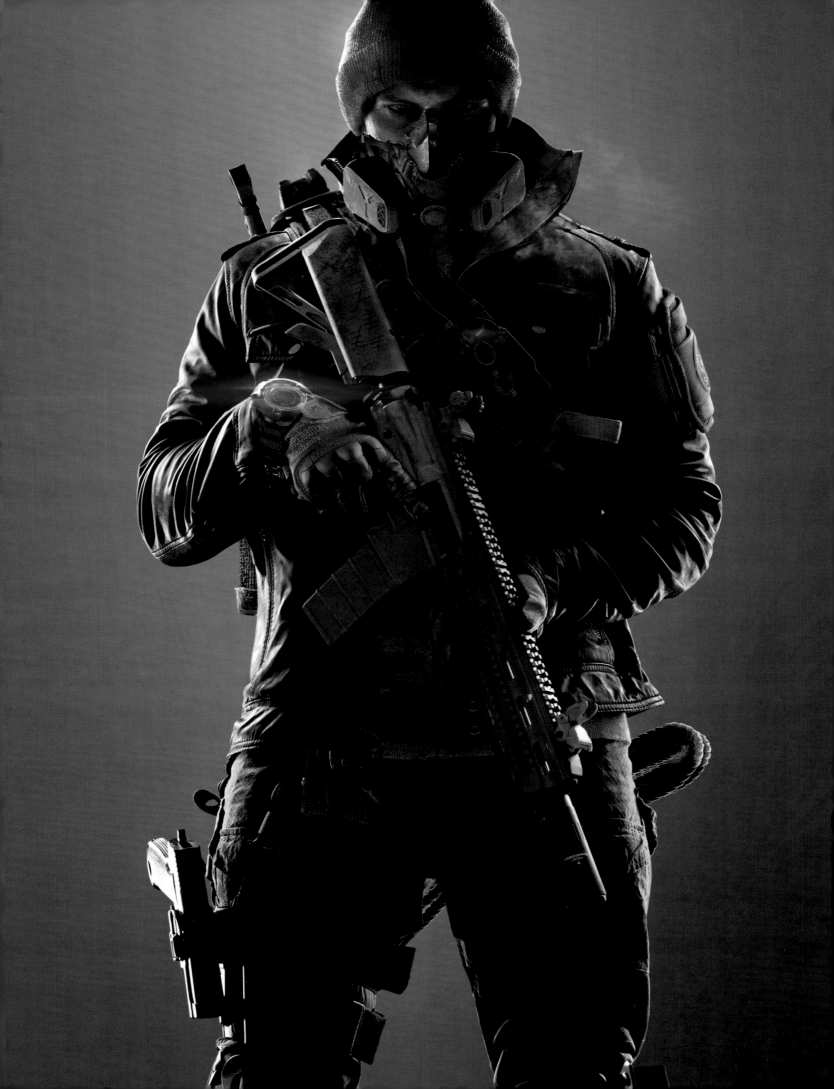

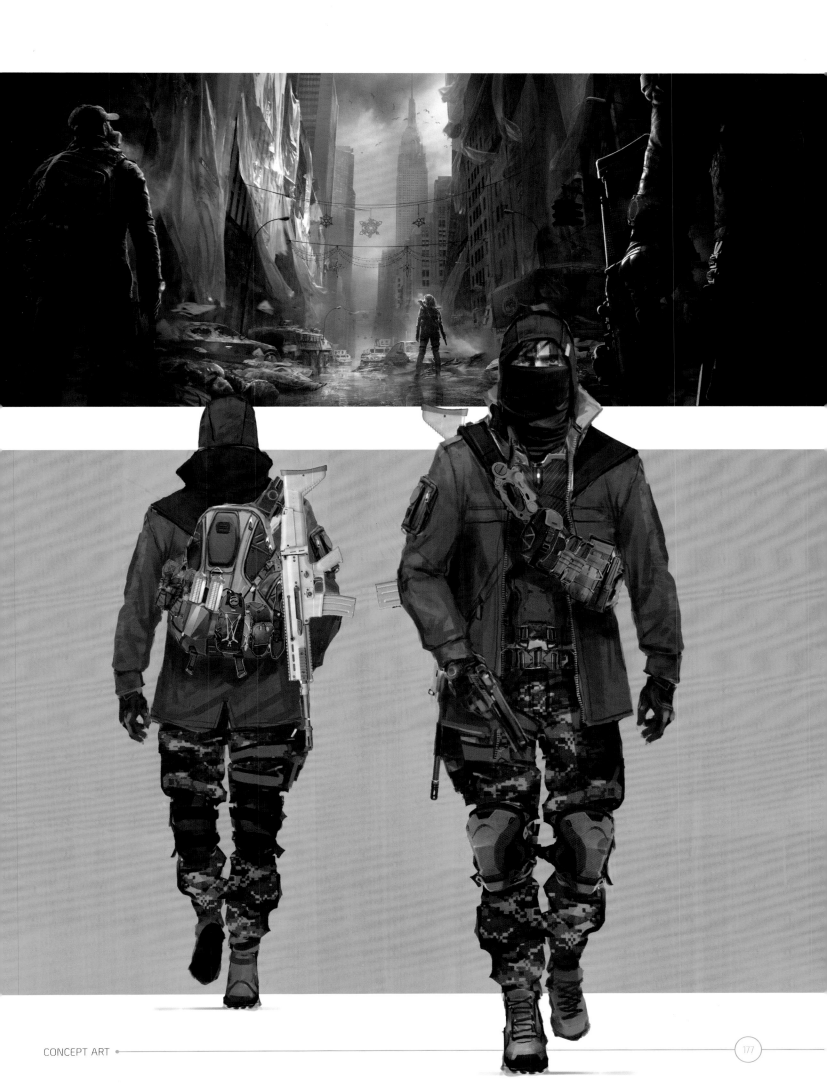

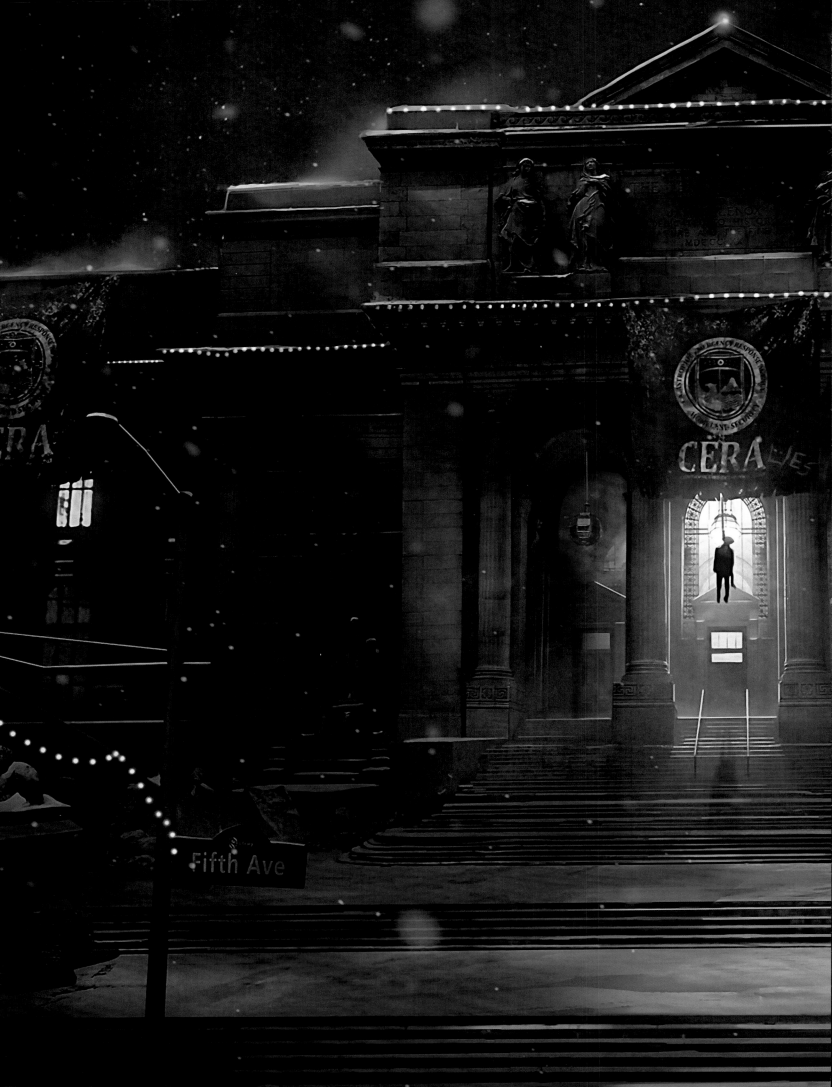

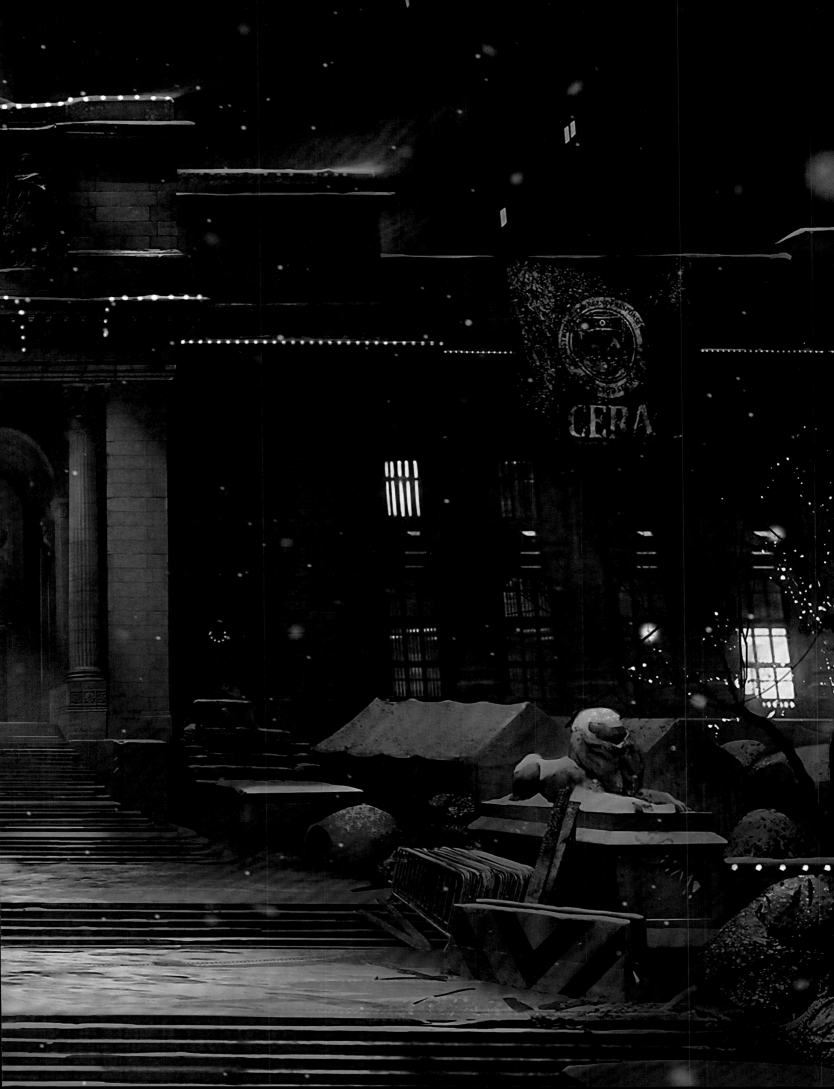

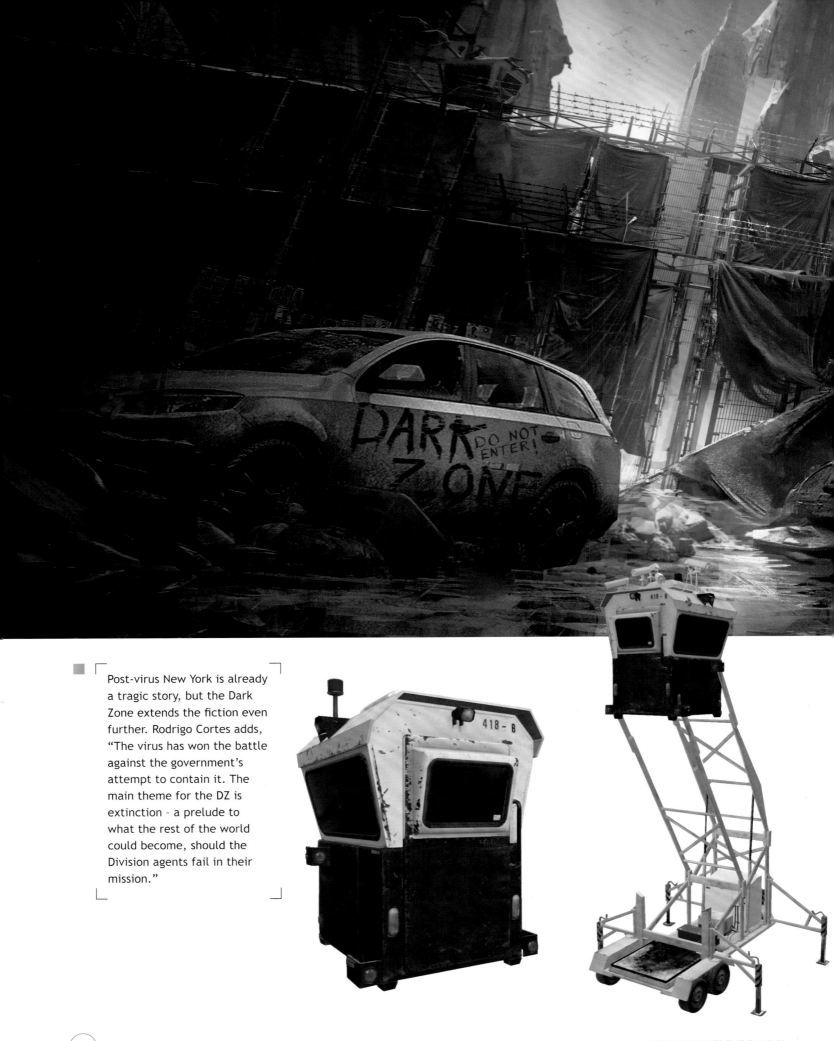

Post-virus New York is already a tragic story, but the Dark Zone extends the fiction even further. Rodrigo Cortes adds, "The virus has won the battle against the government's attempt to contain it. The main theme for the DZ is extinction – a prelude to what the rest of the world could become, should the Division agents fail in their mission."

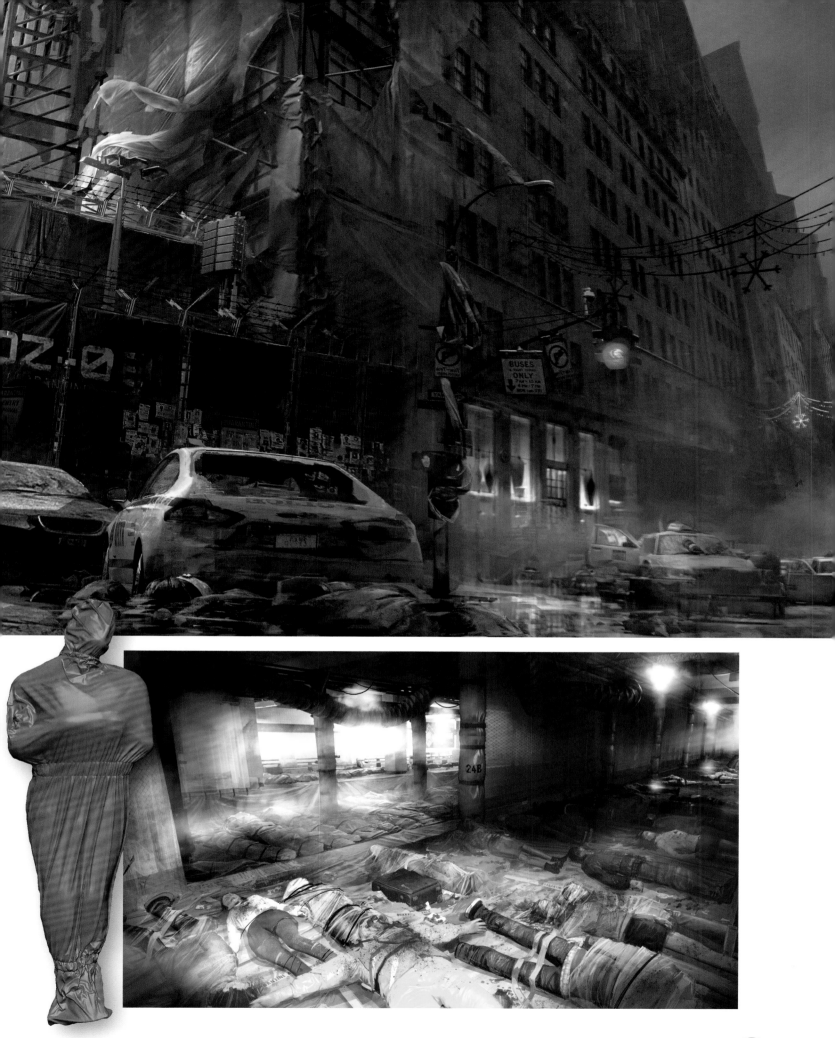

## GRAFFITI

Graffiti is a vital expression of New York street culture, thus it is used in the credible depiction of this vibrant city. Celebrated painters such as Fab 5 Freddy and Futura 2000 helped to legitimize graffiti as an art form. The best works are just as likely to grace a gallery wall as a darkened alley.

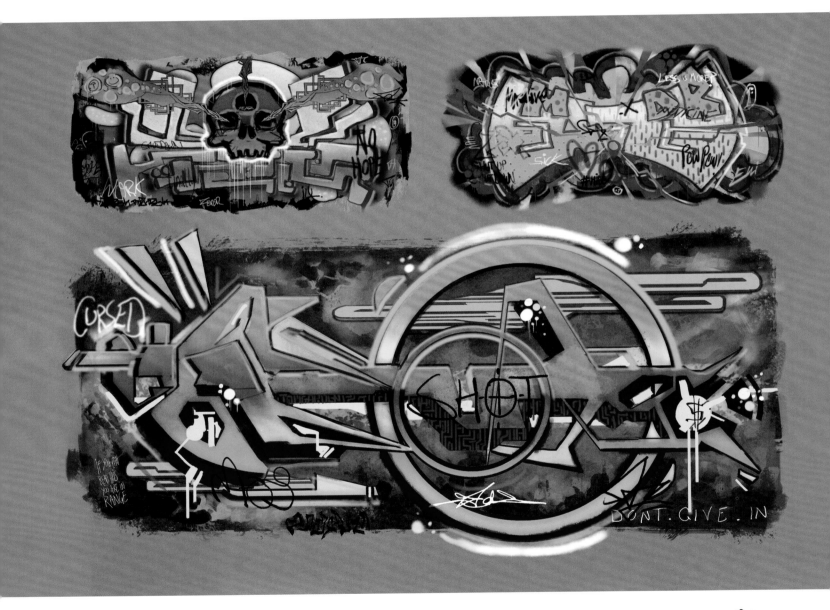

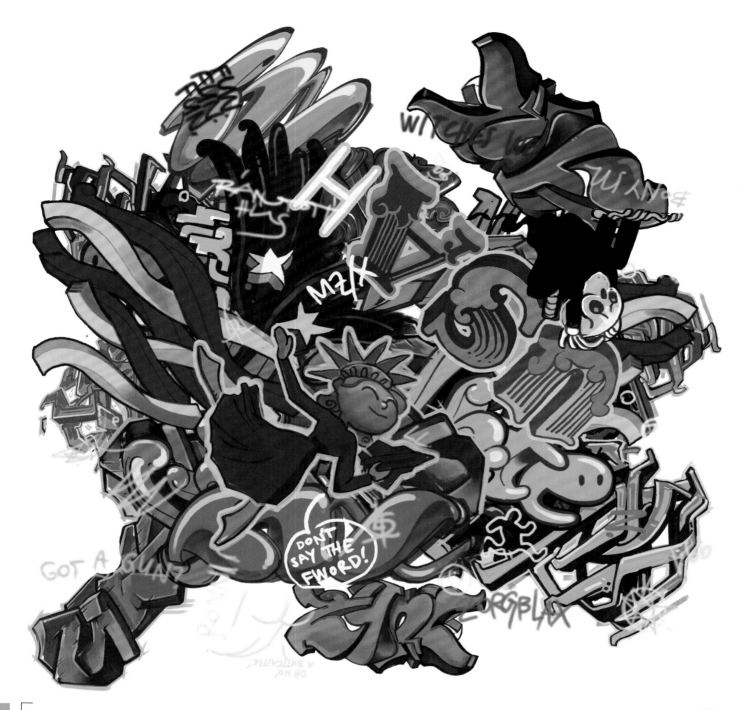

Distinctive graffiti backdrops much of the action in *Tom Clancy's The Division*. Moreover, these artworks bring color and character to snow-covered street scenes. Rodrigo Cortes explains further: "New York is one of the most diverse and 'branded' cities in the world. There are advertisements and graffiti all over, and this was one of the most ambitious goals we set in the beginning. We've designed a huge amount of 'companies', each with its own name, iconography and products. From these we create advertising signs, logos and storefronts that we spread out in appropriate areas of the game. This is one part of creating a realistic NYC. Graffiti is also a huge part of the look and feel of NYC, and we have done many research trips to the city with this specifically in mind. We also contacted real street artists to create authentic art for our setting."

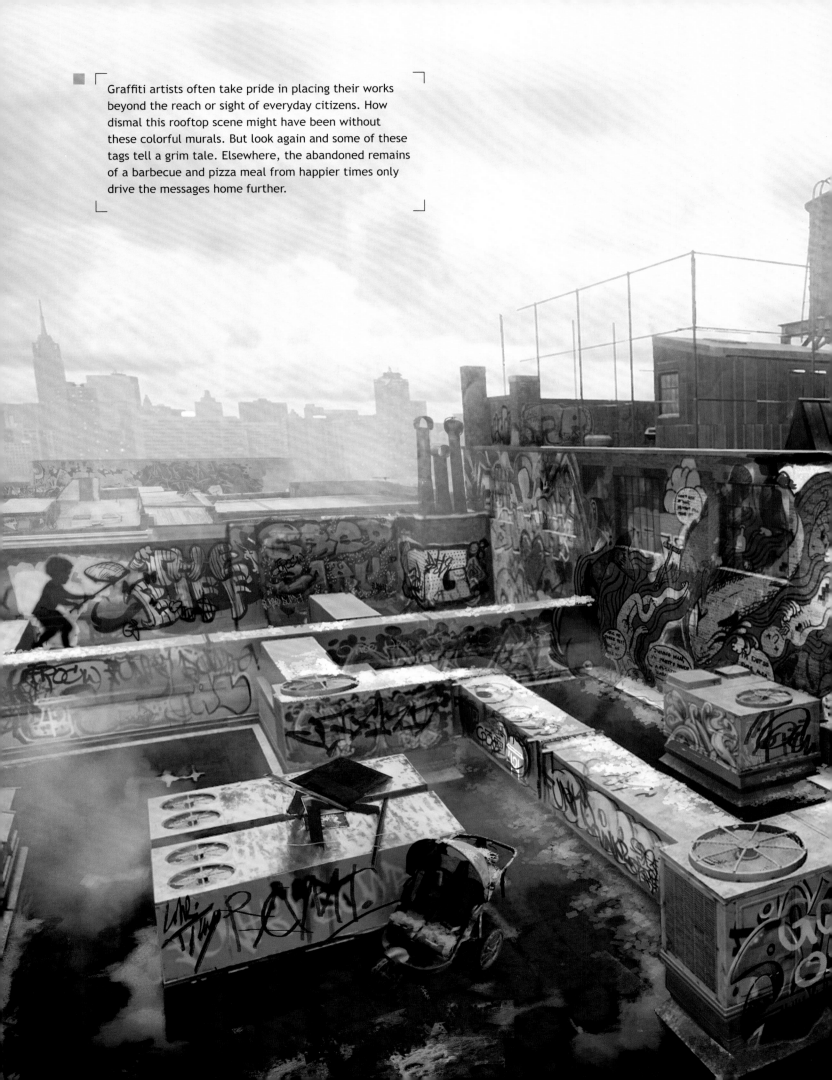

Graffiti artists often take pride in placing their works beyond the reach or sight of everyday citizens. How dismal this rooftop scene might have been without these colorful murals. But look again and some of these tags tell a grim tale. Elsewhere, the abandoned remains of a barbecue and pizza meal from happier times only drive the messages home further.

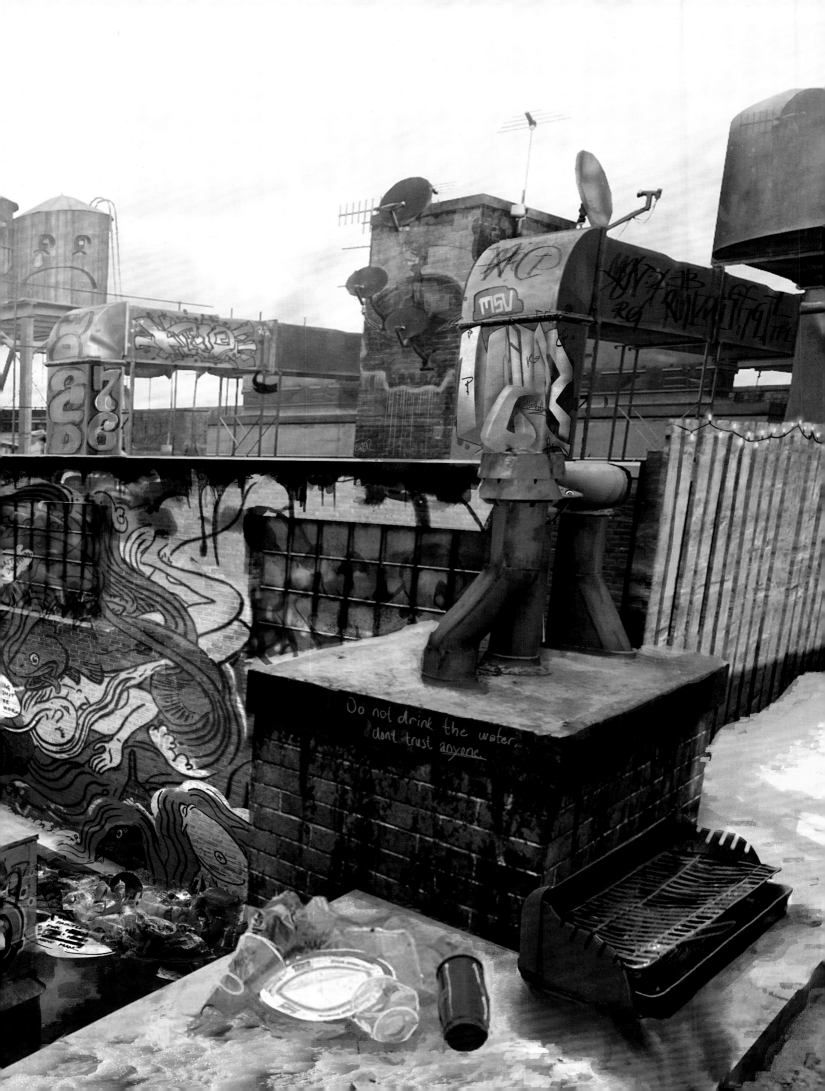

Do not drink the water,
dont trust anyone.

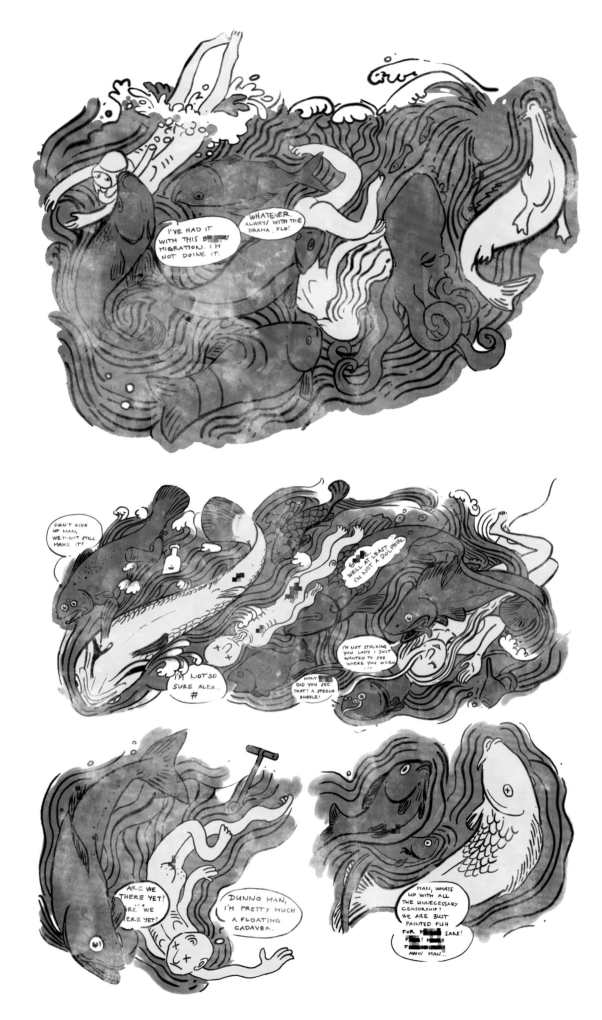

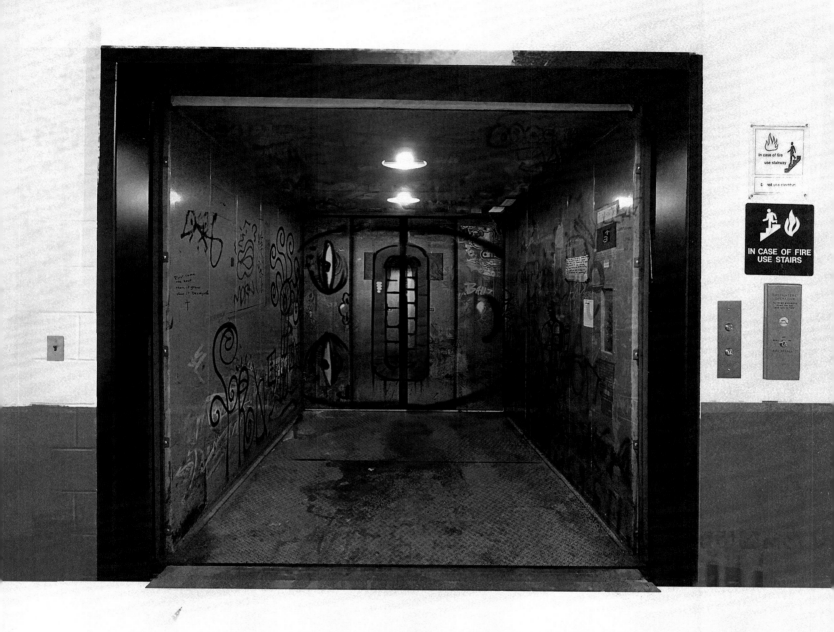

Floating bodies join migratory fish in an allegorical escape scene [*left*]. This dreamlike sequence comments on the powerlessness that is felt, but also conveys an acceptance of whatever fate has in store. To really attain a true feeling of New York the art team spent a lot of time creating unique graffiti for the game. As Tom Garden explains, "We researched the style of graffiti present in the city today, as well as creating some visuals that helped to drive district colors, factions or storytelling. Not only did we make some beautiful pieces, but we also made sure we had some more general, trashy-looking graffiti, or graffiti that has been around for years." It was very important to get many styles into the graffiti and not make it look like one person made everything, so all of the concept art team contributed.-

# POSTERS AND BILLBOARDS

Part of the overall task in creating the reality of the city was to fill it with the kind of advertising that fits aesthetically into their version of New York City. These elements are in the background, on walls advertising a movie or a brand of beer, or a flier for a jazz band crumpled on the street. These small touches make the whole experience come alive and the player feel like they are walking through a real New York City in the midst of an apocalyptic event.

**ENTO MOLOG**

**INSECTS IN ART**

NYC MUSEUM OF ART HISTORY

**JAZZ BAND**
5TH ANNIVERSARY FESTIVAL

A FILM BY
**ÈDITH LAGRANGE**

KATHERINE L. KINCHEN          HARBIN LEPAGE

"INTIMATE AND PROFOUND"
A WARM AND PLAYFUL DEPICTION OF
EVERYDAY LIFE

**KICK IT!**

— THREE ACTS OF SPELLBINDING MUSIC —
**A MUST-SEE MASTERPIECE**

"Absolutely magnificent"
—MAGAZINE

"Entrancing and inspiring"
—NEWSPAPER

Performances MON–TUE at 6:30PM & SUN–SAT at 1PM

**CUT! CUT! CUT!**
The claim to fame
Tickets available for purchase in box offices and online
**A BROADWAY MUSICAL**
visit CUTCUTCUT.BOP to read more!

*The Bell Jar*
April 13th

*Seven Kings*
A NEW MUSICAL

GERSHWIN THEATRE, 222 W 51st ST.

**1932**

**NEW YORK**

Visit New York this summer
First Class with the Blue Ribbon Victoria Line

Our offices are in LONDON
Belgrave street No.57 B, and New York, Water street No.272/a

**SOPHOCLES**

**KING OEDIPUS**

Premiere: Dec 2

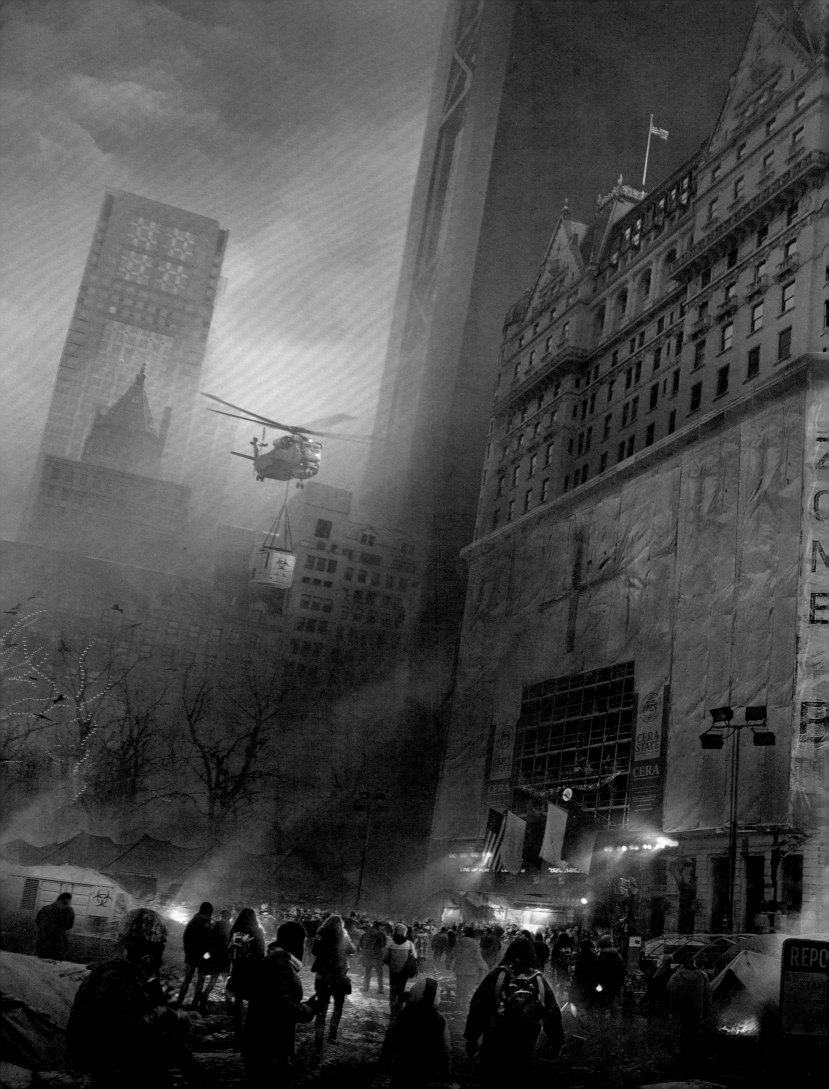

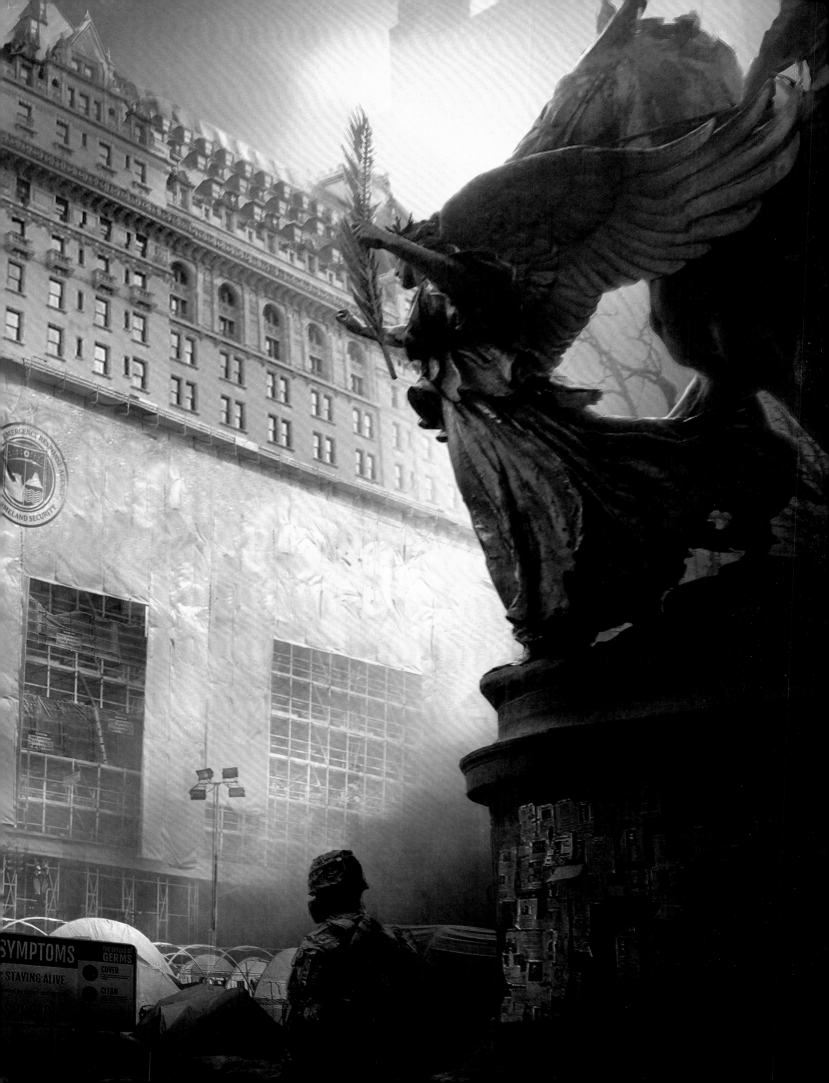

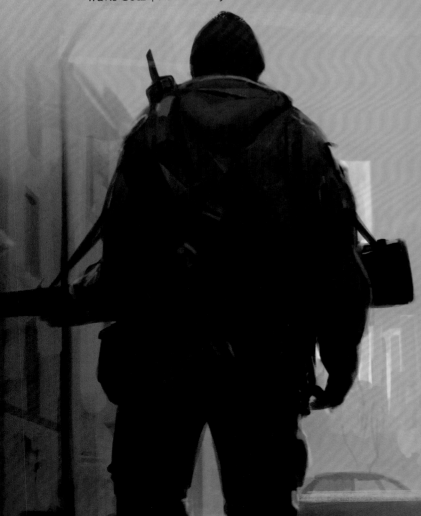

# ACKNOWLEDGMENTS

## STUDIO PRODUCTION

Magnus Jansen | Creative Director
Julian Gerighty | Associate Creative Director

Gabriel Odgren | Art Director
Christer Wibert | Art Director
Mike Haynes | Art Director

Tom Garden | Lead Concept Artist
Miguel Iglesias | Senior Concept Artist
Gergely Fejérváry | Senior Concept Artist
Oscar Sjöstedt | Concept Artist
Daniel Törngren | Concept Artist
Johannes Bergcrantz | Concept Artist
Robert Grafström | Concept Artist
Ronja Melin | Concept Artist
Debbie Tsoi | Concept Artist
Titus Lunter | Concept Artist
Bianca Draghici | Concept Artist
Torben Lindström | Junior Concept Artist
Ludovic Ribardiére | Illustrator
Stefan Olsén | Cinematic Lead Artist
Florian de Gesincourt | Concept Artist
Amr Din | Authenticity Coordinator, Visual Identity
Tony Nichols | Senior Graphic Artist
Nick Georgopoulos | Lead Prop Artist
Tommy Alvarez | Expert Environment Artist
Richard Case | Creative Services Coordinator
Anna Wahlström | Legal Associate Producer
Travis Getz | Authenticity Coordinator

## STUDIO BRAND

Eric Moutardier | Brand Director
Rodrigo Cortes | Brand Art Director
Alexander Tinglöf | Brand Artist
Johanne Beaupied | Lead International Product Manager
Giulia Palmieri | International Product Manager

## OURSOURCING

Opus Artz
One Pixel Brush
Blur Studio

## UBISOFT | EMEA

Alain Corre | EMEA Executive Director
Geoffroy Sardin | EMEA Senior Vice President Sales &
    Marketing
Guillaume Carmona | EMEA Marketing Director
Lionel Hiller | EMEA Group Brand Manager
Pierre Miazga | EMEA Brand Manager
Charlotte-Patricia Labeau | EMEA Operational Product
    Marketing Assistant
Marc Issaly | EMEA Product Marketing Assistant
Clément Défossé | EMEA Live Brand Manager
Pauline Gaultier | EMEA Operational Live Marketing and
    Marketing Online Assistant
Alexandre Guenounou | EMEA Digital Marketing Manager
Clémence Deleuze | EMEA Publishing Executive
Elisabeth Torre-Vincent | EMEA Trade Marketing Group
    Manager
Heidi Etcheverry | EMEA Trade Marketing Manager
Inès Agbanchenou | Trade Marketing Manager
Maxence Terrier | EMEA Trade Marketing Assistant
Guillaume Mammi | Com. Tools Purchasing & Manuf.
    Manager
Timothée Boyreau | Com. Tools Purchasing & Manuf.
    Coordinator
Darie Mayeux | EMEA Planning Coordinator

## UBISOFT | NCSA

Laurent Detoc I President, North America
Tony Key I Senior Vice President, Sales and Marketing
Rich Kubiszewski | Vice President, Operations
Adam Novickas I Vice President, Marketing
Josiane Valverde | Senior Director, Operations
Danny Ruiz I Senior Director, Marketing
Ann Hamilton | Director, Marketing
Alex Banks | Brand Manager
Mayya Grinberg | Associate Brand Manager
Trevor Shackelford | Senior Live Brand Manager
Dilip Priyanath | Associate Live Brand Manager
Ben Swanson | Associate Director Digital Marketing &
    Content Strategy
Kemoa Frederickson | Digital Marketing Manager
John Lee | Associate Digital Marketing Manager
Paul Audino | Senior Manager, Shopper
Scott Horowitz | Senior Shopper Marketing Manager
Cherrie Chiu | Senior Retail Programs Manager
Lindsey Poto | Shopper Marketing Manager
Katherine Stanton | Associate Shopper Marketing Manager
Oliver Fernandez | Assistant Buyer
Emmy Lee | Key Master
Katrina Medema | Manager, Purchasing
Rachel Reyes | Manufacturing Coordinator